Jill Bennett is Professor and Director of the National Institute for Experimental Arts, and Associate Dean of the College of Fine Arts at the University of New South Wales. She is the author of *Empathic Vision* (2005), a study of art and traumatic events.

'Jill Bennett is one of the strongest as well as most subtle voices in contemporary art criticism and theory.'

– Mieke Bal, cultural theorist, critic, video artist and Professor, Amsterdam School for Cultural Analysis, University of Amsterdam.

'[the book] itself is a kind of encounter, inspiring further creative thinking ... *Practical Aesthetics* will play a key role in re-attaching art to the social.'

– Amelia Jones, Professor and Grierson Chair in Visual Culture at McGill University, author of *Seeing Differently: A History and Theory of Identification and the Visual Arts.*

'In her remarkable new book, Jill Bennett proposes a radical rethinking of aesthetics ... indispensable and richly suggestive for cultural studies, critical theory, and contemporary art.'

– Abigail Solomon-Godeau, critic, curator and Professor Emerita of History of Art at the University of California.

Practical Aesthetics

Events, Affects and Art after 9/11

Jill Bennett

I.B. TAURIS

LONDON · NEW YORK

Radical Aesthetics–Radical Art

Series editors: Jane Tormey and Gillian Whiteley
(both at Loughborough University)

Promoting debate, confronting conventions and formulating alternative ways of thinking, Jane Tormey and Gillian Whiteley explore what radical aesthetics might mean in the twenty-first century. This new book series, *Radical Aesthetics–Radical Art (RaRa)*, reconsiders the relationship between how art is practiced and how art is theorized. Striving to liberate theories of aesthetics from visual traditions, this series of single-authored titles expands the parameters of art and aesthetics in a creative and meaningful way. Encompassing the multisensory, collaborative, participatory and transitory practices that have developed over the last twenty years, *Radical Aesthetics–Radical Art* is an innovative and revolutionary take on the intersection between theory and practice. Published and forthcoming in the series:

Eco-Aesthetics
Malcolm Miles

Indigenous Aesthetics: Art, Activism and Autonomy
Dylan Miner

Practical Aesthetics: Events, Affects and Art after 9/11
Jill Bennett

The Aesthetics of Duration: Time in Contemporary Art
Paul O'Neill and Mick Wilson

For further information or enquiries please contact *RaRa* series editors:

Jane Tormey: j.tormey@lboro.ac.uk

Gillian Whiteley: g.whiteley@lboro.ac.uk

To Luc and Lita

Published in 2012 by I.B.Tauris & Co Ltd
6 Salem Road, London W2 4BU
175 Fifth Avenue, New York NY 10010
www.ibtauris.com

Distributed in the United States and Canada Exclusively by Palgrave Macmillan
175 Fifth Avenue, New York NY 10010

ISBN 978 1 78076 144 2 (HB)
 978 1 78076 145 9 (PB)

A full CIP record for this book is available from the British Library
A full CIP record is available from the Library of Congress

Library of Congress Catalog Card Number: available

Printed and bound in Great Britain by T.J. International, Padstow, Cornwall

Contents

List of Illustrations

List of Plates

Acknowledgements

Research for *Practical Aesthetics* was funded by a three-year Discovery Grant from the Australian Research Council and was in other ways supported by the University of New South Wales (UNSW). The manuscript's completion was enabled by a Sterling and Francine Clark Fellowship, which was generously hosted at the Clark Institute (Massachusetts) in 2009 by Michael Ann Holly and Mark Ledbury.

The concept of practical aesthetics arises from my work at UNSW's National Institute for Experimental Arts and Centre for Contemporary Art and Politics, institutions that are committed to transdisciplinary experimentation and the extension of aesthetics into everyday life and politics. My colleagues in Sydney (notably Jennifer Biddle, Anna Gibbs, Anna Munster, Felicity Fenner and David McNeill) have provided a rich context for thinking about the potential of aesthetic activity, particularly through the co-organisation of exhibitions and of seminars and workshops on affect, aesthetics and politics.

My ideas on the relationship of events to art have been aired through various conferences of the Art Association of Australia and New Zealand (and the Association's Journal, which in 2005 published an early version of part of Chapter 2) as well as in lectures and seminars hosted by colleagues at many institutions, including Columbia University and Leiden University. The latter

have allowed me to benefit from continued engagement with valued colleagues and formative thinkers such as Mieke Bal, Ernst Van Alphen, Andreas Huyssen and Marianne Hirsch.

Many artists, curators and theorists from different disciplines have engaged with this work in its early stages. I am particularly grateful to Hito Steyerl, Shona Illingworth (who initially commissioned my research on her work for Film and Video Umbrella's 2011 monograph '*The Watch Man, Balnakiel: Shona Illingworth*'), Dennis Del Favero and Susan Norrie (the discussion of whose work, *Havoc*, I originally developed for the ZKM exhibition forum *Unimaginable*); also to Mark Reinhardt of Williams College for helpful discussions of Chapter 7.

I am especially appreciative of those who have directly assisted in the preparation of this manuscript: Veronica Tello, Rachael Kiang and Gail Kenning.

Part of Chapter 4 first appeared in an essay titled 'Aesthetics of intermediality' published in *Art History* (licensed by John Wiley and Sons) but is here revised in light of new ideas on the event as media spectacle.

Chapter 5 is adapted from the essay 'A Feeling of Insincerity', eds Alphen et al. *The Rhetoric of Sincerity* Copyright © 2009 by the Board of Trustees of the Leland Stanford Jr. University. All rights reserved. Used with the permission of Stanford University Press, www.sup.org.

This book is dedicated to my children Luc and Lita ('Yeah Mum, too much screen time!').

Preface

Post-postmodernity, there has been a resurgence of interest not only in the complex relationship of art and culture to society and politics, but there has been a radical rethinking of the contested term – aesthetics. Significant contributions to these debates include recent publications such as Jacques Rancière's *The Politics of Aesthetics* (2004) and *Aesthetics and its Discontents* (2009); Alain Badiou *Handbook of Inaesthetics* (2005); Francis Halsall, Julia Jansen and Tony O'Connor (eds) *Rediscovering Aesthetics: Transdisciplinary voices from art history, philosophy, and art* (2008); Gavin Grindon (ed.) *Aesthetics and Radical Politics* (2008); Beth Hindeliter, William Kaizen and Vered Maimon (eds) *Communities of Sense: Rethinking aesthetics and politics* (2009). Rather than being condemned as a redundant term, aesthetics has undergone rehabilitation and has re-emerged as a vital issue for critique, exposition and application through practice.

Invigorated by this revitalised debate, in 2009 we initiated the *Radical Aesthetics-Radical Art* (*RaRa*) project at Loughborough University to explore the meeting of contemporary art practice and interpretations of radicality through interdisciplinary dialogue. Of course, radical is a term that is open to interpretation but we use it to promote debate, confront convention and formulate alternative ways of thinking about art practice and

reconceptualise radical notions of aesthetics. We set out to consider how art practice engages with the different discourses of radicality, its histories and subversions, and to develop the project in a number of directions beyond the confines of the institution. With an ongoing series of symposia, events, an ever-expanding network of individuals working at the intersection of art, culture, ideas and activism and various associated curatorial and dialogic initiatives in the planning stages, we now introduce our book series.

The *RaRa* book series explores what aesthetics might mean at this critical moment in the twenty-first century. The fundamental premise of the series is to reconsider the relationship between practising art and thinking about art. It aims to build on the liberation of the notion of aesthetics from visual traditions and to expand its parameters in a creative and meaningful way. Bridging theory and practice, it will focus on the multisensory, collaborative, participatory and transitory practices that have developed in the last twenty years.

With the resurgence of interest in affect as a significant feature of cultural relations, we are particularly pleased to be publishing Jill Bennett's *Practical Aesthetics* as the first volume in the series. Bennett positions affect as central to an examination of transdisciplinary aesthetics. Appraising the direction of practice post-9/11, she examines the practical value of aesthetics and repositions aesthetic perception in relation to its engagement with world events. While proposing an alternative way of thinking about art as a practice of *doing* in its relationship to the social field, *Practical Aesthetics* importantly challenges both the persistent conception of aesthetics as disconnected from social concerns, and the assumption that a practical aesthetics must be one of activism. *Practical Aesthetics* argues for a fundamental

reorientation of the fields of aesthetics, visual culture and art theory and it does so intelligently, imaginatively and poetically. We are sure it will play a key role in the ongoing debate about art and aesthetics as it unfolds.

Radical Aesthetics–Radical Art
Gillian Whiteley and Jane Tormey

1
Practical Aesthetics: Beyond Disciplines

Aisthesis and practicality

By the 1970s, so the story goes, aesthetics was on the wane. Cultural studies was in the ascendancy, along with critical and social theory, and Western art had turned away from formalism toward more worldly concerns. 'Aesthetic reflection', as one notable encyclopaedia puts it, seemed to distract from the more important consideration of art's embeddedness in the social world; moreover, art practice itself, from the 1960s onwards, reinforced the sentiment that 'beauty was besides the point'.[1] In this light, the conjunction of the terms 'practical' and 'aesthetics' presents something of an antinomy. Seemingly inimical to social enquiry, aesthetics had come to signify the very antithesis of anything 'practical'.[2]

Characterised as a discipline concerned with the definition of art or beauty, aesthetics is readily marginalised in this way. Since its inception, however, aesthetics has promoted the study of *aisthesis*, perception via the senses (in the 1750s Alexander Baumgarten derived the discipline name from the Greek 'aisthanomai').[3] It thus

inclines not only towards the judgement of art – which has proved its predominant concern – but also toward a more general theory of sensori-emotional experience, potentially crossing from the arts into psychology and social science. Twenty-first-century aesthetics has exploited this base more extensively. While resisting a collapse into a theory of sensation, the work of a philosopher like Jacques Rancière reconfigures the aesthetic as the site for the systematic ordering of sense experience – a kind of regime of the sensible, which in turn establishes the political function of aesthetics.[4] At the same time, media theorists (drawing on thinkers such as Gilles Deleuze and Félix Guattari) have shifted the terms of aesthetic analysis to focus on media dynamics, affect and perception. Questions of beauty and taste are no longer a wedge at the forefront of this more broadly engaged field of aesthetics, which opens itself to considerations of practical value.

To engage in *practical* aesthetics is not to contest directly the philosophical ground of aesthetics or its historical determinations; nor is it simply to 'apply' aesthetic theory. It is to conceive of an aesthetics informed by and derived from practical, real-world encounters, an aesthetics that is in turn capable of being used or put into effect in a real situation. In other words, it is to orient aesthetics – with its specific qualities and capacities – towards actual events or problems (much as practical ethics is shaped around specific problems).

It could be argued that an investigation of specific instances of the interface of art and life is a project for art history more than it is an aesthetics. But to work effectively at this interface art history must account for processes of aisthesis, which, by their nature, transgress the borders of disciplines. Studying these processes entails paying attention both to art and to what exceeds art; specifically, to how practices are transformed through engagement

with what lies beyond them. Art history is but one of several disciplines in a position to work out new ways of rendering aesthetics more 'useful' in a broader field. The premise of *Practical Aesthetics* is, however, that the study of aisthesis cannot occur 'inside' art history, or within any framework that privileges its own disciplinary concerns and approaches over external engagement. If there are skills of art and visual analysis that might be exported from art history and brought to bear in this project, there is also a disciplinary certainty that must be left behind.

Practical aesthetics is the study of (art as a) means of apprehending the world via sense-based and affective processes – processes that touch bodies intimately and directly but that also underpin the emotions, sentiments and passions of public life. It is, then, the study of aesthetic perception at work in a social field. As such it is not a philosophy *of* art but an endeavour in which art and exhibitions participate as they engage with and reflect on aesthetics-at-large.[5] Art, in this sense, offers an exemplary instance of practical aesthetics. From the perspective of the theoretical writing of practical aesthetics, art figures as an aesthetic operation (a way of *doing*, as opposed to an *object of* philosophy) that takes as its subject matter the already aesthetic nature of everyday perception. This operation occurs on an aesthetic continuum (rather than in a rarefied realm), connecting art to the practices of everyday life.

It is not difficult to dispose of the historical opposition of aesthetics and practicality in light of the many ways in which art is practical and socially engaged. But the aim of this book is not merely to write about art that is explicitly defined by its social purpose; it is specifically to highlight the often elided term 'aesthetics'. My focus is less on a specific kind of art with a given set of objectives than on the *aesthetic means* of art and other expressive forms. To this end, the notion of practical aesthetics preserves a

subtler antinomy, reflecting a tension in art's orientation toward the world of practical action. Deleuze captures its essence in his evocation of the 'affection image' as one that stops short of action, embodying precisely that which occupies the interval between a troubling perception and a hesitant action.[6] Aisthesis, as a mode of apprehension, is not in itself an action. In certain instances where direct action is required, the work of aesthetics may seem like an indulgence (as in the case of catastrophe and human suffering, where making images or art is not a first priority). But, as Chapter 7 explores, the rhetorical opposition of the aesthetic to more 'useful' work is often overplayed. Clearly there are certain practical actions – forms of physical assistance, for example – to which aesthetics is dispensable. On the other hand, the 'real life' arena is not – even in the aftermath of catastrophe – devoid of aesthetic process. Actions, gestures, decisions, reactions, and the media by which these are relayed, are inflected by affect and particular sensitivities – as was particularly clear in the aftermath of '9/11' and will be apparent in analysis of events such as famine.

It is the capacity to dwell in this interval and to untangle some of its complex operations (the links – and blockages or 'hesitations' – between apprehension and action, between feeling and believing, appearing, saying and doing) that makes a creative aesthetics so valuable to the study of social life. The aim of this book is not to close this gap – to insist that art collapses into the world of 'practice', its expressions and actions indistinguishable from other forms. Hence it resists the idea that useful art must conform to a single ideal of 'activist' art measured in inaesthetic terms; that is an activism obliged to disavow aesthetics in order to render itself more serviceable. Nor does the book focus on art that constitutes itself primarily as an action. While much interesting work on the conjunction of politics and aesthetics is located in

the realm of 'activist' art, the intent of this study is to cast a wider net, focusing specifically on the work of aesthetics and aisthesis. Aesthetics is precisely about attending to the dynamics of form, to different material and immaterial ways of connecting. It is to ask what art and imagery *does* – what it *becomes* – in its very particular relationship to events.

The field

So what can art – or the study of aisthesis more generally – actually do in this field of social relations that is not already accomplished by social science? In what sense can we talk about the practical value of aesthetics without merely placing art in the service of a social agenda or promoting its 'application' to other fields? Answers to these questions may be discerned through an examination of how art and aesthetics encounter 'problems', how these practices re-imagine social relationships in the face of such problems, and how they generate new spaces and terms of operation beyond the social identities already in place. Aesthetics in this sense does not confine itself to the study of a fixed set of objects (objects of art, objects of popular culture). In fact, it might be argued that aesthetics with a real-world orientation perpetually reforms itself, looking beyond its 'given objects'. It extends the broader field of social enquiry or humanities by, to quote Bruno Latour, turning 'the solid objects of today into their fluid states' so as to render visible the network of relations that produces them.[7]

An object for practical aesthetics might be said, then, to arise from an encounter with an event (just what constitutes an 'event' in aesthetic terms is discussed in Chapter 2). The implication of such a real-world orientation is that modes of analysis are affected,

challenged and potentially altered by a momentous event. If practical aesthetics may be generalised to a set of practices in the arts today, a major impetus for its emergence has undoubtedly been the attacks of 11 September 2001. After '9/11', key thinkers were moved to analyse the very concept of a 'major event', raising questions about the way in which such events are apprehended and understood.[8] Art and visual culture play a particular role in this regard. Whereas media assumes the function of witnessing and documenting what actually happens – and hence sets up the terms and conditions of aesthetic mediation – art (the critical, self-conscious manipulation of media) has the capacity to explore the nature of the event's perception or impression and hence to participate in its social and political configuration. In this sense, the aesthetic is not art's exclusive province but a method of engagement in which art specialises.

Aesthetic 'knowledge' has historically been understood as a complement to scientific knowledge or conceptual understanding. Baumgarten termed this 'sensuous' or 'sensitive' knowledge.[9] Such knowledge is now recognised as fundamental to everyday decision-making in many areas, from marketing to politics. This has prompted both experimental and philosophical analysis, as well as neuroscientific investigations of sense perception and affectivity in processes from voter deliberation to consumer-product evaluation. A recent experiment, for example, demonstrates that sense-generated information, visualisation techniques and emotion are important components of consumer decision-making, offering the evidence of electroencephalograms of the brainwaves of market 'mavens'.[10] These product-savvy consumers are monitored watching television advertisements – making, in effect, an aesthetic evaluation of a product via visual media. The disciplines with a stake in aesthetics (like philosophy and theories of arts) generally have little appetite

for this kind of instrumental enquiry; indeed, the philosophical practice of aesthetics is very often defined in terms of the critical reflection on process that is manifestly lacking in this commercial application. How, then, does aesthetics connect with this everyday arena that – for whatever ends – is beginning to produce empirical data that might extend the basis of aesthetic enquiry?

For a while, visual culture studies found its purpose in a critical semiotics (informed by Marxism, psychoanalysis and feminism) that revealed and deconstructed consumer culture's manipulation of desire and emotion. But this role has evaporated as media users have become more sophisticated, and popular culture and advertising increasingly comments ironically on its own techniques of persuasion.[11] Smartly scripted television tantalises audiences by revealing (in the process of seducing us, so that no pleasure is lost) just how seduction works. This was the brilliance of a show like *Boston Legal* (2004–8), which deployed the conceit of the smart-talking attorney to run through the mill of speech most of the decade's hot political topics, demonstrating how the right phrase and the right affect could – regardless of any relationship to truth – tip a jury/audience one way or the other; or of the comedian Ricky Gervais, whose turn on a 2007 Comic Relief telethon (see Chapter 7) is a primer on how to put together a tear-jerking famine appeal. Watching these, enjoying the joke, we understand the tricks of media and performance as they continue to work on us. We learn that media affect is supremely potent; no mere overlay but the substrate of communication. We can read and understand it, even redirect it if we have the tools to intervene in media, but not negate it.

Today's 'viewers', moreover, are not passive consumers who rely on specialists to deconstruct their imagery but often times media users who produce and post on YouTube their own ironic

mash-ups of media footage, drawing out unintended inferences and latent affects to challenge the fake sincerity of politicians and others who once controlled the way they appeared. Audience emotion or 'impression' may be exploited by media-makers, but viewers may now respond in kind. Visual literacy or 'visuacy'[12] is taught in schools, not just in the form of art history but as a technique for living; a pedagogical response to the realisation that we engage in practical aesthetics in multiple domains – politics, religion, consumerism – all the time.

There has been much contention over whether the objects of such practices warrant heavyweight analysis – whether, for example, the complex paraphernalia of semiotics is required to 'decode' a Madonna video or other ephemera whose meaning is not difficult to unearth.[13] The important question here is not whether certain objects are worthy of study but whether we have the right means (whether, indeed, the apparatus of semiotics can be recalibrated and adapted to 'lite' culture). In an interdisciplinary field, characterised by the import and export of methods, aesthetics is often a casualty. Semiotic analysis intent on revealing meaning and ideology is, as Michael Bérubé argues, apt to 'instrumentalise' aesthetics, flattening out differences; it misses, Bérubé wryly observes, the 'question of whether the politics of social semiosis is danceable'.[14] Moreover, by insisting on locating politics with legible signs, it disregards the political dimensions of non-linguistic semiosis – of how politics is enacted affectively through aisthesis itself.

Both 'objects' and 'field' (the field of contemporary culture) can be understood as fluid and heterogeneous entities. If once it seemed tenable to configure 'art', 'media', 'popular culture' and so forth as distinct realms, it is abundantly apparent today that objects, images and ideas routinely range across different spheres. Art does not just raid popular culture or science for its own ends – for 'ideas' to which

it might give aesthetic form. It becomes entangled with other forms of practice and knowledge, other ways of seeing and perceiving, so that it is possible to conceive of art contributing to the production of ideas in the same way that science or popular culture give rise to aesthetics. Latour suggests this is the nature of all contemporary thought, inasmuch as ideas come from amalgams – and it is to the crossings and meetings between disciplines or languages that we must attend. Newspapers, he notes, are full of 'hybrid articles that sketch out imbroglios of science, politics, economy, law, religion, technology, fiction', churning up all of culture and all of nature so that even the most fundamental distinctions in the philosophy of knowledge (like nature/culture) are compromised.[15] Hence, rather than trying to reclaim discussions of specific objects or phenomena within disciplines (as if we can somehow purify knowledge and come up with truth by rigorously applying the analytic methods of a single discipline) the scientist or cultural analyst must follow the 'imbroglios' wherever they take us, shuttling back and forth within a network of ideas. The methods we deploy in analysis of interdisciplinary objects and ideas must track the way in which these are transformed as they pass through different registers. The object in this sense is not merely the subject of layered interpretations but is, in essence, the infolding and unfolding of ideas and perceptions.

To this end, the concept of practical aesthetics evokes aesthetics as a *modus operandi* rather than as a field in its own right. It is an approach (potentially comprising different methods) to working within the field of contemporary culture – a means of qualifying the varied aesthetic expressions that combine to characterise an event. Hence, this book addresses events such as an environmental disaster or famine, or post-9/11 politics, through art that is itself thoroughly imbricated in 'other' practice – art that pushes into the realm of transdisciplinarity. In this realm the practical value

of aesthetic method becomes readily apparent. When the field of operation and what belongs to that field is no longer clearly delineated, classification of objects is irrelevant. What matters in terms of differentiation is the way in which an object moves, behaves and relates: an aesthetics of process. Hence, thinkers with a commitment to transdisciplinarity and opening up new spaces of cooperation have grasped the wider potential of aesthetics (Guattari, for example, understands its transformative potential in political and social terms; and activists working across art, politics and social science have identified aesthetics as a means of forging new collectivities) more readily than mainstream art history, which carries the baggage of its prior relationship to the discipline.[16]

The discipline problem

Art history's interest in aesthetics reawakened in the twenty-first century. Several major conferences and anthologies have highlighted the limits and constraints of the discipline's relationship to aesthetics. But debates are often mired in the tussle between the two disciplinary silos (even as such titles as *Art History Versus Aesthetics* are wielded self-consciously by critical theorists who acknowledge the impasse of our own making).[17] The terms of the 'rediscovery' of aesthetics also play to an entrenched disciplinary narrative that ascribes the 'waning' of aesthetics to the rise of postmodernism.[18] Aesthetics is thereby nominally tied to a set of formalist concerns, categorically defined in opposition to postmodernism (and, by extension, to 'postcolonial' art too). Diarmuid Costello has argued, however, that this 'narrow modernist conception of the aesthetic has overdetermined the anti-aesthetic bias of postmodernism'.[19] The latter might be just as easily – and more progressively – characterised as a period in

which aesthetics proliferated in new and diverse forms, hitherto unacknowledged by the canons. Postmodernism (in stylistic or epochal terms) is, after all, the moment that art proclaims itself more democratic, more heterogeneous, engaging with the market and popular culture, with sub- and minority cultures: with 'difference'. That it attracts the epithet 'anti-aesthetic' by virtue of its shift from formalist to more external concerns – and specifically the enfolding of various externally derived aesthetics – is a mark of the degree to which it renders aesthetics impure.

Art history's insistent separation of aesthetics from the melting-pot of postmodernism and the neglect that unwittingly preserves aesthetics in a rarefied condition enacts by default what Latour terms disciplinary 'purification'.[20] Instead of doing aesthetics differently – and understanding that aesthetics lives in other forms and arenas – mainstream art history wrote the epitaph of a purist aesthetics. Surprisingly, the logic of the chimeric anti-aesthetic has proved remarkably constraining. As James Elkins observes, very few writers have managed to escape the dichotomy, to envisage a future beyond the opposition between the aesthetic and the anti-aesthetic.[21]

Postmodernism's embrace of a wider aesthetic field marks a turning point from a time when aesthetics might have represented, as Rancière puts it, 'the fateful capture of art by philosophy'.[22] There is, argues Rancière, no necessity for an aesthetics that deals with the question of what art is (this is because art 'is not the product of a unifying thought which has assembled a set of common properties into a single notion' but the product of intrinsically 'dissociating thought'). Postmodernism – the diversification that follows modernism – is the testing ground that demonstrates the empirical failure of this inherently flawed project. Art that was reinventing its purpose in relation to the everyday could no longer distinguish itself in terms of a unified project grounded in formalist

values; we could no longer ask 'What is art?' – only 'What is this art doing?'

It is at this point that art (if not art history) calls for and performs a new kind of aesthetics – a field-sensitive aesthetics rather than a top-down application of theory. This call is all the more difficult to ignore in the context of the contemporary mediascape, sometimes referred to as 'contemporaneity'.[23] Image production is now interdisciplinary and intermedial to the point of no return; disentanglement, or a retreat to pure disciplinarity, is no longer possible. If aesthetics – in terms of practice and politics – has effectively moved into a transdisciplinary zone, 'deterritorialising' disciplines in the process, art history and visual studies will need to *go with* rather than return to aesthetics.[24]

The aim of this book is not, then, to dwell on the inheritance of the 'anti-aesthetic' but simply to do the kind of practical aesthetics precluded by restrictive discipline-bound notions of aesthetics. The field in which such work should be possible is that of visual culture – a spin-off of art history that purports to move across (if not dissolve) the divide between art and other visual forms. Commentators seem divided over whether this field represents the future of contemporary art study or whether it has reached an impasse, mired in its own internal disputes over whether it studies a class of objects or, alternatively 'the visual', the latter inclining toward the study of aisthesis but generating a new set of concerns with the isolation of a single sense.[25] In fact, visual culture seems to function fine when faced with a new set of visual images (of the Iraq war, or 9/11, for example), or a crisis sparked by the visibility of images (Abu Ghraib; censored artworks), or a 'regime' of the visible (such as surveillance).[26] In what ways, then, is not visual culture already synonymous with what I am terming practical aesthetics – and how might such a concept enable us

to move beyond metadisciplinary quibbles towards a productive critical aesthetics?

Aesthetics, I am suggesting, has the merit of exceeding the scope of disciplines. Far from aligning naturally with art history or visual culture, it is characterised by a dynamic and free-ranging quality – this is because it is process-based and concerned with perception and affect. It is thus not a means of categorising and defining art but of tracing the affective relations that animate art and real events. To frame this argument I propose some key terms for practical aesthetics – terms that have proven problematic for visual culture, defined in disciplinary terms. The first of these is the 'case', a term I invoke to signify the event or contemporary phenomenon to which practical aesthetics attends. This will lead into discussion of the specific 'case' of 9/11. The second term, which is a primary focus of the book and of my interpretation of aisthesis is that of 'affect'. Affect, I will argue, is the natural medium of aesthetics but problematic for visual culture in its disciplinary configuration.

The case

Casus, a case, happening, instance, event; literally that which has fallen.

Cases are important to practical aesthetics – not in the substantive methodological sense of 'case study', nor even as readily definable objects – but as points of orientation in relation to which method is shaped. The case, corresponding to an event or real-world occurrence, is not merely a delineated topic (the definition of an event is itself at issue in aesthetic work) but conveys the principle of engagement with a contemporaneous phenomenon.

In this regard one of the touchstones for practical aesthetics – conceived as a play on the concept of practical ethics – is casuistry, the etymology of which derives from the Latin *casus*, meaning occasion, event or case (and also, relating to the verb *cadere*, to fall, 'a falling'). Casuistry is essentially a problem-solving endeavour focused on practical issues of the day.[27] Rather than using theories as starting points, it begins with an examination of cases – with the concrete problem. Instead of working from a body of principles or rules, it derives its theory of the case inductively, taking account of 'presumptions' about the thing in question. In contradistinction to applied ethics, then, casuistry brings experience to bear rather than subsuming experience under a general theory imported from outside. It is attentive and adaptive rather than rule-bound. Hence, Richard B. Miller describes casuistic method as a 'poetics of practical reasoning' – a means of tracing how reasoning happens. This requires a certain 'hermeneutical perspicuity' but not adherence to fixed method.[28] Casuistry's methods are in fact *illative* – that is inferential, involving a 'carrying in' or a motion toward, a responsiveness to what is happening. Responsiveness of the kind that involves giving up a little; changing to suit the demands of the present.

The objects of casuistry are not formalised, then, since they essentially comprise whatever emerges as a 'problem'. Its contemporary appeal is in large part due to casuistry's orientation toward a dynamically changing society in which no single moral code prevails; to the fact that it moves, as a matter of principle, with the times. Practical aesthetics shares this orientation toward the contemporary, finding its cause in art and imagery, defined as 'contemporary' not merely by the time of its production but by its relationship to contemporary life. Within such a case/event-based framework, aesthetics works not on processes of reasoning but nevertheless on the nature of experience and presumption. It

investigates the substance of affective association: the sensate binding that links ideas to objects and forges social relations. This is a very different endeavour to the one that *carries off* objects to its home discipline. Practical aesthetics in this sense may be said to be undertaken in the field and to remain *in the field*. As the locus of affective and social relations, events and object-making, this unbounded field may be understood in terms of what Massumi calls the 'whole field',[29] the transdisciplinary cultural space open to practitioners arriving from any discipline whatever. This is not to say that the objects of practical aesthetics do not function effectively or politically within their 'own' institutional fields – say, within an exhibit in an art gallery or a museum. But they will necessarily challenge old models of display and representation, as further chapters elucidate. Contemporary art – where contemporaneity is the operative term – is resistant to showcasing to the extent that it calls for an exhibition model that exploits continuity rather than the constitution of a separate 'aesthetic' sphere. The trick for curators, writers and artists is not merely to reclassify objects into new clusters of visual artefacts but to animate dynamic relationships and trace connections further afield; in other words, to trace aesthetic process as it plays out across this 'whole' field.

Visual culture and the case of 9/11

> What does it mean, I wondered, that visual culture has so little to say about an event so overwhelmingly important and so overwhelmingly visual?
>
> James Elkins[30]

James Elkins's concession that visual studies has little to say about the events of 11 September 2001 is a jolting one. How could it be that the events that transfixed the world, inflamed passions,

transformed politics and everyday life and inspired art and memorials of all kinds left the emergent discipline of visual studies mute – or, as he puts it, with nothing 'helpful' to interject into the morass of cultural commentary? Elkins's musing on this subject took place in October 2001. It was apparent to him at this point that the attacks had undeniably changed the image of Manhattan; that they were, as W.J.T. Mitchell and others later discuss, an attack on an image or symbol.[31] For Elkins, however, the kind of hyper-visibility that renders the meaning of a symbol transparent to all obviates the need for 'expert' visual cultural analysis.[32] A subtler angle is required.

The social, emotional and political response to 9/11 occurred in many registers and many expressive forms. As an expanding discipline, often characterised by its capacity to move freely across the divide between art, media and popular culture, visual studies would seem to be well placed to track cultural impact. But the pitfall of such an expansive endeavour, Elkins points out, is the tendency to overreach – to assume licence to comment on all aspects of contemporary culture, whether or not one's disciplinary perspective has a whole lot to offer. Thus, 'ill-conceived essays on 9/11' achieve little and attenuate rather than grow visual studies.[33]

An exceptional event, by its nature, exerts pressure on conventional disciplinary practice. The events of 9/11 led writers of many kinds to abandon the constraints of disciplinary method in favour of forms of commentary that were often raw and impressionistic, grounded in emotion rather than clarity of vision. Literary, anthropological and art-historical sensibilities all contributed to a body of writing that might be located within the realms of trauma studies or cultural studies, insofar as such writing does not claim a portion of the event (its imagery, for example) for a home discipline.[34] Such transdisciplinary fields are often characterised by

orientation toward an external problem. They function to inculcate methods for apprehending complex social phenomena, recruiting those who would put their disciplinary techniques in the service of the broader cultural or political project. This problem-centred endeavour is somewhat at odds with the kind of cultural study (visual or otherwise) that proceeds from a disciplinary base and that – as a matter of principle – shores up this base rather than responding to any and all emergencies. Inclining in this moment toward the latter, Elkins asks whether visual studies (the art-historical derivative that puts the visual before other objects of study) is justified in moving into the 'area' of 9/11: are there not some topics that simply do not warrant analysis from a visual-studies perspective? Elkins does not rule out future study of this terrain, but strikes a note of professional caution directed at those who publish in haste or because they can.[35]

Leading writers who offered theoretical or creative work 'in response' to 9/11 concur on the difficulties of grasping the event, their work often distinguished by a focus on the quality of uncertainty or the very experience of things not making sense. '"Something" took place,' argued Derrida a few weeks after 11 September, 'we have the feeling of not having seen it coming [...] But this very thing, the place and meaning of this "event," remains ineffable, like an intuition without a concept.'[36] For Derrida, the event is not known through its circumscription and containment, much less its imaging and objectification. A certain sequence of events is marked and remembered with its date stamp – the now endlessly repeated appellation '9/11'. But the feelings which constitute the impression of the event – such as *the feeling of not having seen it coming* – themselves confound the idea that this 'event' has defined parameters. Thus, Derrida argues, the repetition of its shorthand name – three digits, representing 'the attacks'

– serves to underline 'that we do not yet know how to qualify, that we do not know what we are talking about'.[37]

In this sense, 9/11 did not enter art and writing as an historical event but manifested as a phenomenological shift: a watershed. Hence it does not provide the cultural disciplines with exemplary 'objects' of study (the distinctive visual forms of expression that visual studies claims as its own). In visual arts, 9/11 is best evaluated as a profound reorientation, the trace of which is not an abundance of art *representing* the event, of 'great works' (which may or may not materialise years hence), nor even of new and distinctive visual forms. The effects of 9/11 on this field emerge in its reorganisation; in new ways of working – of seeing, doing, thinking, perceiving through art or other aesthetic forms. Change does not cohere around 'great works' in the first instance but is the measure of various resonating shifts and points of divergence, which themselves engender new transdisciplinary alliances. As with social phenomena such as globalisation or migration, the terms in which we evaluate an advance within a discipline are inadequate for weighing the effects of external pressures, which often resonate in unexpected ways and places. In this regard, the impact of 'external' change on a given field or practice can only be calibrated transversally; that is, in terms of much wider transdisciplinary relationships, which exert a force locally.[38]

Evidence of a post-9/11 shift is discernable in exhibition practice. Exhibitions – the great monoliths that organise a mass of contemporary work on a rolling basis – not only 'reveal' trends but themselves function to create new sequences, new histories and genealogies, responding to the contemporary and materialising relationships between art and the outside world. Hence, large-scale surveys – like *Documentas*, triennials and biennials – are a barometer of change, cohering emergent practice relatively quickly

and on a large scale, more or less knowingly but always with an element of unpredictability. If they are not always in and of themselves a summation of change (as the concept of a biennial or 'survey' exhibition might imply), they are a visible means of realising sets of relations. *Documenta 11*, the first major '9/11' show, curated by Okwui Enwezor in 2002, was distinguished in this regard for its attempt to map both uneven development and fraught connectivity.

But still, in 2006, Enwezor talks of the 'uncertainty of artistic responses' to 9/11.[39] It remains unclear how 'responses' are to be tracked or evaluated when work is not overtly 'representational'; or when the work makes sense in relation to global forces, themselves not fully understood, rather than in relation to a given genre. How are connections between different events to be established; and how are connections to extra-artistic practice manifested within and across disciplinary venues? These challenges, which are beginning to be addressed in the exhibitions discussed in the following chapters, are not merely curatorial concerns but the essence of a shift from disciplinary segregation to transdisciplinarity – a shift that calls for new aesthetic thinking. How one makes sense of and links exhibits from Palestine, Israel, Iran the USA *in aesthetic terms* is a practical challenge – but one that folds into the more general question of how we might track the symptoms of deeper shifts, deeper thought, deeper emotion.

If 9/11 reoriented art practice toward the real, it did so in a way that galvanised the development of new approaches to political events. Old forms of political didacticism – the denunciations and programmatic assertions of more certain times (if they continued to be practiced) – were no longer in themselves sufficient, particularly as the emotions increasingly at play in the political field themselves became a focus of analysis. For many the event

called initially for something other than imagination ('I wanted to be told about the world,' said the novelist Ian McEwan),[40] but the intractable pull – and insufficiency – of the empirical facts of the event have, at the same time as making actuality and politics a necessary topic, engendered a focus on how the event is apprehended: on perception and feeling as constitutive of the event itself. Hence a notable development in contemporary art has been the rise of 'documentary', epitomised in *Documenta 11* and *Documenta 12* by artists such as Zarina Bhimji (see Chapter 2) and Hito Steyerl (see Chapter 6): a documentary profoundly rooted in a politics of affectivity and aisthesis. If early work on 9/11 represented inchoate phenomenological explorations of this fragile condition of unknowability (could any brand of cultural theory grasp the event in the early days?), more recent practice, focused on contemporary events and politics, has consolidated an 'affective turn', resonating with wider cross-disciplinary interest in affect and emotion as a determining feature of social, cultural and political relations.

Affect

Affect was visible. Not simply in the manifestation of trauma – in the palpable signs of loss, compassion and anger at 'Ground Zero' – but in politics and media, where it is always present in varying degrees of intensity. The politics of 9/11, distinctively, played out in terms of a set of particularly high-key affects: fear, anxiety, anger, hope.

Affect does not merely denote the emotion layered onto political rhetoric and the self-consciously performed. Affect, as André Green puts it, 'erupts from the interior body [...] without the help of representation'.[41] Termed 'basic emotion' by some psychologists, affect

moves in the space between the visceral body and consciousness, manifesting on the body, which is in turn 'the spectator of affect' as Isobel Armstrong argues.[42] How this spectatorship takes place is a subject for post-9/11 practical aesthetics.

Elkins's 9/11 piece in fact lists a whole lot of potential angles for visual culture; studies that could be made of the role of media and memorials, of the photography of 9/11 and subsequent art production.[43] An abundance of possibility. But the worry for Elkins is that none of this is distinctive enough; it is either too generic (applying to the whole class of disaster images) or not specifically visual. Much of the interest in 9/11 visual culture boils down not to the 'quality' or original nature of its images but to the emotionality of the event: to the way in which image repetition increased tension and hysteria, or to the quality of 'American emotionalism' manifested in image consumption.[44] In other words, to the quality of affectivity itself.

Affect – Elkins effectively acknowledges – is apt to elude the grip of both art history and visual culture, coursing through expressive or aesthetic interaction and flowing on. Unlike meaning, iconography or a formal quality, affect is not easily anchored in an image. It may be expressed, activated or incited by an image; but at the same time, affect does not always come *from* a single image. This is part of the reason that exhibitions are so instructive, since they orchestrate affects, feelings and sense impressions to flow between works (as subsequent chapters discuss). Exhibitions are as much about escaping affects as contained ones. Moreover, strong affect seems sometimes to pursue the image; as Nietzsche argues, it seeks out effigies against which to vent.[45] Whether we think of affect in the terms proposed by the American twentieth-century psychologist Silvan Tomkins, as a subjectively originating energy that attaches itself to objects; or in the trans-subjective terms of Deleuze-inspired

media studies, as a force within media itself; or, indeed, in Green's psychoanalytic terms that cast affect as an aspect of the drives with a propensity to hook onto things real and imagined[46] – we can concur that sometimes images and objects are simply in the path of an oncoming affect. Affect 'enlivens' objects and experiences because it invests them with joy, sadness, wonder, rage…

Under any of its dominant theories (Tomkinsian, Deleuzian, Freudian) affect is essentially mobile. It pursues its own course, conducted and amplified through media vectors and varieties of image. If fear or anxiety readily attaches itself to effigies and escalates as media intensifies its focus on such objects, and if the inspirational, sentimental and patriotic imagery of 9/11 was in some sense formulaic and predictable, this nevertheless poses questions of how specific visual forms enfold emotional politics.

The story of 9/11 *was* one of emotion (shock, grief, anger, resentment, hate, patriotism, compassion) extended through visual media and subsequently analysed through art: a story told through those memorials in Union Square, through the saturation coverage, the impromptu photography exhibitions; then through the escalating emotions orchestrated in media fear campaigns, critiqued in films by Michael Moore and others; through popular websites (like werenotafraid.com) and the transformation of art and exhibition practice in the longer term. And even, retrospectively, through the prescient work of a documentary artist such as Johan Grimonprez whose *Dial H-I-S-T-O-R-Y* (1997–2004), a study of plane hijacking and its media aesthetics, was presented in *Documenta 10* (1997) (Plate 1).

Dial H-I-S-T-O-R-Y blends documentary news footage, sci-fi and the everyday with stylised reconstructions of 1970s airport scenes and the lives of glamour hijackers like Leila Khaled, set to a soundtrack (by David Shea) that incorporates sugary disco

along with passages from Don DeLillo's *Mao II*. Inaugurating an approach to history that presages Adam Curtis's *It Felt Like a Kiss* (see Chapter 3), Grimonprez evokes the historical moment through a rush of images and sense impressions. The event is a *feeling*, at once nostalgic and exuberant, poignant and jolting, inspired by the retro glamour of a set piece, which now functions as a surreal prelude to a more disturbing present. An exhilarating sequence of crash landings, set to Van McCoy's jaunty disco song *The Hustle* evokes visceral memories of the 1975 dance craze, of flicked hair and flares, of a television soundtrack that encapsulates that period of existence. Hijacking, seventies-style, is an emotional ride, 'running the gamut of many emotions, from surprise to shock, to fear, to joy, to laughter, and then again, fear', in the words of a hijacked Pepsi executive featured in the video. The poignancy of nostalgia, sustained as a style and expressed as an aesthetics, lies not just in the loss of a past or of an imagined innocence; hijacker glamour, born of the realisation that 'home is a failed idea' (DeLillo), now reads much more starkly as the beginning of something that outlived its media moment. Suddenly the story of the emotional journey of the individual hijack victim is not that of a unique political event; it is the description of History itself, unfolding in media.

This story could be written in terms of the figure of mobile affect; affect that passes through a sequence of images. But whose story is this to tell? What methods, in other words, function to trace these circuits and entanglements wherever they lead, and to account for the specific ways in which images animate and intervene in affective transactions? The premise of this study is that affect – a central component of aisthesis – is the natural subject of transdisciplinary aesthetics, and that it eludes art history and visual culture to the degree that these fields configure themselves as

separable disciplines, thereby blocking the pathways and conduits that run into unfamiliar territory. Such a project could be undertaken by visual culture, but only a visual culture interested in and guided by process. Books since 2001 (Mirzoeff; Werckmeister; Mitchell) have characterised a 'post-9/11' visual mediascape, drawing attention to the way in which the politics of events such as the Iraq war or the emotive 'War on Terror' have played out in a particular conflagration of images.[47] The notion of images as targets – as symbols of pride, anxiety and vengeance – has also come to the forefront of visual cultural analysis. If such work focuses on the emergent visual mediascape (the 'natural' subject of visual culture), what is still required is a framework for understanding the affective connections that extend and animate the objects within that mediascape. In other words, a means of studying the principles and connections (beyond 'the visual') that give images life.

The images of 9/11 (like many others) have an emotional life; that is to say, they are not only affective expressions but are co-opted into circuits of affect; they are used, incorporated, entrained. W.J.T. Mitchell sets up the possibility for the study of this lifeworld when he argues that 'images are like living organisms [...] things that have desires (for example, appetites, needs, demands, drives); therefore the question of what pictures want is inevitable.'[48] But, as he says with a nod to Marx, if people make images with desires, these are not always expressed 'under conditions of their own choosing'. Hence, the emotional life of an image is a process of engagement; of continual enfolding and unfolding.

The rhetorical move that anthropomorphises the 'picture' by imbuing it with its own figurative affect or desire is an important one; not an attempt to install a personification of the work of art as a master term, Mitchell explains, but an attempt to make *relationality* the field of investigation. 'Process' and 'affect' are

thereby foreshadowed as potential terms of analysis for Mitchell – and indeed will prove to be the critical terms in this study for tracing the connections between images and ideas, images and other objects, images and audiences, images and other images.[49] From such a platform Mitchell is able to characterise the imagery of the World Trade Center and its attack as exemplifying 'the sensuous spectrum of image anxiety of our time'.[50] But it has been on the radical edges of media theory that the notion of a processual aesthetics has been most fully developed, along with accounts of the fluidity of affect and its mobilisation in the politics of fear. As Brian Massumi demonstrates with a further level of personification, the spectrum designed to calibrate the threat of terror 'spoke'; it told us when to feel fear.[51] And it worked. It was not merely a symbol of anxiety but the instrument by which fear was inculcated and regulated. Such work takes the autonomy of affect as its subject but also (following Deleuze) understands that affect is an expressive quality: affect-at-large finds expression in an image.

We are confronted, then, not only with the life and wants of imagery but with the question of *what affect wants,* what it does, and how it transforms objects and perceptions. Some might argue that 'the affective turn' is a momentary diversion for the arts; on the other hand, the idea that art and visual studies could choose to ignore affect – or ever got away with doing so – seems increasingly unbelievable. Eve Kosofsky Sedgwick and Adam Frank argue in their work on Tomkins: 'There is a real question whether anyone may fully grasp the nature of any object when that object has not been perceived, wished for, missed and thought about in love and hate, in excitement and apathy, in distress and joy.'[52]

This methodological observation seems to have particular purchase in relation to the imagery of 9/11 – not so much the

mementos and memorials for which we already possess a ritual context and understanding, but the new aesthetics of affect. By this I mean the particular circuits that render affect visible and transmissible: the vectors of fear and anxiety, as well as of affective resistance (which include websites such as werenotafraid. com and the work of various art exhibitions discussed in the following chapters).

The prism of practical aesthetics enables us to move from the notion that some art 'deals with' affect as subject matter to the concept of affective process, expressed in art and aesthetic relationships. Art, like affect itself, inhabits an in-between space and is an agent of change. Armstrong makes this case in a brilliantly synthesising argument that not only recognises affinities between affect (which brings different psychical and social orders together in the larger cultural field) and art, but also presents affinities between divergent theories of affect.[53] Discourses on affect from phenomenology (Hegel), psychoanalysis (Green) and also Tomkins can, in her view, be roughly sutured if not reconciled because all have at their centre the creation of new relationships that give rise to an understanding of the artwork as in-between (or, in Deleuze's terms, interval). This approach is the key to any kind of practical aesthetics, grounded in the empiricism of affective relations and real-world events. Whereas philosophical aesthetics is concerned with points of theoretical difference, this work is concerned to use ideas about aesthetics to illuminate the connections and processes that give life to visual culture. If this turns on the question of affect, it is because affect is what gives us the feeling of life; it 'makes us feel alive' (á la Armstrong and Green) and in turn gives images life.[54]

Contemporaneity, transdisciplinarity, connection

To summarise, then, the project of practical aesthetics invokes three key figures or principles.

Contemporaneity

The first is the principle of being-in-time, in the sequence of events – and of allowing oneself and one's practice to be shifted by events. Privileging the event – the forces of contemporaneity – over disciplinary organisation moves against Elkins's requirement for visual culture, reversing the presumption that the discipline's methods and objectives lead us to the right object choices. But, Elkins is of course quite right that theory can be wrongly applied or over-extended. There is little point in asserting our right to do 'pointless' visual analysis, produced from the wholesale application of art-theory methods to any new set of images. Notwithstanding the visual skill set that can enhance the exercise of aesthetic analysis, this book argues that methods must be attuned to and derived from specific cases; that aesthetics of the contemporary studies various interfaces with real events, but that the 'case', the 'event' must be treated as itself a problematic: an indeterminate entity in formation.

Not all art produced today assumes this outward orientation. But this is the distinguishing feature of practical aesthetics (as a particular configuration or extension of visual studies or as art practice). Practical aesthetics is that which seeks to understand the contemporary and thus asserts that events shape ways of seeing and doing and that we must reorganise our studies accordingly.

Transdisciplinarity and movement

The provocation underlying the case for practical aesthetics derives from the failure of much recent theory to come to terms with the unbounded field of aesthetics – with the ontological truism that aisthesis, like expressivity occurs anywhere and everywhere – and that aesthetics, whether we like it or not, is a transdisciplinary endeavour. Wolfgang Welsch insists,

> Since aesthetics is a field of research comprising all questions concerning aisthesis – with the inclusion of contributions from philosophy, sociology, art history, psychology, anthropology, the neurosciences, biology and so on – aisthesis should provide the framework of the discipline while art, although important, will be only one of its subjects.[55]

Such transdisciplinarity is not achieved on a single front through the meeting of two neighbouring disciplines (this amounts to a mere 'display of interdisciplinarity' as Welsch suggests; moreover 'polemics among disciplines does not produce good concepts, only barricades made of any available debris,' Latour warns).[56] But what are the principles of interdisciplinarity that matter, given that, as Welsch implies, we all come with a disciplinary inheritance and bring to bear specific skills? First, bilateral interdisciplinarity misses what it means to function in an 'open' system; second, and as a consequence, it restricts the object of enquiry, not just definitionally but in the literal sense of constraining the object so that we do not fully describe its fluid relations. This, as I have outlined, is inimical to the operations of affect, which know no discipline or institutional boundaries.

Affect is already a problem for disciplines – aisthesis simply foregrounds this in its demand for transdisciplinary study. Affective transactions (whether in the space between objects in a gallery,

between subjects and subjects or subjects and events) create new spaces that are by definition transdisciplinary: new spaces outside the parameters of any discipline's organisational base. By the same token, events cannot be the objects of disciplines. Only transversal links (those cutting across institutionalised divisions) make sense of art's relationship to a new event or a catastrophe in the world. This is why 'contemporaneity' is a useful term of methodological orientation: a principle of connection to an unspecified present, to whatever might happen next.

Practical aesthetics is, then, a rubric for the study of aesthetic process in an inherently unbounded global field. It is not antithetical to visual culture studies except as the latter insists on clumping and confining its objects. Latour has dismissed the concept of 'material culture' (and *visual* culture follows suit) on the basis that 'objects are never assembled together to form some other realm', To talk of material culture, then, is to imagine objects 'simply connected to one another so as to form an homogenous layer'.[57] But what do these objects really do? In fact they deploy multiple ways of acting and relating, exceeding the designations of their makers and interpreters. Images in this sense are the objects of aesthetic interactions, but to that degree may be subject to diverse processes, finding themselves co-opted into different and varied networks of association: *wanting* in many senses.

Within this 'whole field', there can be no metadiscipline, according to Latour – no metalanguage of analysis in which ordinary practice and language is embedded. Analysts 'possess only some *infra*-language whose role is to help them become attentive'.[58] Hence, art does aesthetics, writers do aesthetics, deploying such an infra-language as a means of tracing connections, the threads that animate objects.

Desmology: from the Greek 'desmos' (ligament, bind, link)

In focusing on objects that are moving targets for affects and interpretations, objects forged at the intersection of different practices and perceptions, we shift emphasis away from the object *per se* to its dynamic relations: to process and method – to the means of connecting. Touchstones in this regard are thinkers who have made connectivity central to theory, such as Michel Serres, who coins the term 'desmology' to describe a project that he argues is more vital than that of ontology: the study of the links between things.[59] Why, though, is this a creative process – and hence, an intellectually radical one – more than an interpretative process?

For Latour the social is made through the enacting of connections. There is no social force that determines identities and group relations, other than that which is produced through the performance of connection. In tracing the threads of a network we determine how relationships come into play and into place, but also outline further possibilities, new lines of connection, new ways of organising. This is why for him the social researcher does more than merely *reveal* something to actors within that field. In the same sense, practical aesthetics enacted in an open field is unlike the more traditional critical theories (Marxist, semiotic, feminist etc.) of art or popular culture that aspire to reveal how actors are subjugated by social relations and their representation, clarifying a set of givens that eluded the consciousness of those in the field.

The opposite of 'revealing' – as Deleuze and Guattari show – involves experimenting with the relationships that compose an intellectual field; creating new circuits, intensifying relationships and forces so as to reorder the field. For Deleuze (and for David Hume before him)[60] the unmasking or revealing of what is already given is not creative thinking; thinking beyond what is actually

given is a creative intervention potentially occurring in writing or art, but only when the field is extended.

Being-in-the-field is in this regard a principle of any kind of new or creative analysis. This is the impetus – the necessity – for transdisciplinarity. In order to understand contemporaneity – to be in it – we need to leave something behind, something of the old ways of organising and analysing ('suffer amputations', as Guattari puts it).[61] We do this, as a matter of course, by tracing the lineaments of connectivity: by studying aisthesis rather than the aesthetic object. The role of aesthetics is, one way or another, to visualise or render connectivity, following and extending what Benjamin calls the 'thread of expression'.

The chapters that follow attend to these principles in different ways, focusing on specific art engagements and attending to the ways in which forms, expressions, affects and subjects migrate, moving across and between different media, discourses and worlds. Beginning with a theoretical analysis of the event in art after 9/11, the book encounters a series of different events: an environmental disaster in Indonesia, famine in the Sudan, as well as the smaller events of everyday politics, and the organised media event. In doing so, it identifies an orientation toward the real and toward a form of politicised art practice. But how does art conduct a politics in aesthetic terms? How does it engage in practical terms with actuality if it is no longer to be understood as 'revealing' or documenting? What role is there for the aesthetic – which is neither specifically ethnographic nor documentary, but essentially creative and productive? I have suggested that connectivity is the key modality of a practical aesthetics, but what remains to be shown is how this is enacted, not just in terms of the macro (how global connections are imagined) but at a micro level, where fleeting gesture and expression and the smallest sign of a passing

affect may be no less political or far-reaching as components in a media circuit. This is the nature of aesthetic experimentation: to trace relations of closeness and distance, shifting dynamics and orientations. This book, then, does not approach the event – general or specific – from the perspective of history, nor even as a fully determined subject of study, but rather from the inside, from the point-of-view of the affective engagements that give it traction in experience and imagination. It is an attempt to trace threads of aesthetic enquiry, identifying in the process just what it is that practical aesthetics does.

2
One Event After Another

The news as art

News events – the definitive markers of contemporaneity – are emphatically on the agenda of contemporary art. At the same time, they are almost never 'represented' in any straightforward or categorical fashion by contemporary art as they were in a traditional genre such as history painting. Isaac Julien's *Ten Thousand Waves* (Fig. 2.1), a much-awaited video installation premiered in 2010, is billed as having been inspired by the tragic drowning in 2004 of 23 Chinese migrant workers in Morecambe Bay. The majestic nine-screen installation incorporates police footage of search and rescue into a meandering excursus through the remote countryside of Guangxi province as well as Shanghai, past and present. The 'real event' in this case is the pretext for an imaginative journey, linking the tragedy in England to a traditional fable of sixteenth-century fishermen lost at sea and aided by the goddess Mazu. The event-as-news, unfolding in the search footage, populates a section of the video; a slice of the real mobilised to confronting effect, cut against sequences of the flying Mazu. Neither backdrop nor a

Fig. 2.1 Isaac Julien, *Mazu, Silence (Ten Thousand Waves)*, 2010.

driving force of the narrative, the real event remains at the core of this work, whose radiating imagery extends over a vast terrain, far removed from the place and time of the tragedy.

Gordon Burn's experiments with the non-fiction novel have similarly operated in tangential relation to the real, developing fictional futures for well-known public figures like 'moors murderer' Myra Hindley. While Julien's intermodal combinations – of choreographed movement and calligraphy, news and fable, grainy police surveillance video and sumptuously filmed landscape – depart from the format of the news story, Burn elaborates on and within this format. Burn's work culminates in the full-blown 'news as a novel' conceit of *Born Yesterday*, which mimics the format of the 24-hour rolling news bulletin. Set in 2007, it tracks a range of simultaneously unfolding news events

from the resignation of Prime Minister Tony Blair and attempted bombings in London and Glasgow to the disappearance of a young child on holiday in Portugal. These news events and their media qualities are not simply the subject or inspiration of the book but its structuring principle: the news is comprehensively *rendered* in the novel format, which supports startlingly poignant characterisations of news celebrities, along with Burn's acute analysis of their media settings.

Born Yesterday is definitively driven by current events ('the news'). Rather than reflecting upon their impact on the everyday or personal realm, Burn writes the event itself, from the inside. There are certainly visual-art equivalents of such direct rendering: Gerhard Richter's *October 18, 1977* (1988) – a photographic cycle on the deaths of the Baader Meinhoff group – or Harun Farocki's video installation *Deep Play* (2007) on the 2006 World Cup final (discussed in Chapter 4) are each distinctively engaged with the event as news, its cumulative significance and the inflections of its media presentation. Indeed, an abundance of artwork concerns itself with the texture of an event's unfolding in this regard. Yet there is a quirkiness to Burn's use of the subtitle 'the news as a novel' precisely because it is uncommon to think of the news unfolding in a creative format, or of events as the domain of art.

A longstanding tradition of theoretical analysis acknowledges the aesthetic basis of the event, which is today barely conceivable in separation from its constitution as a media event or as 'news'. Conversely, few exhibitions claim events as their primary subject matter. Throughout the 1990s and 2000s exhibitions embraced globalisation and postcoloniality, expansive tropes that could encompass events, personal, political and global, but also denote a condition. The 'postcolonial' as a conceptual framework qualifies a

politics and an approach to creative endeavour, whereas the 'event' resolutely demarcates an extra-artistic entity: a collision point. Art does not produce the event as it produces the postcolonial disposition. At some level, the event simply *happens*; at the same time it cannot be defined merely as what occurs. In *Ten Thousand Waves,* the disaster is, correspondingly, a jarring presence in a sweeping intercultural narrative: the tragedy of Chinese migrants, unable to speak the local language; unable to swim yet working at sea as cockle pickers. A transnational dynamics of migration determines the flow of this work, linking the real to the fabled event. But how does such a linking elaborate (and not attenuate) the actual event?

This chapter considers how practical aesthetics – defined by an orientation to real-world experience – provides a means of inhabiting and moving through events. It examines aesthetics of connection that posit links between events: aesthetics that emerge from a disposition, an openness to what happens, the measure of which is being 'in' rather than 'about' an event. *Documenta 11* (Kassel, 2002) – the first edition of the world's premier contemporary art exhibition this century – occurred in the shadow of an event and is a touchstone in this regard. In conventional artspeak, it was 'a response to' 9/11. Conceptually, however, the term 'response' is inadequate, having always sat uneasily as a descriptor of what art does. The notion that art responds – much like the idea that art is 'about' – is at once reductive and somewhat grandiose, ascribing both fixed meaning and high ambition (hence it is always easy to parody claims that one's art responds to a world crisis, is about the human condition, and so forth). 'Responding' is reactive; engaged aesthetics is simply always already grounded in a principle of contemporaneity.

Contemporaneity

If *Documenta 11*'s connection to the event is a function of its contemporaneity, this rests on an explicit acknowledgment of the conditions under which the exhibition took place. It was not focused on the events of a specific day or the evidence of Ground Zero (in the case of 9/11, as Elkins intuited, such material scarcely needs re-presenting or reinterpreting through art). *Documenta 11* simply situated itself within an event's unfolding, turning attention to the aesthetic and eminently practical question of how art apprehends real-world happenings. An exhibition itself is always in part a live event, unfolding in the here and now: an orchestration of present affects rather than a retrospective analysis. It connects as it exhibits. In the vein of curator Okwui Enwezor's earlier projects, which loosely evoked transnational connections through trade and migratory routes but also the fault-lines animating global politics, *Documenta 11* articulated a set of relationships. The assembled work related to a broad range of diverse political events from race riots in the UK, to the Palestinian Intifada, to the expulsion of Asians from Uganda, to political terror in Central America. The question raised therein is how – by what concept, narrative, process or set of relations – are these works linked? If the politicisation of the exhibition as a whole was implicitly framed and motivated by 9/11, an event that has no direct connection to many of these other states of affairs, whatever connections manifest within the exhibition space link disparate events across a lacuna. But to what end? *Documenta 11* is often characterised as politically driven, but a high-level concern with politics neither distinguishes it from the *Documenta 10* nor accounts for the manner in which events are introduced and assembled.

The dynamics of interconnection embody an approach at odds with the notion of the event anchored in fixed historical time: an aesthetics focused on the extension of the event rather than on its delineation. Apt to exceed its designated historical space, as Marc Augé suggests, 'the event or occurrence has always been a problem for those historians who wish to submerge it in the grand sweep of history, who saw it as a pure pleonasm between a before and an after.'[1] An aesthetic approach, by contrast, envisages a different kind of event time, aligning more readily with Gilles Deleuze and Félix Guattari's conception of the 'time of the event' as 'no longer time that exists between two instants', but a 'meanwhile', a kind of between time with its own characteristics.[2] This 'time of the event', they argue, is quite distinct from the historical time in which events occur. It cannot be conceived in terms of a sequential unfolding, sandwiched between a past and a future.

The shorthand date of 9/11, names a singular catastrophic consequence, which in Western terms was initially perceived (because experienced) as the start of a campaign rather than as an irruption of ongoing tension. The events of 9/11 did not, of course, begin on 11 September, which is nevertheless a watershed; nor in any meaningful political sense do they finish on this date. Historical events such as wars or terror campaigns in general have no precise temporal boundaries; it is not always clear when they begin or when their effects cease to be felt. They are structured by relations with other events and may even involve long periods when it appears that nothing is happening.[3] If the ebb and flow of such events are 'covered' by media, the question of how they may be represented in art is increasingly moot, as the notion of documentary (further explored in Chapter 6) moves away from established precepts. The issue is less whether art can capture and frame the event, and more how the ambient, supervening event may be apprehended – grasped

distinctively – through aesthetic process. The practical ends of such a theoretical reframing become evident in the specifics of how art extracts and reconfigures features of an actual event.

The virtual event

The German artist Thomas Demand, who has consistently experimented with major events over the past twenty years, produced his work *Poll* (2001) (Plate 2) in response to the contentious count in the 2000 US presidential election, of which he remarked,

> I was astonished to note that a truly momentous political event – which some have even gone so far as to call an attempted coup d'état by far-right Republicans – was represented to the public largely via various photographs of stacks of paper [...] The event itself (the vote count) plays only a subordinate role here [...] I wanted to avoid looking through the lens of historical distance. I wanted to be so close to the real event that my pictures of it and the media coverage would become indistinguishable.[4]

Demand happened to be working at the time with representations of behavioural tests, and commented that

> The Emergency Operations Centre in Palm Beach seemed like part of a maze-based behavioural experiment – which it is in some extended sense, as the reduction of behavioural possibilities to a ballot corresponds quite nicely to the experimental setup for testing certain hypotheses about the behaviour of, say, mice.

He goes on,

> The conceptual structure of *Poll* is, naturally, devoted to a very specific set of political circumstances, but whether the work has any real significance will be evident only when the political event recedes into the background. In a certain sense, this work is a site-specific installation, in that the site is precisely the American short-term memory.[5]

Through the sculptural reconstruction and subsequent photographing of a location in pristine form Demand realises the 'event' in its incorporeal form. As he puts it, the model forms create surroundings that are 'untouched' and 'utopic'. While the image embodies the surface and materiality of the event, it sheds the specific details of its incarnation. The formal apparatus of a ballot count is thereby transformed into a virtual site, which Demand conceptualises in terms of structure rather than texture, pointedly invoking the analogy with the behavioural experiment in which 'the number of options for actions are radically limited and simplified' in the interests of producing a demonstrable result.

In this apparent trajectory from the actual to the virtual, *Poll* approximates Deleuze's conception of the pure event, characterised in terms of an inherent structure or problem that may be conceived in separation from its actualisation in particular circumstances. For Deleuze and Guattari, 'What history grasps of the event is its effectuation in states of affairs or in lived experience, but the event in its becoming, in its specific constituency, in its self-positing as concept escapes History.'[6] Hence, we can choose to consider the event by going over the course of the event, recording its effectuation, conditioning, deterioration in history – or by reassembling the event, inhabiting it and going through all its components.

An aesthetic project, in this sense, offers more than a record, a flashback or reconstruction; it generates a means of inhabiting and simultaneously reconfiguring the historical event as a radically different experience. Such an enquiry carries with it the possibility of reorienting the study of the *traumatic* event (that is, the shattering experience of a real event) away from historiographical endeavour. Within trauma studies, an area of humanities uniquely forged against the backdrop of a debate over the limits of representation, the writing of Holocaust history has been a formative concern. Impelled on the

one hand by the apparent unrepresentability of the Holocaust (the touchstone for this being Theodor Adorno's famous formulation that to write poetry after Auschwitz is barbaric) and on the other by the categorical necessity of its representation – of writing the history of the Holocaust so that it should not be forgotten – theories of the role of aesthetics have been shaped around the ethical exigencies of this singular case.[7] Such theorisation epitomises a practical orientation but is in key respects non-generalisable (the implication of any truly practical aesthetics being that its radical contingency delimits its efficacy); not all trauma – as the hyper-mediatisation of 9/11 might suggest – will confront the limits of representation in quite the same way, nor is there is a compelling need to conceive all trauma in relation to a historical record.

The analysis of aesthetic process – and of trauma in art – is, then, in some instances ill served by historiographical orientation. The modelling of traumatic memory as non-adaptive, real-time, somatic event, in opposition to narrative memory, has provided theorists with a useful schema for distinguishing an imagery of traumatic memory from conventional narrative history, as a sense-event that is essentially non-representational.[8] But this focus on a symptomatic reading of trauma in contradistinction to the writing of history perpetually reproduces a certain dynamic: history must be made to bear the mark of trauma, so that a subjective realm of experience is registered as a counterpoint to history with a capital 'H', a supplementation, adding the texture of experience. There are problems here for a general theory – or empirical study – of traumatic events in art insofar as much of the work associated with this rubric addresses neither the event as it occurs in historical time nor the subjective expression of a personalised traumatic memory.

Doris Salcedo's sculptural installation *Tenebrae: Noviembre 7 1985* and *Noviembre 6 1985* (1999–2000) was inspired by an actual

event – a terrorist attack on the High Courts in Bogota on those dates (Fig. 2.2). Like Salcedo's earlier work, it is fundamentally concerned with a mode of inhabitation – installing oneself within the event – which does not of course unfold in linear time, but encompasses past and future, interminable nothingness and a relationship to multiple other events. In her previous work (such as the evocatively titled *Casa Viuda* or *Widowed House*) the uninhabited event space is characteristically an evacuated rather than pristine space: a space that bears apparent traces of departed subjects. *Tenebrae,* however, resists any such personalisation.

As I have argued elsewhere, the dominant feature of Salcedo's work, in common with a plethora of political landscapes, is the isolation of affect within space, or its disembodiment.[9] Affect does not emerge from an individual subject or collective entity, but

Fig. 2.2
Doris Salcedo, *Tenebrae: Noviembre 7, 1985,* 1999–2000.

simply from space itself. Hence, Salcedo describes her work not as depicting or commenting on a single subject (whether that be a person or an event) but in terms that construe affectivity as the material substance of an event, and the means by which we enter into a given event, state of affairs or situation. Thus she argues that the physical and emotional constraints implied in a work like *Tenebrae* derive not only from the events of November 1985 but from multiple instances of terror and violence.[10]

By the logic of this process, art 'abstracts' from the actualised event a virtual structure that stages, in a particular kind of way, an affective encounter – an aesthetic encounter which is, by definition, relational and open-ended. But does this aesthetic transformation of elements related to an actual event constitute a critical/political practice or simply an apolitical poetics?

When Deleuze or Foucault insist on conceptualising events outside history they envisage an alternative practice of genealogy by which the components of an event – the same elements that make up history – are reassembled.[11] The point of such genealogy is not to reinterpret events or reveal hidden meanings in existing history but to put things together in new ways in order to generate counter-memories, or conditions under which different actualisations might take place. Rather than reproducing the accepted order of events in a single series, genealogy re-serialises events, potentially upsetting and transforming collective memories. Accordingly, an aesthetic reconfiguration of experience – to which affective connection is material – does not simply restore subjective experience to history but generates new ways of being in the event. It thereby holds out the possibility of reshaping the outcomes of a given event.

Aesthetic process – as embodied in art or within an exhibition – may generate thought and ideas. It is not, however, concerned with conceptualisation *per se*, but with the material and immaterial

processes of apprehension. In this vein, modern and contemporary art practice has long been identified as a site where a reordering and transformation of conditions of perception can occur. In the early twentieth century, the Russian formalist Viktor Shklovsky advanced the concept of defamiliarisation as a strategy for undercutting familiar or accepted meaning by means of an intensification of sensation, arguing that, 'The purpose of art is to impart the sensation of things as they are perceived and not as they are known.'[12] The conjunction of politics and aesthetics is similarly understood in terms of sensibility by a number of contemporary thinkers. Art for Jacques Rancière, for example, is concerned with undoing the formatting of reality and the relations between the visible, the sayable and the thinkable, so as to create the conditions under which new perceptions, and ultimately new forms of subjectivity, might arise.[13] The subject of art is, in this sense, not an actual event but its apprehension: aesthetic perception itself.

Such a *modus operandi* is evident in the work that Ugandan-born artist Zarina Bhimji developed from research in newspaper and film archives on the reign of Idi Amin and the expulsion of both Asians and Africans from Uganda in the early 1970s. This work includes photographs of desolate landscapes and empty or destroyed interiors, and a 16mm film *Out of Blue* (2002), commissioned for *Documenta 11*, in the catalogue for which Bhimji reproduces press reports describing the events of expulsion in Uganda and the reception of Ugandan Asians in England (Plate 3).

By imaging sounds and giving sound to visual form Bhimji effectively realises space through sensation – aesthetic space as perceived through the senses (photographs of abandoned places are given titles such as *Grenade* or *Howling Like Dogs, I Swallowed Solid Air* (both 1998–2003) (Fig. 2.3). In the film *Out of Blue*, it is the movement of the camera and the way camera angles work

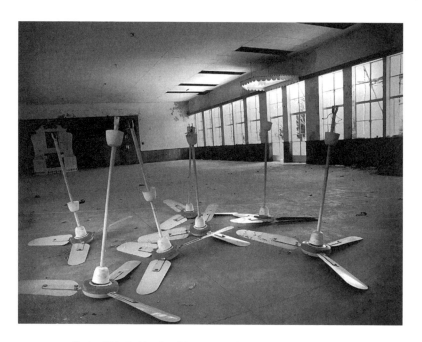

Fig. 2.3 Zarina Bhimji, *Howling Like Dogs, I Swallowed Solid Air*, 1998–2003.

with the soundtrack (of crackling fire and murmuring voices) that create the effect of giving visible extension to sound and sound to form. The project is about 'learning to listen to difference,' says Bhimji: 'The difference in shadows, microcosms and sensitivity to difference in its various forms. Listening with the eyes, listening to changes in tone, difference of colour.'[14] Hence the focus of the work is a form of resonance and its perception. By allowing the viewer to perceive a play of forms and sense impressions the work does not aspire to reveal what happened or promote a correct mode of viewing, but rather to sever any simple connection between seeing and revealing, or perception and signification.

Martin Seel sums up 'the perception of resonating' as essentially 'an encounter with formless reality'; an occurrence 'without something perceivable occurring'.[15] This happens in life when we

look at a shimmering sea or a dazzling neon cityscape – that is, when we are aware of a vibration, an oscillation or a shimmer, but cannot perceive its source. An 'encounter with resonating' in art proceeds from a focus on effect which in turn deflects simple narrative readings of an event. The (temporary) suspension of narrative destabilises normalised perception and meaning, creating the basis for a politics grounded in aesthetic process itself. Politics, in this context, arises in the practical engagement of perception and sensation rather than in the instrumental or didactic use of art.

Art becomes practical rather than abstract to the extent that it maintains a tension between aisthesis and signification. By playing off the processes of perception and recognition it produces what Rancière calls a 'double effect': a dynamic combining 'the readability of a political signification and a sensible or perceptual shock caused conversely by the uncanny, by that which resists signification'.[16] However, the coordinates that facilitate a form of recognition – like the date in Salcedo's subtitle that would signify for a specific Colombian audience – do not function in a fixed relationship to the affective component of the image. That is to say, artwork embodies sensation in such a way that it carries or conducts a kind of politics, even as its relationship to a given referent is a shifting one.

Alfredo Jaar's *Lament of the Images* (2002) (shown in *Documenta 11*) itself embodies this proliferation of referents (Figs 2.4 and 2.5). Organised simply and effectively around a manifestation of blinding whiteness, *Lament of the Images* presents three distinct allegories or event narratives on wall panels. One of these, titled *Cape Town, 1990*, describes the event of Nelson Mandela's release and how the images of this event showed a man squinting into the light as if blinded. It refers also to Mandela's time in the limestone quarry of Robben Island where, chained to other prisoners, he was

Practical Aesthetics

46

forced to break rocks, blinded by the glare of sun on limestone. The second event in April 2001 concerns Bill Gates's acquisition of one of the world's largest collections of historical photographs, which he is purportedly about to bury forever in a limestone mine (see p. 189). The soon-to-be-concealed photographs include images of Mandela, the Vietnam War, the Wright brothers in flight, and countless other landmark events. The third panel, headed *Kabul, 2001*, describes the first air strike on Afghanistan, ordered by President Bush, and immediately prior to this, the US Defence Department's purchase of exclusive rights to all satellite imagery in the surrounding region – acquired in order to secure an effective 'white out' of the operation.

After reading these panels, the viewer proceeds down a corridor into a blinding white room. 'Whiteness' in this structural relationship to the text is essentially illustrative, notwithstanding the fact that it is staged as pure resonance – so some might find this

Fig. 2.4　Alfredo Jaar, *Lament of the Images*, 2002.

work a little too overdetermined, or perhaps nostalgic for a time when imagery could actually be seen. But at the same time, it is the perfect encapsulation of Rancière's claim that the ideal double-effect of political art 'is always the object of a negotiation between opposites, between the readability of the message that threatens to destroy the sensible form of art and the radical uncanniness that threatens to destroy all political meaning'.[17]

Here Jaar plays with the capacity of the resonating image to connect with these discrete textual images; to plug into various narratives. The possibilities for interplay in this instance are clearly not unlimited – blinding whiteness, particularly in its literal connection to the narratives, is not a generic concept. However,

Fig. 2.5 Alfredo Jarr, *Lament of the Images*, 2002.

three discrete events are conjoined here, through this single culminating manifestation of whiteness, in an effective paraphrasing of Deleuze and Guattari's image of a concept as a string of ideas 'reconnected over a lacuna (rather than linked by continuation)'.[18]

Such a process by extension may be orchestrated across distinct artworks in the space of an exhibition. *Documenta 11* remains an interesting test case in this regard, since it effectively proposed multiple relationships between works arising from diverse social and political circumstances, such as Salcedo's *Tenebrae* or Bhimji's *Out of Blue*, which were shown in proximity. I have written previously about some of these, such as the conjunction between Mona Hatoum's *Homebound* (2000) (the domestic setting behind a wire fence, made up of appliances wired to an electrical circuit), which appeared with South African photographer Santu Mofekeng's imagery of Auschwitz and Robben Island.[19] That particular juxtaposition does not depend solely on the prevalence of signifiers denoting imprisonment. Instead, the affective impact of *Homebound* carries through into the viewing of Mofekeng's work on the opposite wall, so that Rancière's 'double effect' – the play between readability in terms of a particular political signification and a non-signifying element – is no longer confined to a single work.

As Jaar effectively demonstrates, there is not a fixed one-to-one correlation but rather a sliding relationship between the non-signifying, affective or resonating element and the signifier of a message that always in any case threatens to dissolve into pure resonance. Moreover, the relationships to multiple significations invoked in Jaar's *Lament of the Images* did not serve to compare or relate disparate events but to extract a feature – a motif of blinding whiteness – to express a concept of visibility and erasure, a concept underlying the real events described on each of the panels.

Desmology and resonance

In *The Logic of Sense*, Deleuze explicitly argues that 'all forms of violence and oppression gather together in th[e] single event which denounces all by denouncing one'.[20] And he cites a somewhat grandiose passage that affirms

> The psychopathology which the poet makes his own is not a sinister little accident of personal destiny, or an individual, unfortunate accident. It is not the milkman's truck which has run over him and left him disabled. It is the horsemen of the Hundred Blacks, carrying out their pogroms in the ghettoes of Vilna […] If he cries out like a deaf genius, it is because the bombs of Guernica and Hanoi have deafened him.[21]

Seemingly, such a statement flies in the face of a *realpolitik* that has beset poets' attempts to link one trauma to another, an infamous example being Sylvia Plath's evocation of her own personal trauma – the being run over by the milkman's truck – in terms of Holocaust imagery. Unsurprisingly, Plath provoked a backlash from those who justifiably insisted that the Holocaust as a lived event is not available as a metaphor.[22] The works under discussion, however, are not in this sense metaphoric. They do not appropriate the imagery of traumatic or violent events, nor even do they purport to describe actualities. Bhimji says explicitly that her work on Uganda attempts to 'link with similar disturbances' that have taken place in Kosovo or Rwanda.[23] This is not a test of its 'aboutness', so much as of the capacity for its resonance to be invested. In other words, the artist does not choose or claim to represent one or two or more actual events; rather she constitutes an event as a virtual event (engaging sensory perception and a sense of the particular) that may in turn find traction in memories of other specific events.

In response to the question of how art conducts a politics or propounds a politics, Rancière has suggested,

It is necessary to reverse the way in which the problem is generally formulated. It is up to the various forms of politics to appropriate, for their proper use, the modes of presentation or the means of establishing explanatory sequences produced by artistic practices rather than the other way around.[24]

Art, in other words, does not represent what has already occurred, but generates a set of aesthetic possibilities, which may in turn inform political thinking in regard to particular circumstances. If art can in some way evoke the pure event as a virtuality, the test is whether the virtual event is then amenable to different actualities.

Deleuze equates events with 'verbs', 'not substantives or adjectives', a distinction that evokes something of how they emerge in art: not as representations, descriptions or even concepts *per se*, but as actions considered independently of subjects and objects and particular conjugations.[25] This idea imbues *Prepossession*, an exhibition I co-curated (with Felicity Fenner and Liam Kelly), which featured the single-channel video installation *Non-Specific*

Fig. 2.6 Willie Doherty, *Non-Specific Threat*, 2004.

04) by the Northern Irish artist Willie Doherty (Fig. 2.6).[26]

his work generally, Doherty constitutes a space of affect, in the sense that the affect precedes, rather than emerges from, the presence of subjects who effectively pass through the space. In *Non-Specific Threat*, the camera's continuous circling pan focuses on a single figure of stereotypically menacing appearance. The vision is accompanied by a voiceover spoken by Kenneth Branagh (an Irish actor with a standardised British accent) that gives voice to various threats and prophecies that may be understood to emanate either from the figure imaged, or from another unseen figure menacing him, or as others have suggested, from God.

The disjunctive effect or slippage between subject positions is characteristic of Doherty, whose work doesn't simply reflect given positions or sides in a conflict, but traces the ways in which spaces makeover inhabitants as victims or perpetrators. Within this arena Doherty moves beyond – or perhaps within – the subject of sectarian division in Northern Ireland. The title *Non-Specific Threat* is telling in this regard – it is not the source or the precise nature or outcome of the threat that is documented here, but a sense of the threat as an animating dynamic that subsists within conflict: 'I am any colour, I am any religion you want me to be, I am the embodiment of all your fears,' says the voice.

In *Prepossession* this video installation was shown with work linked to other sets of historical occurrences: South Africa at the time of the fall of apartheid and postcolonial Australia in the wake of the report on the 'stolen generations' and land-rights claims. In one sense, the overarching theme of this show might be taken to be a response to contested land, and to racial and sectarian violence. But these three situations, each represented by multiple series of actual events, are utterly disparate. To present a contextual analysis of the three regions would be a sociological undertaking. To unite them

under a single theme would be to gloss manifest differences. An exhibition does more than simply compare or combine actualisations of an event. It curates the relationship that certain artworks can embody, whereby the pure event – or a kind of virtual structure – is constituted in such a way as to recast the terms on which events or states of affairs are conventionally seen and judged.

Hence, Doherty's work activates a dynamic of preoccupation or prepossession – a state of being in an event – that inheres in different sets of actual events, the test of which is ultimately its resonance or capacity to extend across these diverse situations. *Being in* an event is in one sense experience, but as with the work of Bhimji or Salcedo, *Non-Specific Threat* does not embody an account of personal involvement. Instead, it expresses certain conditions of possibility, and also constraints inherent in a given political reality as it is inhabited.

In a real and practical sense, then, aesthetics is as much about escaping from history and the particular as reproducing its events. Yet at the same time, aesthetic enquiry makes manifest and navigates the event, returning a practical vision to the particular: a concept of how the past, present and future might be productively inhabited. The challenge of the real event is precisely its non-theoretical character: the fact that it originates in actuality and directly shapes history, politics and lived experience. Art's purpose remains to reveal the tenuous nature of the event's representation and the substance of its dynamic, passing through its notional boundaries but keeping in mind Deleuze's proposition that 'the event is not what occurs (an accident), it is rather inside what occurs, the purely expressed'.[27]

3
Atmospheric Affects: Past Events and Present Feeling

Air

A man describes the panic aroused in him by the experience of walking through the village of Durness, a remote outpost in the north-west highlands of Scotland: pounding heart, breathlessness, a sickness like hunger, a silent hiss in the head; adrenalin taking possession of a body that feels 'so completely wired'. This man's voiceover is part of Shona Illingworth's *Balnakiel* (2009) (Figs 3.1–3.3), a video and sound installation named for the village of Balnakeil, near Durness, both of which are seen from the aerial perspective of a plane in an opening sequence.[1]

Prompted by memories of the local community's hostility to 'incomers', the man's anxiety is, it seems, common to many adults reviving childhood experiences of this isolated place, rendered inhospitable by geography and climate as well as by community division. Bounded by mountains, rock and bog, and pounded by continuous weather fronts during winter, the area has been shaped by a history of forced removal ('highland clearances') and by its new populations: incomers from the South, escaping the pressures of

urban living, and the military, who arrived during the Cold War to set up an early-warning station to guard the North Atlantic.

Threat – imminent or realised – has, at various moments, driven the inhabitation and organisation of this landscape, which has functioned as both retreat and front-line defence installation. If threat was the dominant sign of the Cold War, embodied in the early-warning station, the air of anticipated danger finds an echo not just in the affective tenor of remote village life but in the military manoeuvre underway as the man recounts his symptoms. His voice is counterpointed with that of an air-traffic controller rehearsing a show of force, a tactic of contemporary warfare in which planes fly as low as possible over a target area to 'buzz' the ground population, frightening civilians into hiding and exposing enemy combatants. Tornados, armed with live bombs, are guided in by features of the terrain; hence we hear the air-traffic controller 'speaking' the landscape as the jets approach their target. In this explicit territorialising of threat, the Cape Wrath Bombardment Range stands in for the theatre of conflict and for the enemy

Fig.3.1 Shona Illingworth, *Balnakiel*, 2009.

insurgents: a virtual Afghanistan. Threat is materialised in the air, in this precise location, for transfer to the next event.

As far as the man remembers, nothing sinister happened to him on the village road. He does not recall an actual event or episode but a sensation, powerful enough to alter biochemistry and neurology. His memory is triggered by features of a landscape associated with childhood experience – with routine trips to the local shop or school. These landmarks, charged with affect, evoke a social experience. That is to say, they are not merely objects onto which inner anxieties are projected, repositories of the personal, but objects shaped by and perceived within a distinct environment. In *Balnakiel* the man experiences not just flashbacks of memory but environmental forces: atmosphere. The resurgence of his anxiety is not 'out of place' or misplaced. It is arguably mistimed, relating to a representation of the village at an earlier moment. But in attending to atmospherics, *Balnakiel* opens up a different possibility, a way of seeing accumulated experience – memory – in terms of an encounter with something that endures in place, with affects that persist even in the absence of other people.

The metaphorics of atmosphere capture precisely this sense of lingering presence, figuring the enduring energies and affects that characterise an event or place as part of an environmental dynamics. People create atmosphere through the social communication of affect within a given environment. A good atmosphere may be generated by the connecting 'buzz' or 'vibe' of a group or crowd, but the setting must be conducive; ambiance arises from the mix of social and environmental forces. The concept of an environment as the aggregate of surrounding things encompasses both the physical and atmospheric, though we rarely discuss the interdependence of social atmosphere and the biosphere that underpins it. In the most palpable sense, however, qualities of air (natural or artificially

Practical Aesthetics

Fig. 3.2 Shona Illingworth, *Balnakiel*, 2009.

regulated) affect the way in which we see, hear, feel and smell in a given place, and hence condition social communications.

The question of how we sense what is in the air (a positive vibe or a foreboding atmosphere), itself a question of affective relations, is thus linked to the more distinctly environmental issue of how we understand and envisage air and climate. *Balnakiel* is a study of actual conditions of perception – of how Balnakeil the village and its environs are perceived from the air, from the sealed cockpit of an aircraft passing through cloud, from the ground immediately below an aircraft as it makes a deafening descent, from interior structures battered by rain, and from the highland terrain during a weather front. It is a study of human communications in terms of what Peter Sloterdijk calls a spherology, focusing on taken-for-granted atmospheric knowledge.[2] Communication and sensing takes place within 'spheres' – areas of inhabitation characterised by specific atmospheric conditions. In *Balnakiel* spheres (which Sloterdijk argues may proliferate and connect as 'foam' or 'bubbles' bordered by membranes) are delineated internally (within the film's

diegesis) by air- and noise-regulating structures such as planes or buildings and externally by the installation space.

The space of engagement, of 'viewing' is itself a sphere – an 'inside-like, accessed, shared circle [*Runde*] that humans inhabit'.[3] Inside-*like* because it is its own regulated atmosphere with its own air-conditions, a social space designed to enable the installation to promote certain means of connecting. *Balnakiel* presents the highland landscape as experience. The vibrations of a plane are sensed through a rumbling sub-woofer in the air-conditioned gallery space. The wind and turbulence of the highland atmosphere appear in the film through various partitions. Glass windows are barriers to the battering gales and rain (which, we hear, can be like an 'attack', confining inhabitants for forty days at a time); a young girl climbs through a window and leads us out into the night; an

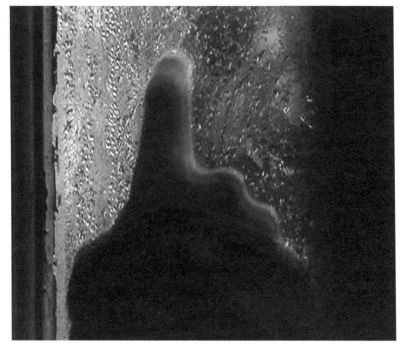

Fig. 3.3 Shona Illingworth, *Balnakiel*, 2009.

air-traffic controller guides in a Tornado from inside a tower with wrap-around windows.

At the same time, the effects of remote or radio-controlled actions in these spheres (a plane's descent, an explosion, heather burning in its wake) are seen but not always heard, their sonic resonance muted in certain sequences as if to draw an atmospheric distinction. A silent explosion appears disconnected from our experience, and hence confined momentarily to a distinct sphere, discontinuous with the present: the virtual event of an explosion in Afghanistan or some future war, or a hint of the past when heather burned in the aftermath of highland clearance. By contrast, other sound effects penetrate the viewing sphere, folding into space and establishing continuity even as sounds distort and change.

Through this continuity of sound, inner mental space or body space is mapped onto external terrain; anxiety arises, as it were, from a pathway, a road, a rock, a low-flying Tornado. Memory is thereby extended topographically, the video and sound installation functioning as a cartographic process, registering the distribution of certain internal sensations across objects and landscape. In contrast to the more self-contained flashback, which confines memory to its own time, such a virtual mapping of actual living space folds into the present.[4]

As Sloterdijk has argued, atmospheric modelling is suppressed in much conventional cartographic representation. It is, however, the natural domain of immersive installation – a genre sometimes derided within art history for the apparently inauthentic nature of the experience it purveys.[5] Sceptics contend that immersive video installation eradicates aesthetic distance, along with any capacity for judgement; being *in media*, as it were, obviates the possibility of thinking through media, purveying only a 'faux phenomenology' in Hal Foster's phrase.[6] Such a debased phenomenology delivers

an experience with no perceivable link to actuality or 'outside' conditions; an experience beyond disorientation, the equivalent of 'being lost in space,' Foster suggests. The shortfall of his exemplars is not a function of media or medium, however, but amounts to a lack of atmospheric awareness. Foster does not conceive a remedy in these terms, but a practical and conceptual engagement with atmosphere as a dimension of perception opens the possibility of mapping and navigating this space.

Conceived as an extension into space, a communication or an expression encounters degrees and qualities of resistance in air and environment. Hence, memory or thought that is externally mapped is transformed in its passage through the environment, which may be variously accommodating or resistant. It is possible in these terms to envisage place and atmosphere as modulating perception and affect, as intensifying or transforming anxiety rather than serving as its object. Air is, in this sense, not an object of art but a hyper-medium, materially altering conditions of perception. A strand of immersive installation explicitly engages this medium in order to investigate the condition of inhabiting and moving through an environment.[7] With its implicit technique of defamiliarisation, highlighting what is routinely absorbed in everyday transformations, such 'atmospheric' art fits within a long tradition of artistic investigation of perception.[8] But rather than removing objects from their environments in order to examine habits of perception more closely, atmospherically attuned study operates inside the sphere, envisaging its density and specific qualities, and the means by which an event or place generates 'an atmosphere' as a perceptible experience.

Atmosphere and event

'An atmosphere' – that quality which an event may conspicuously generate or lack – is an effect of the transmission of affect, a process about which we still know surprisingly little. We theorise about expression and perception or reception – the twin poles of affect – which originate in an individual or social group. But, as Teresa Brennan notes, we know little about what happens in between these poles.[9] Yet all of us know an atmosphere when we are in it: the tension and excitement of the streets, the sense that something is 'in the air', that we are part of something. Moreover, we often think and remember events in those terms; what happened may be less important than how we experienced the event, sense impressions, the detail of what were we doing when such and such happened. That we know where were we when President Kennedy or Princess Diana died is less a marker of the magnitude of the event than of the habit of returning the event – however distant – to experience. Such events precisely *don't matter* to us unless we can write them into our lives. As Christopher Bollas observes, we do not remember world events as historical signposts; the markers of history are rarely coordinates of our parochial lives.[10] Our connection to them is sometimes rendered palpable by direct consequences when an event literally touches 'our world' but more often it is their encompassing atmosphere – their mood – to which we connect or attune.[11]

Art is often casually credited with capturing the atmosphere of a time or place – the fulsomeness of its experience. An artwork can fill out an affective topology in a way that facilitates recognition and stimulates a feeling of being there, in the moment. Painting can do this – film perhaps more so – but immersive installation is the vehicle directly engaged with an investigation of transmission

itself. At the intersection with experimental documentary, immersive video is now a means of examining the experiential reach of an event, as Adam Curtis's *It Felt Like a Kiss* (2009) (Fig. 3.4) demonstrates. For this staged piece, Curtis transformed an abandoned Manchester office block into a 1950s house of fun/horrors, replete with the props of fifties domestic life and a video installation with pulsating sound, running throughout the building. Comprised of a mesmerising mash-up of media events from the America of the 1950s, interspersed with footage of 9/11, the video evokes the 'American dream' and landmark political and cultural events of the fifties not as historical events or icons but as a potent

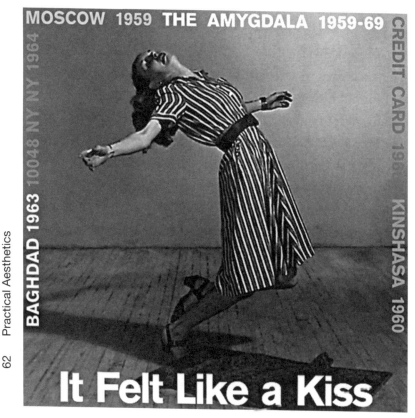

Fig. 3.4 Adam Curtis, *It Felt Like a Kiss*, 2009.

atmospherics, literally 'felt' around the world. It is this 'feeling' – the means of its transmission as contagious affect – and the politics that it sustains that is the object of the work, which literally resonates and vibrates.

Such events and phenomena as the 'Cold War', the 'American dream', 'Vietnam', are epochal signifiers, which is to say that they do not simply apply to actual events located in the theatres of war, politics or economics at their core but to a 'mood of the times'; to a set of anxieties, fears, hopes, dreams, investments that flowed more extensively, that touched, captured, mobilised people in their daily lives. Atmospherics in this regard are central to understanding the social and political reach of events, the boundaries of which are never fully definable.

In materialising the sensate processes that combine to engender atmosphere, art necessarily broaches the relationship of subjects to world events: as Deleuze puts it, 'Sensation has one face turned to the subject (the nervous system, vital movement, instinct/temperament … and one face turned toward the object (the "fact", the place, the event).'[12] But this generation of sensation in the present – in the here-and-now event of an artwork – moves separately of its own accord and away from the 'past' event. Aesthetic sensation is characterised by immediacy. The impact of vibration in the body, and of an affectivity that precedes conscious recognition, it arises in the interaction of spectator and artwork. Affects find their own strength and intensity in the new configurations achieved in art, going 'beyond the strength of those who undergo them'.[13] Hence, art does not capture and replicate a given subject's experience of the event but draws bodies into sensations not yet experienced. It generates new experience *from* an event, moving outside the parameters of what is already known or habitual. How, then, is an affective aesthetic practice

operating on its own terms (that is, by yielding sensory pleasures) made practical (capable of yielding new insight in relation to a real-world event)? *Balnakiel* and a second work of Illingworth's – *The Watch Man* (2007) – enable us to frame this issue. Each is concerned with atmospherics and the mechanics of transmission, and with the manner in which a sensation connects to 'outside' events, both historical and anticipated, personal and communal.

Immersion

The Watch Man (Figs 3.5–3.8 and Plates 4 and 5) is an immersive installation, focusing on an eighty-year-old watchmaker and the activities he performs in the interior of his home/workspace. These activities do not combine to present a narrative or portrait of a worker, but are framed as sequential actions – practical tasks, viewed in close proximity. Hence this is less a study of the worker than of the substratum of daily life: the gestures and movements that comprise the material processes of making or mending. These include tactile processes: a steady hand manipulating tools, setting a ruby, buttering bread, lathering soap onto skin under the shower; and mechanical processes, grinding and planing, polishing.

The watchmaker views the interior mechanism of a watch with the aid of various magnifying lenses – microscope, eyepiece, spectacles – optical devices that are echoed in the format of a circular screen. Viewers see his actions on this screen, as if this were itself a viewing aid, making visible the molecular detail within the normally visible world. But if this framing device is an ocular metaphor, hinting at the capture of the detail under a magnifying lens, it is offset by the surrounding elements of the installation – elements that render vision a profoundly bodily

Figs 3.5–3.8
Shona Illingworth, *The Watch Man*, 2007.

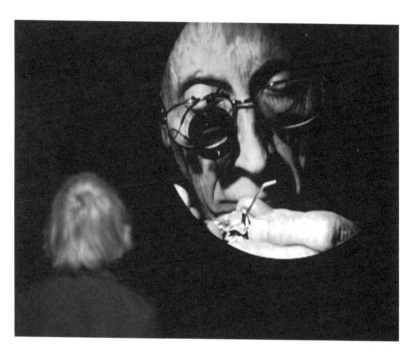

experience, mitigated by other kinds of sensing. The screen is the eye itself (bare trees in a forest in this circular format take on the association of capillaries in an iris) – the eye as physical organ, set in a room tinged blood-red by the luminous floor, which also emits vibrating sound.

To enter this room, to walk on the floor and feel its vibration, yields a particular experience of interiority. The spectator is not merely in this man's space, inside his home, his private world, his memory (all of which are evoked but somewhat circumscribed by the circular screen) but has the sensation of being inside a body, an indistinct, anonymous, collective body, an 'inside-like' experience of a shared space or sphere.

This same trope of turning insides out and outsides in characterises a major installation by Christian Boltanski that similarly references momentous events from an uncertain subject position. The suggestively named *Personnes* (2010) (Plate 6) ('people', 'nobody') on a far less intimate register transforms the vast vaulted glass exhibition hall of the Grand Palais in Paris with the collective thud of thousands of heartbeats, their indistinct rhythm a counterpoint to an installation made from everyday clothing – the recognisable, the personal. Boltanski's work is emphatically about scale: mounds of clothing dwarfed by the cavernous space of the monumental Grand Palais, which is in turn dramatically rescaled when simultaneously experienced as an interior – a pulsing corporeal space.

Both Illingworth and Boltanski's work make oblique links to Holocaust memory: Boltanski's through association with the vast storehouses of clothing and personal effects, amassed in the camps, here turned into 'monuments', a mechanical arm grasping indiscriminately at the tallest clothes heap, evoking the random logic of selection and survival; Illingworth's through what we

learn of the watch man's past in reminiscences voiced in the soundtrack, describing his experience of entering the concentration camp at Belsen as a young soldier – the youngest in his troop – in 1945. The effect in both cases is disconcerting. An unspecific intimacy takes on weighty association, breaching the distance between 'the Holocaust' and us. These works move us inside experience; not, however, towards the privileged vantage point of the witness, but to an interior space where sight is altogether less consuming. Interiority is not *depicted* but felt at a point of contact; rather than peering at the subject through a viewing apparatus, we are, as viewers, in a place where vision is less clear, more tactile – synaesthetic.

Whereas cinematic projection plays to a fixed viewpoint, in *The Watch Man* sound moves across space and through bodies. A deep rhythm of very low frequency sound vibrates in the chest; nine other soundtracks are distributed across the floor and overhead.[14] The different planes of sound, emanating from various areas are synchronised to allow sound to sweep from ceiling to floor – or, conversely, to be contained and isolated. In this way, the sound of a pendulum moves across the floor; and the sound of the watchmaker's lathe, heard overhead, sharp and clear, turns into the deep vibrating sound of a low-flying helicopter, sweeping the floor and rising back up overhead, so as to create a wave that enfolds the viewer. These fluid transitions perpetually open up interior spaces to outsides. The watch man's lathe becomes a military helicopter; his shower turns into forest rain, so that as we catch sight of his intimate ablutions we find ourselves back outdoors.

Sound, in other words, shifts the register of images, repeatedly giving rise to sensations that transform rather than reinforce the meaning of imagery on screen. If there is a narrative framing the action of *The Watch Man*, its imagery is not 'read' in separation from

the sensation generated by the immersive auditory component. This is not sensation that mimics representation or reproduces that felt by a character on screen, it is sensation drawn from the play of elements and energies that subsist beneath representation or the level of semantics and meaning. Deleuze describes this aesthetic operation in relation to Bacon's painting in which sensation emerges from the dynamic interplay of compositional forms.[15] Painting thereby disposes of any radical distinction between subjects and objects, figure and ground. Immersive art, however, makes explicit its concern with qualities of environment and with the transition from one sphere to another.

Aesthetic experience

Illingworth is not directly concerned with the meaning of images, or with undermining meaning. Neither does she abandon the real for the realm of abstraction and formalism. She plays with shifting those conditions of 'real' space which give affect, expression, noise, and so on, their character in a given sphere. Sound – the roar of a jet engine, the grinding lathe, rainfall – originates at a given point, travels through airspace, which has its own turbulence, humidity, density, to a given point in a new sphere (the highland landscape or, ultimately, the art gallery). As it does so, it passes through and conjoins different spheres, sometimes rupturing or extending the membranes that delineate these spheres, which are permeable and extensive – like proliferating foam – at both macro and micro level. Space/place in this context does not equate to 'setting'. Air is not the backdrop against which events occur but a determinant of the quality of sound, seeping into the work at an elemental level.

This transposition of sound elements is the antithesis of an abstracting process that extracts a pure form or sound from its 'social' context. Sound connects to objects in Illingworth's work, playing on a certain habit of hearing. Unlike visual objects, aural objects have a peculiarly 'adjectival' quality, as Christian Metz noted: 'Lapping' is in and of itself an aural object, recognisable by sound alone, yet cultural and linguistic convention leads us to seek out its source, a lapping sea or river to which the onomatopoeic predicate belongs.[16] In film terms this habit tends to privilege the visual image, which serves to anchor the meaning of sound. But in both *The Watch Man* and *Balnakiel*, sound is relatively free-ranging, attaching first to one event and then another. Ambient sounds build into rhythms: ticks, whirs, crackles, ringing, buzzing, splashing are heard as vibrations, often emanating from identifiable sources but then taking on different characteristics, transforming and translocating.

In some of the most mesmerising shots of endless rain in *Balnakiel*, we appear to be outside in the deluged highland landscape itself; that is, within or *inside* that landscape, attending to the sound of rain falling: the sharp pitter-patter of rain landing on hard surfaces, somewhere in audio range but out of shot, as well as on the absorbing earth. We watch rainfall in one place, but the *sound* of rainfall is supervalent, coming not from the image but from multiple surrounding sources. Or sound might be absent, slow-building in contrast to a violent event imaged on screen. This is not, then, a natural fusion, surround sound as 'ecomimesis', but a differential sense experience in which seeing and hearing are in a fluctuating accord.[17]

Dewey argues that we habitually undergo sensations as mechanical stimuli without fulfilling the interest of insight; we see without feeling, hear without vision and so forth.[18] From this we might infer that the virtual presentation of an ecosphere in

surround sound does not guarantee the perfect, simultaneous engagement of all senses. A video installation offers not merely the illusion of reality, of being there, but reality filtered in ways that enhance, often simultaneously, discrete modes of perception. Accordingly, an intensification of sensory stimulation does not in itself engender greater knowledge. Aesthetic processes transform knowledge by achieving greater sensitivity to perceptual activity.

At stake here is how we understand information or meaning to be carried; that is, the issue of transmission. We readily assume that the meaning of a sound or an image is conveyed through signification. But sounds and images have their own qualities and intensities or valences. They may be social in origin but physical in impact, experienced as a matter of vibration, and hence of intensity. Even where speech expresses meaning and agency, *prosody* – the rhythm, stress and intonation of speech – is central to its 'message', or more precisely to the effective transmission of a message. Hence Brennan argues that we have failed to understand how 'the social and physical transmission of the image are one and the same process', how sights and sounds are carriers of social matters, physical in their effects.[19] This being the case, however, prosody or the affective response to sound or image may outweigh and ultimately countermand a message, producing a cognitive dissonance that allows one to feel with or without believing. Hence, one may feel anxious on a given street even when one believes there is no just cause, no actual threat.

If the study of atmosphere in art is a study of communication and perception in a given sphere, each instance is a mapping of the axis of communication (the transmission of affect from one body or entity to another) in dense space, a modelling of intra-personal connection through an examination of the quality of space and air in between. The in-between space for Sloterdijk is not a gap

between subject and object but a forcefield of turbulent tension in which human encounters are no longer merely 'intersubjective' but figure as 'interfacial greenhouse effects' ('gattungswirksame Zwischengesichts-Treibhaus-Effekte').[20]

Brennan is equally concrete in her attempt to model relational space, in this case by tracking mechanisms of transmission through air. The theories of entrainment utilised by Brennan prioritise two senses in particular, smell and hearing.[21] Smell is a key vehicle for chemical entrainment, which encompasses pheromonal transmission (pheromones are externally secreted substances which may communicate fear and anxiety, for example, when detected in the air). Nervous or electrical entrainment – 'the driving effect one nervous system has on another' – is effected by touch, sight and sound, but particularly through the communication of rhythm, in regard to which auditory cues have priority.[22] Whereas chemical entrainment is largely unconscious, however, rhythmic or auditory entrainment may be both conscious and more readily manipulated (as, for example, in the case of dance parties or crowd chants that raise the intensity of an event).

In Illingworth's work rhythm plays a central role in effecting continuities and discontinuities, producing accord and discord through entrainment and dissonance, designed to disrupt habits of perception. The metaphorics of *The Watch Man* are explicitly concerned with the production of rhythm: with time and timing. It is the measurement of time – rather than the time of the historical event – that is thematised.

Clocks strike and tick, their metronomic function anchoring the acoustic rhythm of the piece but modified in places so that the marking of time becomes unstable, slightly out of synch, a struggle between competing forces. Where rhythm builds and connects, narrative remains inchoate.

The Watch Man – in spite of its arresting colour and visual sequences – might be deemed a sound installation first and foremost. Sound is the driving element, hearing the connecting sense, changing how things are perceived, and changing relations between sight and sound, sight and sensitivity. Yet the shrouded figures of Belsen, 'slow moving [...] not reacting [...] not walking [...] just shuffling' and the 'smell of decay' remain the most pronounced and striking images in the watchmaker's account of Belsen. Those images are not illustrated or replicated in any sense. Evoked simply in the words of the watch man, they are etched in memory as sights and smells, described but not transmitted.

The question of what is transmissible or accessible is an important one in this context. Acoustic rhythm achieves a 'deep' level of engagement in *The Watch Man*; sound is literally penetrating. At the same time, the projected imagery and radiating light is vibrant and textured in a way that offers a haptic engagement with surfaces, with details and processes, from tea making to watch mending. Yet none of this takes us into the narrative of Belsen. Neither abstract, nor an aesthetic detour, the sound installation makes only the vaguest gesture toward storytelling. The watch man's description frames this piece, making Belsen a kind of touchstone for everything that goes on, but his voice does not transport us there, its rhythms and prosody miring us in the space of the present.

The Watch Man is not a work *about trauma* in the sense of ordering images to evoke a traumatised subject. There are no flashbacks or images of Belsen. Traumatic memory of the horror of Belsen does not impinge on the here and now in a way that pathologises the former as out-of-its-time. Memory flows freely in the present, the watch man now able to describe the scenes of death and his own trauma (an 'uncontrollable suffocating, frightening feeling'), but both clocks and voice anchor the monologue in the

here and now ('It's four o'clock, just past four,' he reminds us). Trauma has been muted in the life of the watchmaker, as he tells it ('people did not want to know; they did not want to hear'), but it is neither suppressed nor enacted here. The Holocaust and the liberation of Belsen is an impetus for *The Watch Man* but, as with the life portrayed, not its *leitmotif.* The irruption of memory in the present follows a different logic, that of Deleuze's open, expansive cartography or of Dewey's rejection of representational and cognitive viewpoints that 'isolate one strand in the total experience, a strand, moreover, that is what it is because of the entire pattern to which it contributes and in which it is absorbed'.[23]

The 'total experience' is not the reconstructed past but the dense weave of everyday life. Insight through aesthetic engagement comes through making (creating, producing) connections, rather than through retrospective analysis.[24] In this vein, we might read *The Watch Man* as a study in aesthetic perception – a mode of perception enacted 'diegetically' in the watch man's transitions between everyday tasks and recollection – envisioning memory as inhabited experience, distributed across the terrain of everyday life, the world around him.

Making tea, busy work, taking a shower, occasional reflection, reminiscence, reverie, or anxiety. Such practical activities are not left behind as memory takes hold; on the contrary, they sustain memory and promote its transformation. Memories are invested with meaning, affect and sensation; gestures, actions and objects enjoined into circuits of affect that carry thoughts, ideas and memories. In this sense, we can say that Illingworth's works are about remembering: processes of memory and processing memory rather than the memory image itself.

Most importantly, these works demonstrate the capacity of the aesthetic (aesthetic thought or practice) to redirect affect. The notion of the aesthetic defined in terms of its capacity to conduct, orchestrate,

intensify, redistribute is the antithesis of the idea that an image generates intensity by virtue of what it represents. Certainly it is the case that shocking images of Belsen or other atrocities or violent acts incite anger simply because of what they are; on the other hand, there are many other kinds of image that take on a demonic status by virtue of an intense affective interest arising independently. The psychologist Silvan Tomkins explains this in terms of the propensity of affects such as fear to seek out objects. Hence, fear may precede the image and find its scapegoat, rather than the other way around. In this sense, affects travel benignly or otherwise in art or by aesthetic means, finding a place in the everyday.

Art is not about fixing the emotion to the event (in *The Watch Man* affect does not cling pathologically to its object; nor does it merely repeat or haunt the subject). Instead it offers the creative possibility of changing an emotional relationship to the event, gradually over time, suddenly, emphatically and radically. By contrast, some of the most controversial work on Holocaust imagery is that which holds to the possibility of representation and capture; to the conviction that a phenomenological trace of a subject might subsist within art, like a fragment of memory.[25] Such claims are always mired in arguments about their redemptive aspirations for art. For if art preserves a trace of a real life, it becomes a relic; and with the preservation of life in this form comes a duty of care. 'We must remember' Auschwitz, 'must imagine for ourselves', argues Georges Didi-Huberman.[26] This imperative is more than simply that of 'not forgetting' or marking the loss. It enjoins us to 'witness'.

Herein lies the hubris in the representational position. Can art ever claim to capture profound trauma, the witnessing of which entails extreme horror? Its failure to do so is, of course, implied in the well-established argument that the Holocaust is 'unrepresentable'. But often what is at stake is not representation but response: what

we make of an image and how we perform memory in relation to it. Believing in the claim of representation and capture, the secondary witness is compelled to mime, to produce a sadness that is clichéd: appropriate but inevitably inadequate to its subject, not by virtue of its insincerity but in its pallor and attenuation.

The necessity for art to refract the past, enabling viewers to experience its trace, diminishes as we attune to the ways in which aesthetic perception operates – always, already – along a continuum, connecting the past to the present. The Holocaust, the catastrophe, the real event is not merely historical subject matter to which art might gain access – or, for that matter, pronounce off limits. Rather, the job of art and aesthetics is to trace aesthetic activity, following the strands that carry the event forth, embedding it in the material world and transforming experience.

Sensation or affect is never novel as such but layered, thickened and accumulated: it is 'irreducibly synthetic', as Deleuze argues.[27] In art it arises from the newly connected with a degree of intensity, strengthened – not attenuated – by the aesthetic process, taking on new character. Likewise, the atmosphere of an event or place is 'charged with accumulations of long-gathering energy',[28] experienced in the present under ever-changing circumstances. Art, then, concerns the lived – and living – event. Whatever it tells us of history – past events – does not come from presenting an image of that past but from the sensation that marks the very extension and reach of the 'past' event: history as accretion rather than history repeating. Aesthetic work follows the threads of a history of sensation that goes to the heart of what creates and energises the event, whether characterised by unrealised threat – a mood of the times – or an all-too-real and inexpressible horror.

4
Intermedia: Field and Detail

Media events

If the event conceived by philosophy and aesthetics has no determinate boundaries, the distinguishing feature of the media event is that it defines its own beginning and end. Media events finish when coverage stops and often begin, just before the main event happens, with a gradual build up of excitation and anticipation. The sudden deaths of Princess Diana in 1997 and John F. Kennedy Junior in 1999 were not unlike the pre-planned mega-event in this regard, unfolding in rolling news coverage of the car crash (Diana) and plane disappearance (JFK) before the respective deaths were verified as actually having occurred. Anticipated by television pundits in advance of the announcement from official sources, and culminating some time after in the state funeral, death is the media event, spanning the scene of the accident through to the memorial with all the infill that saturation coverage requires. The drive to extend coverage to saturation point was fuelled in the case of Diana's death by a groundswell with its own images of excess: the sea of flowers, the outpouring of emotion. But saturation in

and of itself produces intensity through relentless attention; it is hard to watch continuous coverage of a tragic event without being in some way affected, even when one has no prior attachment to the celebrity concerned. At the same time, content is sooner or later exhausted.

The banality and repetition that characterises over-extended coverage intensifies the compensatory search for the 'soundbite', the image and the single poignant gesture: the 'decisive moment' in the old language of photography, coined by Henri Cartier-Bresson. For the co-founder of Magnum, who himself famously photographed the funeral of Gandhi, the decisive moment was the peculiarly photographic expression that enabled an event to be perceived and to signify: 'The simultaneous recognition, in a fraction of a second, of the significance of an event as well as the precise organisation of forms which gives that event its proper expression.'[1]

This concept of the event, captured in a single moment in a metonymic visual, arises from an era of print media and photojournalism. It is an expression of the medium of photography – a kind of visual thinking shaped by that medium – still infinitely recognisable even though photography is no longer the principal defining medium of the contemporary event. If major news networks today govern the way in which event imagery unfolds, photography retains the capacity to extract, synthesise, suspend and virtualise. No longer the main means of imaging and defining the event, it becomes – along with other techniques of art and media – a critical tool, a means of moving through the media event.

This chapter explores intersections of media as a prelude to looking at how the media event is actively inhabited. Rather than simply viewing the event as a multimedia production it considers the deployment of practical aesthetics within a mediascape: a

dynamic field in which media technologies and conventions are readily re-appropriated, retooled, repurposed. Within the media event itself, the play between the photographic and continuous coverage, maximal vision and the summary image, the micro and macro is evident. If saturation coverage generates intensity through its relentless flow, it nevertheless thrives on detail and image. But is the expressive gesture the signifying action that encapsulates the meaning of the event – or does it now mean, do and show something different? Art history conventionally views intermedia in terms of an intersection of art and popular culture or 'other' media. Practical aesthetics reconfigures this relationship by placing art on an aesthetic continuum where it is always already part of a larger mediascape. In this expansive domain, art's practical value emerges in a critical capacity, expressed through the use of media within media.

Intermediality

The terms of the media event are addressed in Harun Farocki's twelve-screen video installation *Deep Play* (2007) (Figs 4.1 and 4.2). Effectively a replay of the 2006 World Cup final between France and Italy, *Deep Play* is conceived as the ultimate extension of the principle of saturation and all-encompassing vision (more cameras, more angles and viewpoints; continuous reporting on the ground and exhaustive studio analysis). This was a final remembered for a single decisive gesture – the head-butt that earned Zinedine Zidane a red card – providing the event with its own distinctive drama, over and above the play and the emotion of winners and losers. But Farocki's is not a work about the narrative of the soccer or of Zidane. It presents the material of media: the raw game as a clean feed, coming in from the cameras on the ground, unedited,

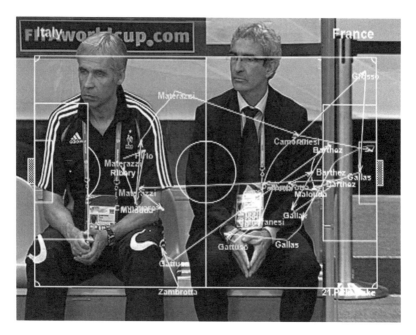

Fig. 4.1　Harun Farocki, *Deep Play*, 2007.

fed through an array of computational processes and technologies. On one screen we see a dynamic bar graph beneath the video of the players, recording their average and peak speeds. Another screen tracks a single player, showing a time graph of his rate of motion. On another, playbacks of fouls are rendered in Laban notation, a standardised system for recording human motion. Another screen shows the Italian and French coaches watching the game overlaid with a schematic diagram of passes, produced by Ascensio Match Expert computational analysis software. The maximal extension of the footage here engenders its own aesthetic, reflecting the necessity for the contemporary media event to fill out its intervals and flatspots with information: an information aesthetics that generates pattern in the spaces of an event where nothing is happening. It offers both too much information and a sense of how any and every detail might be activated as a point of interest. The intense focus of

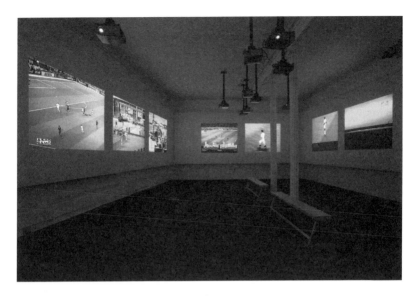

Fig. 4.2 Harun Farocki, *Deep Play*, 2007.

a coach or statistician becomes gestural and expressive at certain moments, as the event folds out not just into image technologies but through the minutiae of marginal activity. This is a distributed rather than narrative aesthetics, playing off the big spectacle and the detail in a way that extends intermedial method.

Gabriel Orozco's approach to sporting events works to similar ends with quite different media processes. For his series *Atomists* (1996), Orozco over-painted and then digitally enlarged photographs clipped from the sports section of British newspapers (Plate 7 and Fig. 4.3). In a number of these he includes the original photo credits and captions, describing the actions of footballers or other sports stars caught in the frame:

> Asprilla, the Newcastle United substitute, attempts an overhead kick despite the close attention of Calderwood at St James' Park yesterday.

> Ferdinand powers his header past a helpless Ehiogu and Bosnich to clinch a vital victory for Newcastle at St James' Park yesterday.

Blindside run: Les Ferdinand fails to connect with his head but Darren Anderton ghosts in to open for England.

Orozco captures these moments in the game as a molecular abstract pattern, over-painting a grid of circular and elliptical forms, keyed to the dominant colours of the underlying photograph. This atomistic translation of the image of dynamism, speed and the body in motion conjures an array of art-historical associations (from the geometrics of Russian constructivism to Robert Delaunay's *The Cardiff Team* begun in 1912, as well as the tradition of 'motion study' in photography). Yet these are clearly not scientific enquiries into biomechanics, nor do they orient specifically towards painterly or art-historical concerns. Rather than simply rendering the images of athletes in paint, Orozco elaborates the found photographic image, overlaying one form of media with another to trace lines of tension and energetic flows within the image. In doing so he creates cells that serve to frame various details: gestures, points of contact, facial expressions.

The image of the athlete in effect becomes gestural in this convergence of media. Bodies engaged in the purposive action of a game are broken into their component parts by the segments and spheres that reframe particular aspects of the action as gestures or expressive movements. To highlight the gestural character of action in this way is to view it not as goal-directed but as activity that is inhabited or 'supported', in the sense proposed by Giorgio Agamben.[2] For Agamben, an activity that is commonly regarded as a means to an end – he cites porn acting, but competitive sport is another example – may be reconfigured in a way that does not deny its function as a means but focuses on 'being-in-a-means'. Gesture is the key figure for this, particularly when it reveals the slippage between an action performed or spoken and the 'inner' sense of this activity, thereby embodying a dialectic between the communicative

(externally directed) and the solitary (inwardly felt).[3] In this sense, the incidental gesture that manifests self-consciousness may be seen as a direct expression of its own being-in-a-medium, and thus as a means of deriving a portrait from an action image.

In a more general sense, gesture reveals what Agamben terms 'the media character of corporeal movements'.[4] In doing so, it constitutes corporeal actions – or bodies – as interfaces, engaged in a relational dynamic, whether with an 'interiority', with media proper (film, video, image) or with the larger action that encompasses it (the game, the sex in a porn film). This interface is manifested when gesture is isolated within the image of an action, originally configured as a means; in other words, through an intervention within media.

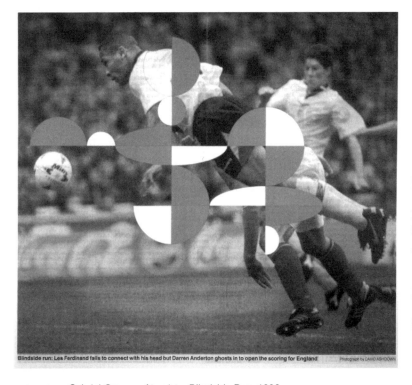

Blindside run: Les Ferdinand fails to connect with his head but Darren Anderton ghosts in to open the scoring for England Photograph by DAVID ASHDOWN

Fig. 4.3 Gabriel Orozco, *Atomists: Blindside Run*, 1996.

In this regard, the convergence of media that characterises the *Atomists* must be understood not simply as a translation of an image into paint, but as an intervention (through painting and digital reproduction) into a wider knowledge nexus. If the *Atomists* evokes bodies and actions as 'medial' in a conceptual sense, the works embody, in the broadest sense, a tendency in contemporary practice to operate between media (and between all kinds of semiotic codes). The old descriptors of 'mixed media' and 'appropriation' are inadequate in the characterisation of such practice, which is more readily captured by the concept of 'intermedia' – a term which implies more than the internal differentiation or mixing of media that occurs within art itself. Realised as the intersection of different practices, technologies, languages and sign systems, intermediality posits a broad transdisciplinary sphere of operation, open to – but not restricted to – interventions in aesthetic form.

Intermediality, then, is not just an issue of medium; nor can it be confined to semiotic or iconographic operations. One of Orozco's *Atomists*, with the title *Ascention*, plays on an iconographic correspondence, relating a photograph of a rugby union line-out (a formation in which players are held aloft by team members) to the image of Christ's ascension into heaven. The joke arising from transposition is a familiar trope of contemporary art. British artist Simon Patterson (best known for his revision of the London Underground map, which he populates with the names of famous people) also conflates football and religion in a wall-drawing of 1990 snappily titled *The Last Supper Arranged According to the Sweeper Formation (Jesus Christ in Goal)*. Such work clearly plays on the significance attached to the organisational schema. The *Atomists*, however, are concerned less with significations or the associations of particular sign systems than with the staging of

intermedial relationships, and thus with the creation of an intermedial aesthetic *per se*.

The possibility of an intermedial aesthetic remains a blind-spot for art history, which misses the concept when it reduces the image of the athletes in action to the 'subject matter' of the painter, or when it confines formal analysis to the identification of an artistic lineage. Paradoxically, however, the *Atomists* provide more than ample scope for an art-historical criticism of this nature. Benjamin Buchloh locates the *Atomists* in relation to a rich history of art focused on kinetic movement and the representation of athletic skill, citing orphism, futurism, constructivism and the early-modern fascination with athletic performance.[5] Buchloh's account is exemplary and informative art history, well attuned to Orozco's manifest interest in the historical avant garde, but it confines the issue of intermedia to the parameters of fine arts (specifically to the interrelationship of sculpture–painting–photography), leaving aside the question of how the *Atomists* configure art media within a contemporary cultural formation. Yet amid the layering of art histories, the *Atomists* register a relationship between quite diverse practices and technologies, orchestrating a biomechanics in painting around sport and print media. The geometric grids painted onto the sporting scenes seem to float somewhere between the underlying photograph and the surface of the image, itself generated through a process of digital remediation, so that painting is, as it were, suspended within the image itself.

A further medium in play in this dynamic is text: the words subtitling the photograph, about which Buchloh is silent. The journalistic captions no doubt resonate more deeply with the sports fan. A Newcastle United supporter (unlike a regular art historian) would derive particular enjoyment from the framing of 'a helpless Ehiogu and Bosnich' or 'the close attention of Calderwood' in a

manner informed by – though not reducible to – their earlier viewing of the game, or reading of the sports pages. But the issue here is not whether the art historian's reading should prevail over the popular-cultural reading; notwithstanding one's orientation towards either art or football, the inclusion of a caption locates the aesthetic operation not just with one supervening discourse but somewhere within the triangulation of painting, sporting image and text. Asprilla presents movements, gestures and affects combining in the event of the overhead kick. The caption keys us to the portrait of 'close attention', much as the word 'concentration' resonates with the image of a snooker player in an *Atomist* captioned 'Griffiths, who now needs spectacles, gives a testing shot complete concentration.' These images are not 'about' attention or concentration, any more than they are about sport; rather, these words, clipped and quoted in such a way as to bracket their discursive or idiomatic status, are linguistic elements in play, bouncing off the segmented visual components (Griffiths' one bespectacled eye; Calderwood's relaxed hand in its circular frame; Bosnich's 'helpless' startled face watching the ball head into the goal).

The wit of the *Atomists* derives in part from the extent to which the serviceable text of the sub-editor is drawn into an interactive poetics with the image above. The segmentation of pictorial elements in the frozen tableau has the effect of amplifying certain descriptors in the text, so that captions, economically penned to capture the action in its entirety, give rise to abstractions: conceptualisations of elusive actions or expressions such as 'failing to connect' and 'ghosting in'.

Words, then, are operative elements in the generation of a conception of movement, dynamism and interaction, though it is the medial rather than signifying function of signs that is highlighted. The *Atomists* do not decontextualise signs; rather,

elements or details of the image are transformed as they are framed within – and in relationship to – media. In other words, the *Atomists* do not complete an intersemiotic translation – a movement from one sign system to another, such that signs are now open to a reading within another organised structure (the protagonists of the *Last Supper*, turned footballers, in the 'sweeper' formation). Instead, movements, gestures and words are, in the terminology of Agamben, 'suspended in and by their own mediality'.[6]

The exploration of mediality in this sense implies more than – the opposite of – a focus on medium or mediation, since it reveals the condition of being-in-a-medium, or of inhabiting actions that are generally viewed as a means, like the (literally) goal-directed activity of a football match. For Agamben (as for Orozco), gesture constitutes the exhibition of a mediality. It is neither the means of addressing an end, nor an end in itself (a purely aesthetic form) but 'the process of making a means visible'.[7] Hence, Asprilla's attempt at the overhead kick is not shown as the means of gaining possession of the ball, and is set against, rather than transformed into, an abstract pattern. Through the convergence of the gridded molecular patterns, action photograph and caption, the action of and around the kick is presented as a matrix of gesture, expression and affect. The effect of such a capture is to refigure the sign to reveal, in the first order, its medial dynamics, and the media character of corporeal movements, rather than its signifying or instrumental function. It is to ask, in Agamben's formulation, not what is being produced or acted but 'in what way is an action endured and supported?'[8] It is in this particular sense that I invoke the term (inter)mediality to describe not just the literal intersection of media but the enquiry focused on – and conducted through – medial relationships or mediality itself.

Operating at the intersection of different discourses, practices and aesthetics, these images constitute an intermedial space through which new ways of seeing and new terms for analysis can emerge. In this regard, the *Atomists* are emblematic of a mode of contemporary art practice that, by its very interdisciplinary constitution, sits within a visual cultural paradigm. That is to say, the work's theoretical counterpart may be understood as an art theory that formulates itself within the expanded field of cultural studies.

However, in spite of the emergence of visual culture studies as a multifarious practice, operating beyond the boundaries of art history, leading voices allied with both visual culture (Mieke Bal) and the broader field of cultural theory (Brian Massumi) argue that cultural studies has missed expression (Massumi) in critical ways, too readily confining itself to a bounded domain of popular culture that effectively excludes art and analysis from its particular modes of operation (Bal).[9] In this sense it does not take up the challenge of describing an intermedial aesthetic as this is embodied in contemporary art practice. Such theorists may be situated in relation to both current trends in practice and a mode of art analysis undertaken in a broader interdisciplinary field, going back to Aby Warburg.

The task of practical aesthetics, as I argued in Chapter 1, is to cut through the diversionary discourse of disciplinary demarcation to the substantive issue of methodology – specifically to reorient aesthetics to an open field. Here I will further examine the elements of a method of intermedial analysis. These elements may be distinguished in terms of three interlocking concepts: 'whole-field analysis', 'co-production' and 'differential', through which a fourth, 'visual thought' may be extended.

Whole-field analysis

The 'whole-field' in effect names the indeterminate sphere of operations that characterises practical aesthetics. The concept of a 'whole-field' operation emerges in Brian Massumi's critique of cultural studies as a defining feature of a practice that cuts across disciplinary boundaries and divisions between 'high' and popular culture.[10] In contrast to the discipline that defines its parameters in terms of a specific group of either objects or subjects, an interdisciplinary cultural studies engages what Massumi calls 'whole-field modulation'. The 'whole-field' in this sense is not a substantive concept that lays claim to a particular terrain, but a description of the potentially unlimited arena of a practice that relinquishes the need to predetermine its object domain.

Nevertheless, Massumi argues, this cultural studies does not exist, except as a potentiality. The reason for this is that cultural studies, in its current institutional formation, has missed two key concepts: process and expression. It clings to the notion that 'expression is of a particularity'; in other words, it treats expression as an attribute or property of a predefined group of persons (a culture, a subculture, a gender, a minority).[11] In doing so, it fails to actualise in its own more radical terms, veering back towards sociology or social-policy studies. Rather than practising intervention within an expanded field, it turns to regulation and reform. On this basis, visual culture studies may be readily aligned to the study of popular culture, and art (and its formal analysis) ceded to art history. Art may be embraced by visual culture studies by virtue of its content, context of production or the cultural identity of its producers. But aesthetics – the dynamics of form – is not prima facie the business of visual culture studies, if and when it exhibits the limitations ascribed by Massumi to cultural studies.

Practical aesthetics, in effect, names the potential of cultural studies to operate *as an aesthetic force* in the broader sphere of culture. It signifies free-ranging aesthetic process with the capacity to adapt to and investigate movements and shifts in the field. The concepts of process and expression to which Massumi alludes are methodologically allied to whole-field modulation inasmuch as they describe the dynamics of cultural forms, insisting on a focus on movement and transition (the behaviour of aesthetic entities) rather than on their classification (the definition and qualification of an object as art or popular culture). Cultural analysis in these terms is the tracing of process lines running through a range of disciplines and practices. No longer circumscribed by classifications of discipline, genre or iconography, the 'line through' is characterised purely by its aesthetic and adaptive (practical) qualities.

Aby Warburg stands as a pioneer of such whole-field analysis, exemplifying the methodological embodiment of the concepts of both visual thought and co-production. Warburg's key work in this regard is *Mnemosyne*, the atlas, compiled between 1924 and 1929.[12] The atlas was, for Warburg, a means of doing art history without words – performing image analysis through montage and recombination. *Mnemosyne* is constituted from the large panels, stretched with black cloth, on which Warburg arranged images from disparate sources: photographs of classical statuary, news clippings, magazine advertisements, maps and amateur snaps, which were then re-photographed. Like Orozco, Warburg finds formal resonances linking certain sporting images to painterly and sculptural compositions (on one panel two images of golfers in mid-swing are juxtaposed with an image of Judith holding the head of Holofernes, as well as several advertising images and classical seals).[13] But *Mnemosyne* is not an artwork, nor even a finished object. Having been subject to continual modification by Warburg, it is best

understood as the embodiment of a method: a means of studying the internal dynamics of imagery, and the ways in which formulas emerged in different contexts and periods in history.

Central to Warburg's method was the idea that pictorial forces were at work across a wide-open field. Thus he insisted that the analysis of art – of aesthetic form in a given medium – could not be undertaken without exceeding the borders of art history; that it must entail a kind of geography of a vast field of visual imagery. The atlas was in this regard 'an instrument of orientation', tracking the emergence of figures at different points in a history of representation and tracing their migration into different cultural domains, areas of knowledge, genres and media.[14]

For Warburg, *Mnemosyne* was a psychological study, rather than one that is art-historical in the pure sense; it might now be routinely classified under the rubric of visual culture studies, but for the fact that its enquiry is closely focused on aesthetic principles. Those who persist in defining visual culture as art history's other, as the study of culture excluded by the 'high art' canon, might find *Mnemosyne* disappointingly orthodox in its disproportionate focus on classicism. Yet its radical nature lies precisely in the fact that it constitutes its domain as the whole field of culture. Thus it cannot be defined through delineation of a group of material objects. It enshrines a practice that is no longer the study of art *per se*, but the study of dynamic principles within imagery.

The precise terms of analysis emerge in the execution as sets of relations cohere around the dynamics of gesture, and affect. These terms arise from the recombination and reframing of pictorial elements, not by virtue of their iconographic significance, but through the dynamics of interaction. Warburg, as Georges Didi-Huberman notes, did not strive to 'create a structure out of iconographic detail':

Instead he would discern suddenly a formal line of tension, a sort of symmetry in movement line, sinuous or broken with the alternately slackening or coiling body. Dancing or explosive, yet ever present in the very crux of the gestural chaos distributed by each part of its ungraspable geometry.[15]

His method entailed the identification of 'formal pivots' (in Didi-Huberman's term) – the hinges around which the internal dynamics of an image are organised. Orozco's *Atomists* work in similar fashion; geometry, introduced as a distinctive and separate semiotic code, is not a 'graspable' totalising schema, but a visual method for identifying pivots. If the *Atomists* transform the sports image into a study of gesture and expression, then expression and gesture are not merely semantic or iconographic categories, nor individual properties, but revealed as formal components in a pictorial dynamic. This dynamic has both a critical and cultural

Fig. 4.4
Aby Warburg, Picture Atlas
Mnemosyne, 1924–29,
panel 43.

dimension insofar as gesture is understood as exposing action as it is inhabited in a given site. For the same reason, Agamben notes that *Mnemosyne* was 'historical' precisely through its capacity for transforming the image: because of the fact that this research was conducted through the medium of images, it was believed that the image was also its object. Warburg instead transformed the image into a decisively historical and dynamic element.[16]

Hence *Mnemosyne* is in part a study of the elements of portraiture as they emerge at a particular historical or cultural juncture. One panel of the atlas features a fifteenth-century Florentine altarpiece by Domenico Ghirlandaio, from which the figures of the patron Franceso Sassetti and his circle are clipped and included as separate details (Fig. 4.4). This extraction has the effect of highlighting the entry of the contemporary portrait into the religious scene, and the means by which figures are characterised and rendered expressive. 'Attentiveness' becomes a focus in its own right as a feature of the supplicant figures. Like some of Orozco's *Atomists* that highlight the expression – or what Silvan Tomkins classifies as the affect[17] – of interest (concentration, attention), this reframing of elements from a larger pictorial structure functions to suspend gesture (and its dimensions of expression and movement) within the context of the medium. This is the mode of analysis that Agamben identifies as operating through the reduction of works to the sphere of gesture, a sphere which lies 'beyond interpretation'; in other words, a level of analysis that cuts across signification or iconographic meaning, while at the same time tracing the emergence of cultural forms, the dynamics of which are constituted within the image.[18]

That a contemporary artist like Orozco would turn his attention to the sports photograph is not surprising in an era where the technical imagining of the athlete in motion has become so advanced as to constitute a mode of portraiture within the event.

Interactive television now allows us to select a point-of-view on a football match, or a player on which to focus, and replays in super-slow-mo to reveal the muscle contractions generating specific movements. In 2006 video artists Philippe Parreno and Douglas Gordon premiered *Zidane: A Twenty-First Century Portrait* at Cannes, announced as 'a portrait on film, in action and in real time, of one of the greatest players in the history of soccer, Zinedine Zidane'. Filmed with 17 synchronised cameras, each focusing (almost exclusively) on Zidane throughout the entire course of a Spanish premier-league match, the film is presented as 'a unique endeavour midway between the work of a portrait artist and a high action movie for a broad viewing public'.[19] The elements of a portrait (gesture, expression, affect) are, in other words, found within the very space of the event (the stadium in the real-time of a game), more specifically within the media event, bracketed as a study in concentration and movement.

For the full 90 minutes of the game the cameras follow the trajectory of the body in motion, breaking into details: the soles of Zidane's feet crunching the grass, his relaxed arm and straight back as he runs, his attentive eyes, his smile. Zidane watches the game incessantly as the viewer watches him. As critics have noted, by means of this intense focus on a single player, the film offers a study of a 'man at work', an *ouvrier*.[20] Work, however, is described through interaction and response, registered in movement, gesture, affect and expression. The absence of the whole narrative and whole-game perspective transforms Zidane into the image of the hyper-responsive figure. Every action – from intense concentration and scrutiny to explosive intervention – is keyed to the game, and to largely off-screen action.

The exclusive focus on the single player functions as a constraint, which in turn dictates a pace and rhythm determined by Zidane

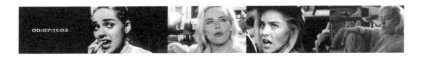

Fig. 4.5 Candice Breitz, stills from *Soliloquy (Sharon)*, 1992–2000.

himself as he moves through phases of relaxed concentration, coiled energy and explosive bursts of activity, and occasionally of emotion. If (as Agamben suggests) gesture registers a tension or dialectic between the solitary and the communicative,[21] such that it expresses precisely the experience of 'being in' an interaction – rather than simply the articulated communication – then Zidane is poised exactly at this interface. Rather than constructing an external (or completely internal) perspective onto the spectacle of the game, or presenting movement and expression as a means to an end, it simply follows the single strand weaving through a game, registering various points of connection and contact along the way.

A similar logic, and effect, is pursued even more starkly by South African-born video artist Candice Breitz, in whose *Soliloquy Trilogy* (1992–2000) (Fig. 4.5), protagonists of three well-known Hollywood movies are cut away from the scenes that make the narrative legible. Dropping in a monochrome black screen (the digital filmic version of the atlas panel screens), Breitz recompiles clips of these characters speaking, though now without evidence of others present in conversations, with the effect that every word, sound and gesture acquires a prominence and intensity. With no context to absorb or make sense of a (corporeal or verbal) gesture, the soliloquy intensifies into a spiralling word flow. As Marcella Baccaria has noted, language loses not just its external context but its 'transcendental angst and inner necessity', taking on an almost psychotic quality as it degenerates into solipsistic babble.[22] No

longer psychological, spoken language becomes (as Beccaria puts it) 'solidified matter' (much as the captions of the *Atomists* acquire a material dimension). Speech runs on relentlessly, unable to flow through the normal communication channels that articulate it into conversation and feedback. It registers as pure intensity: affect characterised by urgency and lack of attachment, disarticulated from motives or drives. In this sense its performance is literally captured in its own mediality.

Overtly, *Zidane* is a study of the dynamics of movement and gesture, though in this instance – as in *Mnemosyne* – gesture is conceived less as subject matter than as method. As has been widely reported, on the morning of the shoot/match Gordon and Parreno took their film crew (whose combined experience ranged from Martin Scorsese films to National Football League events) to the Prado to look at the portraits of Goya and Velazquez. If these were to serve as models for the creation of the portrait of the twenty-first century, it is not in the manner of direct reference but in the mode of visual thought, which Bal characterises in a book that identifies this form of transhistorical relationship.[23] Put another way, they served as a way of identifying – seeing, understanding, modulating – the gestural components of a portrait, conceived in terms of its emergence in the modern arena, forged from a conflation of representational codes, and designed and executed by the subject in collusion with the film-makers.

Co-production

At the heart of this intermedial constitution of a portrait, as in Warburg's study of the Renaissance portrait, is a conception of co-production, operating at a number of levels: between artist

and subject (both with a particular relationship to the medium); between artist and art theorist; between the artwork and the interdisciplinary knowledge nexus in which it is created. This notion describes, but is not reducible to, intersubjective relations, but it emerges from the very logic of cultural studies, conceived as true interdisciplinarity. Hence Bal concludes her methodological argument in these terms:

> Neither the boundary between 'high' and 'popular' culture can be maintained, nor that between visual production and its study. If the object co-performs the analysis...then creating and policing boundaries of any sort seems the most futile of all futilities that academic work can engage in.[24]

In the absence of a consensus about what constitutes the object domain of visual culture, we are, Bal infers, in the realm of the interdisciplinary. The error, then, is 'to persist in [the separatist project of] defining'. The challenge is to negotiate the apparently contradictory demands of a field that cannot be defined in terms of a unified object domain but at the same time derives its ideas, methods and concepts from its objects. If the aesthetic can no longer be located through the classification of an object domain, it must be traced through the distinctive operations of images inhabiting the interdisciplinary field. Its object is, to borrow Philippe-Alain Michaud's description of Warburg's proposition, the 'image in motion'.[25]

Co-performance, in Bal's sense, can be conceived as the co-production of an object of study. As Bal reminds us, Roland Barthes distinguished interdisciplinary practice from multidisciplinarity on the basis that it is no longer a question of lots of people from different disciplinary perspectives looking at the same objects, but rather the creation of a new object.[26] The object that emerges from the interdisciplinary nexus is, of course, not simply a material

object but a conceptual one: an object of knowledge that comes into being through the enmeshed practice of philosophy, art, literature, cultural studies, anthropology and so on. This is the hybrid object described by Bruno Latour as calling for a new methodology in the philosophy of knowledge.[27]

Interdisciplinarity is, for Latour, axiomatic since knowledge can no longer be considered the product of a pure science. Typically, he argues, a newspaper article on the ozone layer will feature the voices and concepts of industrialists, chemists, politicians, ecologists, perhaps not fully commensurable but somehow caught up in the same story, linked by a single thread. Newspapers are full of 'hybrid articles that sketch out imbroglios of science, politics, economy, law, religion, technology, fiction',[28] churning up all of culture and all of nature so that even the most fundamental distinctions in the philosophy of knowledge (like nature–culture) are compromised. If ideas come from amalgams, philosophers must attend to the crossings and meetings between disciplines or languages, and to the way that a knowledge matrix works. This, Latour argues, is best understood in terms of a network: 'more supple than the notion of a system, more historical than the notion of structure, more empirical than the notion of complexity, the idea of network is the Ariadne's thread of these interwoven stories.'[29] Since discussions of scientific phenomena can no longer be assimilated in specific disciplines, the analytic methods of a single discipline are inadequate in isolation; the philosopher must follow the imbroglios wherever they lead, shuttling back and forth within a network of ideas.

The 'object' of knowledge in this sense is not the pre-given object of the discipline of philosophy of science, since it is necessarily the emergent or 'becoming' object of interdisciplinary production: the amalgam, hybrid, or Bal's 'travelling concept',[30] made up of the threads of distinct practices and modes of

understanding, which can only be expressed in terms of their connectivity or symbiosis. These interweaving threads may be distinguished as differently behaving components of an amalgam but not as separable disciplinary perspectives on an object. Thus visual thought (a particular behaviour) is an extension of aisthesis or aesthetic perception, actualising an object in a particular way in a given frame. It articulates symbiosis in its full aesthetic dimension, which (as in Farocki's data aesthetics or Orozco's portraits) allows a gesture or detail to surface.

Differential

> One process line cannot judge another. Process lines can interfere with each other. They can modulate each other. They can capture each other's effects and convert them into more of their own. But they cannot judge each other because they are immersed in the empirical field, not 'reflections' of it.[31]
>
> Brian Massumi, *Parables for the Virtual: Movement, affect, sensation*

The intersection of art and other discourse may be conceived as a production born of the slippages that occur when different practices encounter one another and start to 'speak' from the same field of operation. The field, constituted through intermedial relationships, is contingent and unnamed; it is the space of the differential. The term differential has a currency in media studies, where it describes (in Andrew Murphie's definition) 'cultures and technologies that are based upon the in-between, that is, difference in itself'.[32] Difference in this sense is a constitutive force functioning to create intermedial environments in a context where media are no longer bound forms (film, television) or genres (television drama, news or sports coverage), but constantly differentiate themselves.[33]

Agamben tellingly refers to Warburg's project as the 'discipline that exists but has no name'.[34] This 'nameless science' was variously described by Warburg in terms that convey the sweep of cultural studies: a 'history of the psyche', a 'history of culture'; and in more precise methodological or processual terms as an 'iconology of the intervals', evoking not so much an object of study as the relational space between that comes into being in the collage of the atlas, and the means by which the object of knowledge is created.

Mnemosyne is itself an active production instantiating an intermedial or transdisciplinary arena. As Michaud emphasises, it does not limit itself to describing the migrations of images through the history of representations; it reproduces them. In this sense, it is based on a cinematic mode of thought (the reproductions of paintings and sculpture that comprise *Mnemosyne* are treated as film stills, argues Agamben), one that aims not at articulating means but at producing effects.[35]

This, then, is both a thinking cinematically or thinking visually, and a co-production in which Warburg uses imagery to create a new effect. Warburg is by practice a co-producer, an art historian deriving a conception of history from found images and reproductions. As Kurt Forster first noted, Warburg's sense of the production of art was profoundly collaborative, insofar as he regarded the emergence of secular portraiture not as an artistic phenomenon but as the result of the relationship between artist and patron, and hence as linked to broader cultural shifts.[36] Indeed, Latour's imagery of the network spun from threads (which are traced rather than disentangled by the cultural analyst) finds resonance in Forster's metaphorics when he describes Warburg's own written analysis of Domenico Ghirlandaio's portraits:

Warburg inlays the threads of an essentially pre-photographic, verbal replication of the paintings with the strong yarn of his own concerns. He works them into an interpretation that entangles conflicts […] But he unites the weave and the inlay by transforming the ostensibly self-sufficient, purely aesthetic character of the work of art – as caught in the web of his own enchanting description – into 'something quite different.' And this 'something quite different', which transcends the purely visual substance of the work, is not of the artist's devising, or of the beholder's, but derives solely from the effort of understanding that Warburg demands of his cultural studies. What is quite different is the recognition that works of art are 'documents' that bear a special charge.[37]

Cultural analysis thus engages the 'thought' inherent in aesthetic production. The 'effort of understanding' is itself an aesthetic (rather than interpretive) operation in the first instance, grounded in the double action of the reduction to gesture and the constitution of the interval as a space for the re-emergence and activation of pictorial forces. It is through the interval, conceived as differential, that Warburg generates an understanding of the gesture/image within an historical dynamic. For him, the differential is a space of return, the site at which a latent cultural memory resurfaces in a gestural dynamics. The gesture is itself 'intended as a crystal of historical memory',[38] so that its irruptions, plotted in the differential spaces of the atlas, act as coordinates for the tracing of process lines along a continuum or 'vectors of exchange between heterogeneous spaces and times'.[39] Warburg's 'cultural studies' is, then, the expression of the process line – of an historical and cultural dynamic – as visual thought. This line, characterised by symbiosis, does not, of course, plot the re-emergence of an unchanged form. The concept of gesture as always embodying a differential leads towards the notion of media as an interface, folding out into new relationships.

The redistributed event

Thus gesture (or 'gestural criticism') becomes a means of investigating media itself. Media art opens up such a critical engagement when it promotes looking through, rather than looking at, gesture. The *T_Visionarium* project is archetypical in this regard, furnishing an apparatus for a co-produced criticism (Plate 9). Beyond an analysis of mainstream media dynamics, *T_Visionarium* presents a radically distributed vision of the televisual event, unconstrained by the boundaries of programming. The events of *T_Visionarium*, made up of the components of a television aesthetic, are recombined in ways that reveal the logic and predilections of the medium but that contest the discrete framing of a news, sporting or other event. *T_Visionarium* is a differential structure without predetermined content, an interactive immersive environment that allows viewers to navigate spatially a vast televisual database – and to do this from within the mediascape. Unlike Farocki's engagement with raw media in its pre-production stage, *T_Visionarium* unpacks broadcast media at the point of viewing. Produced by a team of artists, critics and programmers, under the auspices of iCinema, this apparatus functions as an instrument of orientation: an atlas of the digital televisual domain.[40]

T_Visionarium engenders both art and criticism, though resists classification in either category. As a result, viewers and critics may have problems conceptualising their role in the *T_Visionarium* environment. It is certainly 'user-friendly' – spectacular and quite easy to navigate – but the constitution of the virtual atlas is the viewer's prerogative; aesthetic selections must be continually re-made. It is, in essence, a project without an object that forces users to address it as mediality and to think and do co-production.

The second phase of *T_Visionarium*, premiered in 2006, comprises some 300 separate video recordings, viewed on 'windows' (rectangular surfaces) positioned in three-dimensional space. The viewer wanders freely in the darkness of the room, experiencing the spectacle in three dimensions of 300 floating windows, each playing footage recorded from network television. Equipped with a remote control, the viewer may click on any single image to trigger a sort of all 300 windows according to type. Each of the (22,636) segments making up the footage has been tagged according to the degree that it exhibits various kinds of emotion, expressive behaviour, physical behaviour, or spatial and structural characteristics, and also whether it contains male or female characters. The values assigned to each shot are used as the basis for the distribution, along with automatically detected similarities of colour and movement. Thus, if a viewer selects a close-up of a woman speaking on the phone in the bluish light of a television morgue, a flood of images with similar colour values and formal or dynamic properties fly across to the area around the chosen image. The most dissimilar images move to the spaces furthest away – so that all the images facing the viewer will likely be of women and those on the opposite wall of men. Whereas some of the images in the cluster will be of people holding phones, in others the gesture may correspond in a looser way to that of the figure with the telephone (holding a cup to the mouth, for example), or may exhibit only colour or movement similarities. Footage is broken into segments, averaging four seconds long, which loop continually until a further selection is made. The viewer may double-click on a chosen screen to elect to play the footage on that screen in full (for around 30 minutes). When such a selection is made the remaining windows freeze into silent stills, catching the resonant gestures and movements in midstream.

The experience of these images is both visual and auditory and part of the interest emerges from the mismatch or crossover of soundtracks. While words are often emphatic elements, their syntax and dialogic context are rarely, if ever, preserved in these brief clips. Dialogues are transformed into fragmentary monologues, sounds and gestures, stripped of their communicative function. The viewer cannot 'interpret' these gestures, other than in reference to the correlative movements that surround them. *T_Visionarium* is, thus, radically synchronic. Fragments of conversation are re-absorbed immediately into the synchronic arrangement, configured in a variety of new relationships based in shared movements and affects, rather than in the logic of dialogue. This process of recombination tends to mitigate any sense that these are truncated or incomplete actions in need of extension or a response. Seen in this format, corporeal and verbal gestures no longer appear as the tools of interpersonal communication or as properties of the individual, because the overriding impression is one of gestural echo, or of the migration of affect and gesture across the medium.

Again, this effect is crystallised by Breitz. In the companion works *Mother* and *Father*, six Hollywood stars perform motherhood, and a further six fatherhood, in a separate ensemble (Plate 10). Extracted from their respective movies and reassembled twitching and fidgeting against a black backdrop, the actors' incidental gestures of distress, betrayal, self-pity and loss of esteem are transformed from 'meaningful' expressions into displaced symptoms. Julia Roberts's eye-roll, stripped of context, and repeated with a digital twitch, looks hysterical, and when orchestrated with gestural sequences, performed in similar isolation on the other five screens, appears contagious. Breitz's characters do not converse or interact but perform gestures directed outward, towards the viewer; for want of a reverse-shot,

the logic of conversation operates at the level of gestural echo, across a horizontal plane.

In turning this methodology over to the spectator, *T_Visionarium* reveals, simultaneously, how homogenous, yet radically impure and hybrid, television is. *T_Visionarium* combines the full range of free-to-air television screened over an 11-day period in the peak-hour evening slots, within which there is a marked prevalence of drama, principally US crime drama (*Law and Order*, *CSI*, *Cold Case*, *Without a Trace*), along with news and current affairs and the odd feature film. As a mediascape it is marked by the economy of gesture and movement that characterises such drama and news delivery. Headshots and dialogue prevail. There are very few panoramic shots (except in occasional frames from feature films or news footage) or full-body gestures.

There are few silences. Characters seem to talk most of the time, or, failing this, to generate some form of noise (breathing, panting, sighing). An occasional musical score will waft across from one window to another, impressing itself onto the conversation, much as the diegetic sound of *Zidane* (featuring sounds of the game and the stadium) fuses with the soundtrack provided by the band Mogwai. This impure, transient, intermedial space thus seems always to exist already in media – not just in a specific but a general sense. Every mix is already envisaged by the medium.

T_Visionarium is not about television in the same way that *Mnemosyne* is not about art objects – though it uncovers a televisual vocabulary of gesture. Agamben argues that in the early modern period gesture migrated from everyday life into the domain of cinema. Hence, much like Warburg's atlas, early cinema has its centre in gesture and not in the image. Television, ostensibly, has its centre not in the grandiloquent full-body gestures of early silent movies, but in the restrictive close-up (which registers

facial affect and micro gestures), and in the performance of dialogue. Its gestural dimension is reclaimed from dialogue once the medium is reconfigured – through a new technological aesthetics – and made to display its own media character in a changing set of relationships.

Similarly, if the portrait has now migrated to the cinematic domain of sport, where technology reconstitutes it (via Goya, Velazquez and the action movie) through the expansive full-body spectacle, what enables this is the possibility of registering the body within media in its gestural dimension. Hence *Zidane* is not a narrative portrait but a genuinely cinematic – or more accurately intermedial – one.

Transitive verbs: incomplete conversations

The striking feature of Candice Breitz's aesthetic, as well as of *T_ Visionarium* and *Zidane*, is the degree to which the truncating of a conversation or an action focused on another does not register as a loss. Gestural activity without an object is rapidly redistributed across new sets of relations. Orozco's frozen action gestures and expressions are suspended in a way that brackets them from their objects (which are still visible in the larger frame but no longer figured as the end point of activity). They are like transitive verbs that remain incomplete for want of a direct object (a footballer 'attends...'). Zidane, in Gordon and Parreno's film, is often performing in relation to an absent or off-screen focus. Yet in these instances, the whole body in its multiple relationships is the site of expression; as in *Deep Play*, technologies converge to frame each aspect of movement and engagement, so that it becomes gestural rather than communicative or directed towards an end. In a sense,

the portrait – the close-up, registering the detail of expression – is written onto the body of the performing athlete in the intermedial space. Yet it is not configured as a face or an identity. In *Zidane* it is constituted as a continuum, a dynamic trajectory in space and time, subject to interconnection and modes of contact that engage different aspects of the body, at points along the way. The body is fragmented into multiple frames, multiple gestures (as in the *Atomists*); gesture is itself intermedial.

Breitz's movie stars and the athletes of the *Atomists* and *Zidane* should not be reduced to studies of the iconic celebrity forms of the times, and they are certainly not critiques of 'media constructions'. They create a zone between the celebrity 'bio-pic' and a tradition of semiotic media analysis in which technologies can claim the portrait in the form of the image in motion: the full-body performance of concentration, attention, engagement, interaction. Here the corporeal body's media character is neither denied nor presented as its determining feature; it is, however, inhabited. The contemporary portrait, in this sense, can only emerge in the dimension of 'being-in-a-medium'. The portrait is the effect of showing how a body endures an activity, broken into gestural components, which exhibit the interface between body and action. This is not, of course, to argue that the subjectivity of the one who sustains the gesture is at stake; rather that media should be understood through its interfaces, and the slippages that characterise intersections. Gesture, as 'the process of making a means visible' – and as the indication of a body–media dialectic or interface – is the manifestation of slippage.

Gesture is an operative concept: a means of reconceptualising the detail (the image, the decisive moment) in a dynamic, intermedial setting. More generally, it is a means of operating within and out of media, of undertaking practical aesthetics in

a field too expansive to name. As proponents of (visual) cultural studies have demonstrated, to fetishise popular-cultural content, rather than treat it as part of an expressive continuum, is to reduce the field to its most banal constitution. It is to 'miss process' and to miss the forms of expression that characterise the whole field of contemporary culture and intermedia – and that ultimately reveal how media relations operate. I have indicated here that it is a mistake to reduce method to content (as it is to reduce 'event' to content). The 'content' of practical aesthetics is found inside media processes and hence emerges through an active engagement with such processes. Rather than carving up the object domain, we might, then, allow that the media character of a given object is revealed, as it moves, in slippages and interactions. For this reason we need to follow it wherever it leads.

Plate 1 Three hijacked jets on desert Airstrip, Amman, Jordan, 12 September 1970. Still from Johan Grimonprez, *Dial H-I-S-T-O-R-Y*, 1997–2004.

Plate 2 Thomas Demand, *Poll*, 2001.

Plate 3 Zarina Bhimji, *Out of Blue*, 2002.

Plate 4 Shona Illingworth, *The Watch Man*, 2007.

Plate 5 Shona Illingworth, *The Watch Man*, 2007.

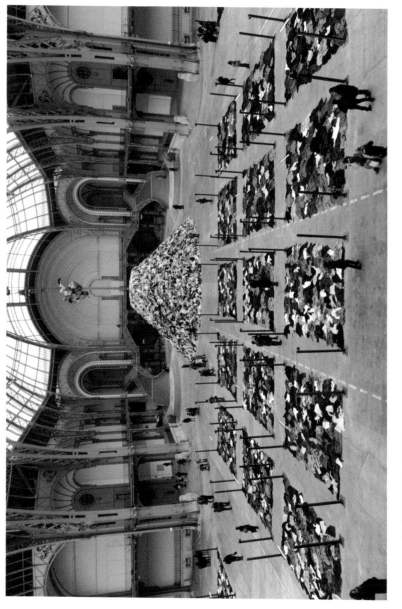

Plate 6 Christian Boltanski, *Personnes*, 2010.

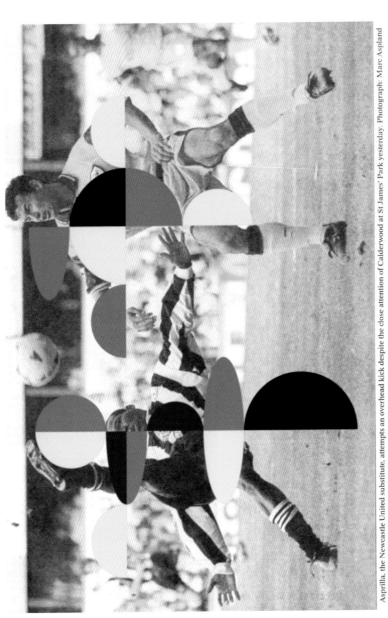

Asprilla, the Newcastle United substitute, attempts an overhead kick despite the close attention of Calderwood at St James' Park yesterday. Photograph: Marc Aspland

Plate 7 Gabriel Orozco, *Atomists: Asprilla*, 1996.

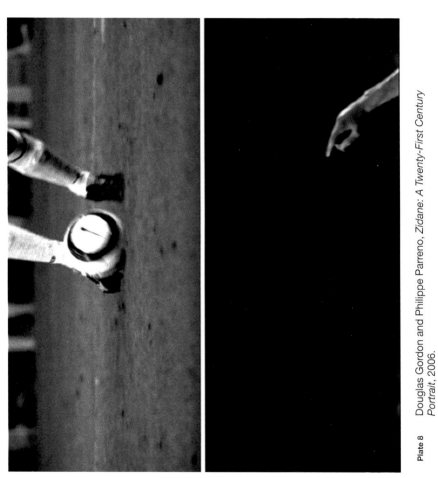

Plate 8 Douglas Gordon and Philippe Parreno, *Zidane: A Twenty-First Century Portrait*, 2006.

Plate 9 iCinema, *T_Visionarium*, 2006.

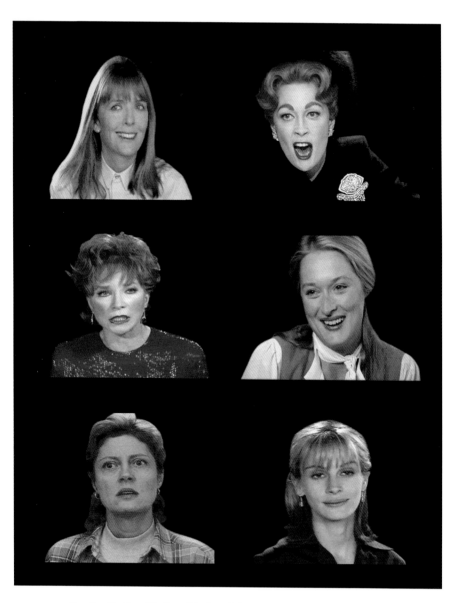

Plate 10 Candice Breitz, stills from *Mother*, 2005.

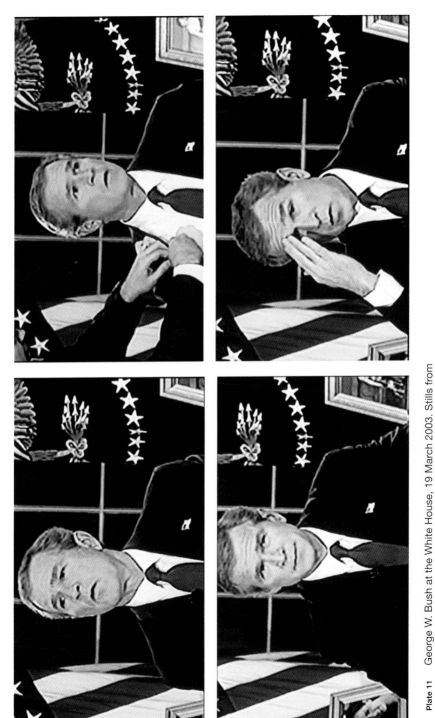

Plate 11 George W. Bush at the White House, 19 March 2003. Stills from Michael Moore, *Fahrenheit 9/11*, 2004.

Plate 12 Pauline Pantsdown encounters Pauline Hanson in Mortdale.

Plate 13 Mark Boulos, *All That is Solid Melts into Air*, 2008.

Plate 14 Susan Norrie (in collaboration with David Mackenzie), *Havoc*, 2007.

Plate 15 Hito Steyerl, *Lovely Andrea*, 2007.

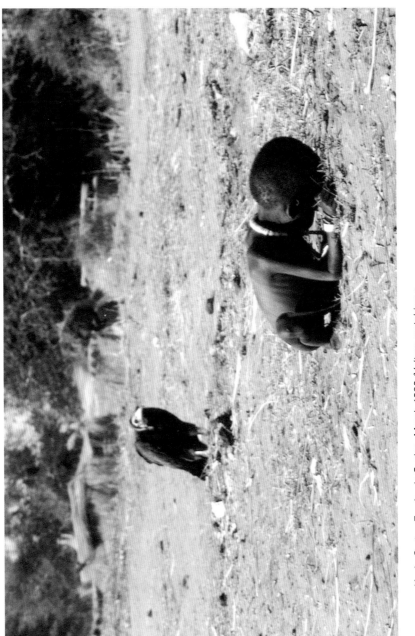

Plate 16 Kevin Carter, *Famine in Sudan, March 1993 (Vulture watching a starving child)*.

5
The Presence
of Politicians

When it happened...

As the 9/11 attack on the World Trade Center unfolded, the US President was engaged in a routine photo opportunity at a Florida elementary school, the scene of which generates an emblematic moment in the film *Fahrenheit 9/11* (2004).[1] A presidential limo pulls into the school; Michael Moore's voiceover speculates that Bush has just been advised of the first attack. He proceeds inside and, as the second plane hits the tower, sits at the front of a class of students. Footage shows the chief-of-staff enter and whisper to the President; this Moore declares to be the moment at which Bush is told that 'the nation' is under attack. To underline the synchrony, the time flashes on screen: 9.05a.m. (Bush gazing past the kids), 9.07a.m. (Bush looking down at a book), 9.09a.m. (looking nervously at aides)...For some seven minutes he does nothing: 'Not knowing what to do, and no Secret Service rushing in to take him to safety, Mr Bush just sat there and continued to read *My Pet Goat* with the children [...].'[2] This image of presidential hesitancy and inaction serves both as broad, politically fulfilling

Fig. 5.1 Michael Moore, *Fahrenheit 9/11*, 2004 (still).

satire and intimate portrait: a portrait of a figurehead inhabiting a shattering historic moment but, more precisely, a portrait of someone inhabiting media (where was the President when the 9/11 attacks took place? He was, literally, *in* media).

If world events are largely mediated through television footage, a key facet of such coverage turns on the presence and recorded reactions of political leaders, both staged and incidental. Media is, of course, adeptly managed by both politicians and its owners; at the same time it is more than ever 'democratised' in the sense that greater numbers of people possess the means not simply to interpret but to produce and repurpose clips, much as Moore does on a grand scale. If the resulting interventions – tactical, aesthetic responses – index major shifts in media culture, they also signal increasing interest at various levels in the aesthetic and affective dimensions of politics.

Television makes affect both visible and palpable. Characteristically reliant on the close-up, it is apt to capture and amplify small signs: micro-gestures and involuntary expressions.

Before the dominance of television, emotion in political speech could be understood largely in the terms of classical rhetoric, since it primarily concerned the accomplished orator's skill of using passion to inspire. The relative autonomy of televisual affect was apparent after the very first televised campaign debate in the USA in 1960, when television audiences polled gave the cooler, more visibly composed Kennedy a resounding win over a perspiring Nixon. Radio listeners (smaller in number) apparently gave Nixon a slight edge.[3]

In more recent times, the evaluation of the election debate has itself become a spectacle. The worm poll (which generates real-time data, graphing fluctuations in viewer approval in the form of a continuous worm-like line) has introduced the possibility of registering spontaneous responses during the debate. Such responses, registered before the speaker's position or argument is fully expounded, equate to 'judgments of feeling', which are often what determine the 'winner' of a debate, regardless of who performs best according to formal rules of logic and argument.[4] But if worm polls track viewer responses to affect-triggers, they do not make these visible in any enduring way. Like the televisual close-up, the worm enables political communication to operate in affective and para-linguistic terms, but much of the substance of this communication – the signs and triggers of positive and negative feeling – pass quickly, registering in subtle or subliminal ways.

If television reveals affect, it does not render its production and effects transparent. This happens only with significant repetition, which occurs to a limited extent through broadcast television but in potentially viral fashion on YouTube or video-sharing websites, where clips and mash-ups of mainstream footage can be cut to draw attention to specific affective dispositions, expressions, gestures or inflections. Through the rise of 'YouTube politics', emotion

in political communication has reached a new peak of visibility. Video-sharing websites exhibit significant volumes of mass-media-produced content, clipped or edited to emphasise the perceived shiftiness of politicians ('Bush caught over 9/11 lie'; 'Clinton lies') or their inappropriate affect ('Hillary Clinton laughs'), as well as unscripted candidate scenes (gaffs caught on camera) and 'citizen-produced alternative political content', where the intent of the posting is to highlight alternative readings of original speech.[5] One of the most effective and notorious examples of the latter is the 'citizen ad' from the 2008 US presidential election, *Vote Different*.[6] A mash-up of the Apple *1984* video advertisement, it substitutes the face and voice of Hillary Clinton for the 1984 'Big Brother' figure, turning Clinton's affectless delivery of a speech espousing 'dialogue' and inclusion into a sinister proposition.

The documentary feature films of Michael Moore (USA) or Adam Curtis (UK) are not, then, unique in probing the affective qualities and motivations of contemporary politics, or in exploiting their audiovisual signs. These two filmmakers do, however, openly attempt to piece together a larger thesis by tracing the flows of affect that connect events across the various registers of media and politics (Moore's *Bowling for Columbine* [2002], a study of fear, uses that particular affect to connect the Columbine massacre and 9/11) and that are embodied in key performers. At the same time, artists such as Candice Breitz have studied the media context of affect and speech in a way that helps us to understand the evolution of political communication – and how media events increasingly now have a continuing *media life*.

Language and performance

In the early 2000s Breitz worked with amateur singers struggling to master songs in a foreign language for two video works. In *Karaoke* (2000) (Fig. 5.2), Tamil, Russian, Spanish and Vietnamese speakers perform the song 'Killing Me Softly' in a New York karaoke bar, their ten performances screened simultaneously on monitors surrounding the viewer. Each singer, striving to embody the words in accented English, interprets the lyrics – 'Killing me softly with his words' – with a conventional range of gestures: the small movements of eyebrows and contractions of facial muscles that serve to express emotion, personalising the song by imbuing the words with feeling. For *Alien*, Breitz worked in Berlin with foreigners who had recently arrived in the city, asking them to learn popular German songs. In the final piece the audio track of

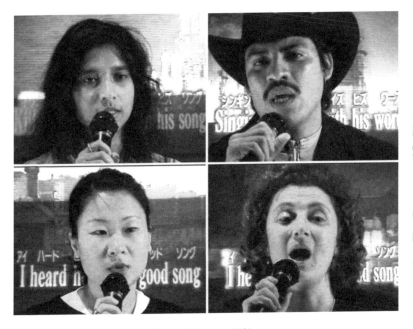

Fig. 5.2 Candice Breitz, stills from *Karaoke*, 2000.

the performances is deleted and replaced with a version by a native German speaker, in a way that is never fully lip-synched, so that again the work dramatises, as Breitz puts it, 'the battle to possess language as opposed to being possessed by language'.[7]

In capturing the process by which a given language and form of linguistic expression is incorporated from an exterior source, Breitz is concerned neither with mastery of language nor with linguistic ineptitude, but with an interaction within language. Her focus on gestural performance, intensified by the ultimate erasure of the singer's own voice in *Alien*, manifests a subject's inner dialogue with this 'received' language, rather than its use as a communicative tool. Breitz's characters are not actors with language at their complete disposal, but are, in the terminology of Giorgio Agamben, 'suspended by and in their own mediality',[8] so that the work essentially makes visible the dynamic of being-in-a-medium.

Such a dynamic is vividly evoked in Mark Crispin Miller's acute description of President Bush tackling a speech:

> His eyes go blank as he consults the Teleprompter in his head, and he chews uneasily at the corner of his mouth, as if to keep his lips in motion for the coming job, much as a batter swings before the pitch. Thus prepared, he then meticulously sounds out every [...] single [...] word, as if asking for assistance in a foreign language.[9]

Crispin Miller's *The Bush Dyslexicon*, from which this account is taken, is one of a number of texts that catalogue not just the infamous malapropisms and linguistic stumbles of George W. Bush, but precisely his struggle with language as this is manifested in face and body. In Bush's case this struggle has a particular televisual presence: micro gestures are immediately registered in the static head-and-shoulders shots that often frame the President – so that as words fail him there is always something to fill the gap.

As Jenny Edbauer has observed,

> The President appears and suddenly something goes wrong. He
> stumbles. He squints. His mouth opens, but the words won't come.
> And when they do come, they are wrong. His body jerks just a little,
> but the camera magnifies the small flinches until they appear larger
> than life.[10]

Sequences of *Fahrenheit 9/11* (Fig. 5.1 and Plate 11) highlight
this plastic transformation of Bush's body in the moments before
and between speech – moments, invariably more compelling than
the speech, which provide good traction for Moore's voiceover.
Betrayed by glances, gestures and less-than-polished performances,
Bush is less a media product than an actor who struggles with
(and hence delivers much that is extraneous to) the media script.
He is a presence in media not because he exploits a capacity to
perform – to blend seamlessly into a media role – but precisely to
the extent that the struggle is palpable.

Like Breitz, Moore reduces on-screen performance to its
gestural elements, affording these an eloquence of their own. If the
potential of gestural performance either to undercut or expand a
script has an obvious satirical value, it further extends into gestic
comedy. The affective presence in such performance also opens up
a new perspective on the relationship of language and emotion in
media. Breitz's work as a whole foregrounds the constraints and
limitations of screen performance, not only in the domain of
Oscar-winning film but in what otherwise might be deemed 'bad
performance'. At the same time, it captures sensations beyond the
script. In media, political speech likewise can become 'bad
performance' through unconvincing delivery or deviation. But
what makes political speech register as sincere?

Sincerity

Although political speech is always subject to judgements of sincerity and credibility, in theoretical terms sincerity is a slippery and somewhat old-fashioned concept. Theories of both the media image (the postmodern 'simulacrum', for example) and performativity have challenged the ontological basis for defining an act or speech-act in terms of a congruence of avowal and actual feeling or belief. Where language is conceived as a tool wielded by a subject who 'does things with words' in J.L. Austin's formulation, there is at least the possibility of being true to oneself in speech.[11] Critical theory undermines this view of language in the service of subjectivity, offering instead variations on the notion of a self brought forth by and through language. Now it is possible to affirm that words 'do things *with us*'; expressions do not always conform to the will of individual agents – nor does belief necessarily precede avowal. As certain theories of performativity have proffered, ideations may themselves be produced through expression, so that we may come to believe something only in the act of avowal.

It is not surprising, then, that the discussion of sincerity has refocused on the semiotics of appearances, not just at an academic but also a popular level. Sincerity is readily understood as an effect of speech or performance, rather than something that is inhabited in any deeper or more ethical sense. What is generally missing in the analysis of such surface effects is, however, a discussion of the experience of speaking belief, of 'doing language' in Toni Morrison's phrase, or indeed of feeling oneself to be doing it.[12]

As Judith Butler points out in her book *Excitable Speech*, doing language is not the same as doing something *with* language.[13] It is not about a speaker creating an effect with language but about

being within language in a certain sense – language, which confers a speaking position upon us; which is given or inherited, but which nevertheless must be interiorised and spoken. This interiorisation or making over of language to the self occurs through what Denise Riley calls the 'ventriloquy of inner speech', which in itself occasions affect, not merely as a component of the drama of the speech act (saying it with feeling) but in and around the reception of language within the speaker, inasmuch as there can be an experience of 'linguistic emotion'.[14] Linguistic emotion in this sense is an immaterial experience that arises out of the process of interaction with – or within – language. This might encompass feelings arising from the struggle to produce language, or the sensation of feeling it run away, of linguistic embarrassment as well as linguistic pleasure.

Riley's idea of language as an inhabited domain filled out with the plenitude of a speaker's emotion disposes of any radical opposition between the notion of language shaping subjective experience, on the one hand, and of language under the control of the subject, on the other. Language is, in her formulation, neither our master nor our instrument, but 'amiably indifferent' to us.[15] Hence it exerts a torsion on us that becomes visible as a struggle in Breitz's work and in the Bush imagery.

Such an approach to language offers the possibility of exploring the affective and political dimensions of sincerity, without reaffirming a hidden interior experience as a substrate – and ethical guarantor – of expression. We might, in this vein, remap the emotional dynamics of sincerity on another axis altogether from the one that indexes avowal to inner belief – and consider instead the relationship of a subject to a speech act and its associated bodily affects and expressions in a way that allows us to see how a sincerity effect might arise not merely from a convincing expression of belief

and feeling, but from the way language is inhabited, and the extent to which this is captured in media.

In visual terms, gesture is a fundamental element of this process – gesture understood not as non-linguistic, but as Agamben puts it as a 'forceful presence in language itself'.[16] As a component of the performance of language, gesture does not simply animate or give emphasis to speech; it is often at odds with the function of communication. In his essay 'Kommerell, or on Gesture', named for the German critic Max Kommerell, Agamben develops a notion of gestic criticism building on Kommerell's description of a 'dialectic of gesture'.[17] This dialectic manifests in the face, which can combine two registers, the solitary and the communicative, engaging in conversation even as 'it seems to tell us the history of solitary moments'.[18] According to Kommerell,

> Even a face that is never witnessed has its mimicry; and it is very much a question as to which gestures leave an imprint on its physical appearance, those through which [a subject] makes himself understood, or, instead, those imposed on him by solitude or inner dialogue.[19]

A more empirical account of this tension emerges in the experimental studies of psychologist Paul Ekman, the well-known expert on lying, who tells us that 'the face is equipped to lie the most and leak the most'[20] because it is not only the vehicle for expression or projection of emotion but also where affect is manifested in a more immediate and direct way. When Ekman observed groups of people watching gory videos, he noted that all subjects – regardless of cultural background – tended to display the same affect; that is, until they became aware of others watching them, at which point they would modulate their expression, and the emotions displayed would differ. Emotion can thus be understood as having a social dimension; it is displayed or projected

feeling. By contrast, what Silvan Tomkins labelled affect is the pre-reflective biological experience of being *affected*: 'affects are primarily facial behaviours and secondly outer skeletal and inner visceral behaviour.'[21] Thus, according to Tomkins and Ekman, affects have generic characteristics or facial signatures. For example, Tomkins describes fear-terror as 'eyes frozen open, pale, cold, sweaty, facial trembling with hair erect'.[22]

Emotion, on this model, is a potent but inherently unreliable component of the linguistic performance of sincerity. Unlike affect, emotion can be faked; it is, by definition, for another. Kommerell's dialectic potentially brings affect and feeling into play in this scenario, by envisaging a sphere of solitary expression which inhabits language as a counterpoint to the outward address. Gesture, he argues, never exists only for the other; 'indeed, only insofar as it also exists for itself can it be compelling for the other'.[23] Hence the capacity to sustain this image of an inner life in tandem with – and often at odds with – external communication may serve to convince us of a person's sincerity. This occurs not through the perfect confluence of words and emotion, but by revealing a struggle with the feeling or experience of something we might call insincerity.

Riley reminds us that language is often felt by its speaker to be incorporated imperfectly, so that even in the moment of truth-telling and transparency we may feel insincere; for Kommerell it is gesture that escapes from us in this way: 'The beginning is a feeling of the "I" that, in every possible gesture, and especially in each of its own gestures, experiences something false, a deformation of the inside with respect to which all faithful presentation seems a curse against the spirit.'[24]

The critical function of media (film, video) arises from the capacity to capture gesture and to reveal this dialectic – a dialectic that effectively presumes an incongruence of inner belief and

external expression – and that is understood as enacted through a 'feeling'. Feeling here is not the complex organisation of affect that we call emotion but precisely the moment of awareness of affect through which the self is experienced – experienced as a deformation of itself.

In this sense, to capture gesture is to capture a face or body sustaining a feeling of insincerity. This feeling does not precede its exhibition in media. It is not a property or characteristic of an individual, revealed by or made the subject of media; it is a function of 'being in a medium'. An artwork or film thus exhibits and exposes gesture in its mediality. To do this is to enact critique in a particular way, scrutinising the body to reveal, not so much what language wilfully covers up or denies, but the point at which language fails – for the gesture, as Agamben argues, is essentially always a gesture of not being able to figure something out in language.[25]

A criticism enacted through a reduction of expression to gesture essentially creates a figure or an image for the condition of 'not being able to figure something out in language', which represents an event or moment within language rather than its breakdown or malfunction. Such critique has particular purchase in the contemporary context, where images of leaders can function effectively by registering a struggle with language, which doesn't always yield readily to the speaker. If the fantasy of linguistic triumph and domination is the televisual presidency of the *West Wing*, the reality is the triumph of Bush, Reagan and the right-wing populist Pauline Hanson in Australia, who have each in different ways capitalised on linguistic ineptitude. They are not successful in spite of their stumbles, malapropisms and misadventures with language, but almost because of them, as Brian Massumi first noted of Reagan.[26]

Insincerity/exposure

Bush, Hanson and other more recent figureheads of the new right understand and exploit the appeal of down-to-earth plain speaking, but there is more at stake here than identification with the home-spun persona, which serves as a housing for a particular form of expression centred in the gesture of not being able to figure something out in language. In the 1990s, Pauline Hanson founded a briefly popular neo-nationalist political party, One Nation, pitching her campaigns in opposition to the slick rhetoric of politicians, which she saw as perpetrating lies. Fuelled by a desire to embody truth in politics, Hanson was undaunted by her incapacity either to speak or comprehend the language of policy, politics and economics, which she sought to combat with the simple fact of her honest conviction – with her sincerity, in other words – and this made her very difficult to subdue with argument. In a now famous interview on the television news programme *60 Minutes* in October 1996, she was accused of xenophobia. Thrown off balance because she didn't understand the word, she blanched and countered with the clipped response, 'Please explain.' This phrase has since entered media-speak if not ordinary language, as a compound noun (news reports might now say 'the government has been issued with a "please explain"...').

Hanson's catchphrase, coined in a moment of linguistic embarrassment – of not understanding – was a forced improvisation, a slightly pained, arch response to someone who had tried to catch her out with fancy words. It was what Agamben refers to as a gag: '[...] a *gag* in the proper meaning of the term, indicating first of all something that could be put in your mouth to hinder speech, as well as in the sense of the actor's improvisation meant to compensate a loss of memory or an inability to speak.'[27]

This gag functioned as an embodied expression within a language game – and its real currency was not as a descriptor but as a gesture. Even when it is used in the media it remains in parentheses because the words have solidified in the voice and body of Hanson.

A large part of the reason for this was the intervention of sound artist Simon Hunt and his drag persona Pauline Pantsdown who stood against Hanson in the 1998 federal election (Plate 12). As a drag act emerging from the context of Sydney gay performance culture, Pantsdown had recorded a song, using cut-and-pastes of Hanson's own voice and the recognisable phrase 'Please explain.' This first recording essentially took the rhetoric of Hanson, the right-wing xenophobe, and in the Weimar cabaret tradition Pantsdown changed the object of the ranting, so that 'Pauline' now became a gay activist.[28] The song *Back Door Man* might have remained within gay subculture and minority radio had Hanson not sought an injunction.

During the race for the senate, Pantsdown released a second recording that had considerable mainstream success – a catchy rap song with a dance beat, titled *I Don't Like It*. Hanson did in fact utter this same phrase when asked her view of Sydney's gay Mardi Gras parade, though Hunt actually created the soundbite through a complex and laborious process, cutting up Hanson's distinctive voice, syllable by syllable, and altering the pitch to create perfectly phrased sequences with appropriate tone, timbre and affect. The lyrics were not purely satirical, but put words into Hanson's mouth:

I don't like it, when you turn my voice about.
I don't like it, when you vote One Nation out.
My language has been murdered, my language has been murdered.
My shopping trolley murdered, my groceries just gone.[29]

This process was effective because, as Hunt observed, Hanson was given to speaking in what appeared to be pre-formed sentences or phrases.[30] Her speech, in a certain sense, already sounded ventriloquised.

This tendency to deliver words in solidified chunks has the effect of reducing their signifying function; Pauline's words didn't readily carry meaning but embodied and performed with their characteristic edge of defiance, resentment and resistance they were effective as 'linguistic gestures'. Their apparent sincerity was not a function of their iteration, nor of the performance of projected emotion, but of what Anna Gibbs, in a formative analysis of the Hanson phenomenon, identified as the presence of competing affects.[31] With this phrase she meant sensations of distress or anxiety that were themselves at large in the voting population.

Pauline Pantsdown was arguably the most tactically efficacious opponent of Hanson in the 1998 election, where the major political parties made the mistake of assuming that the One Nation phenomenon could be stopped with words, and that the fact of Hanson's 'not being able to figure something out in language' would prove self-defeating. In the event, attacks that focused on content – that tripped her up with polysyllabic words or trumped her with facts – were iterations that merely played to her claim to be the disenfranchised voice of the people. Hunt's *modus operandi* was to challenge this claim to authenticity by attaching epithets like 'Please explain' or 'I don't like it' to the body of Hanson in order then to set them loose. Once free they began to plague Hanson on the campaign trail, ringing out in shopping centres.

In the Pauline Pantsdown recording Hanson was confronted with the deformation of self to which Kommerell refers. It induced a form of trans-body linguistic embarrassment. The characteristic of this is, as Riley notes, not a feeling of being exposed, but a

feeling of *wrongful exposure*, in the sense that one is revealed not as one's true self but as a self engaged in mimicry; in other words, as inauthentic. This was the ultimate lie for the politician who believed that her voice was the marker of her sincerity; that it expressed an irreducible truth guaranteed by the depth of her conviction.[32]

Affective politics/exposé

How, then, can we think about 'gestic criticism' through media more generally in these terms? The feeling of 'wrongful exposure' induced in and around Hanson by Hunt is a media event; it is an affective moment sustained by media. Its effect lies in confronting a subject with a feeling of insincerity. This is a particular mode of exposition – an exposé without the conventional grounding in evidence. An exposé that doesn't expose fabrication or a misplaced belief in a politician's sincerity, but that actually induces a feeling.

Moore's documentary strategy is interesting in this regard. As his detractors are quick to point out, he strays readily from the facts, but that could be seen as an issue of methodology, particularly with regard to the 2002 film *Bowling for Columbine*, more radical than *Fahrenheit 9/11* in its deviation from a more empirical approach to political exposé. *Fahrenheit 9/11* pursues evidence, digging up concealed information to discredit the Bush family and so forth; *Bowling for Columbine* searches for ideas, explanations and theories – but more than this, it addresses a politics in which belief is no longer indexed to empirical truth in a simple or demonstrable way.

The primary conceit of *Bowling for Columbine* is the enactment of the incomprehensibility of violence, and the failure of

contemporary America to give account of itself – embodied in the failure of each of its actors to account adequately for excessive levels of gun violence. Moore himself personifies the national befuddlement, setting out on a quest for answers. The image of America congeals around a series of corporeal signs – bodies performing actions which exceed the banal self-descriptions of performers and witnesses: from the Michigan Militia and their calendar girls posing in combat gear, to the hunting dog who shot someone in the leg. These sequences are run against the moments when speech fails the victims or witnesses of violent crime – or when a Colorado home-security consultant starts to expound a theory of how Columbine has changed the way we talk, only to find he can't in fact talk at all about Columbine without choking up.

One segment in particular examines the function of the gag in relation to belief in the contemporary political dispensation. A rapid succession of clips from current-affairs television bulletins announcing a flurry of plagues and threats (Fig. 5.3), spooking the American public in shopping malls, homes and nature, cuts abruptly to the White House press room for a presidential announcement. Bush delivers his lines, slowly and deliberately, with enough lip chewing and blinking to break up the flow of his announcement that the justice department has issued a blanket alert in recognition of a general threat: 'it's not the first time the Justice Department has acted this way. I hope it will be the last, but given the attitude of the evildoers it may not be.' The sequence closes with another abrupt cut to two seconds of a film noir sequence of a woman stalked by an unseen predator, her eyes and then mouth opening wide with what Tomkins would identify as fear-terror.

As Moore highlights, there is no information to impart here. The only effect of the announcement is to induce fear or anxiety

Fig. 5.3 US current-affairs television programmes, stills, Michael Moore, *Bowling for Columbine*, 2002.

– an affect without an object to attach itself to. This is, as Massumi puts it, politics 'addressing bodies from the dispositional angle of their affectivity, instead of addressing subjects from the positional angle of their ideations', so that it is no longer concerned with adherence or belief but with direct activation.[33]

This shift away from an engagement with beliefs or ideations was in some respects pre-empted by Michel de Certeau in *The Practice of Everyday Life*, where he noted that complicity in politics between politicians and voters has displaced belief.[34] Voters now generally acknowledge that the rhetoric of political campaigns is unbelievable, but at the same time they assume that the managers of the political apparatus are moved by convictions and knowledge. The implications of this for the representation of belief are quite tangible; there is no appeal to voters' beliefs, yet there must be a manifestation of believing, at least in a self-contained media domain. De Certeau suggests that what comes into play here are citing mechanisms, since belief is no longer 'expressed in direct convictions, but only through the detour of what others are

thought to believe'.[35] Hence, opinion polls – over and above the content of a politician's rhetoric – convince us of their believability. Slavoj Žižek has made similar arguments to the effect that belief can function at a distance. There has to be some guarantor of it, though the guarantor may be displaced, never present.[36]

The scenario of threat that informed global politics after 9/11 has made the absence of any guarantor of belief much more palpable, particularly as it operates under the sign of the precautionary principle. As Adam Curtis's *The Power of Nightmares* (2004) documents, actions are justified on the basis of an imagined future, and the threat of a force that hasn't yet acted or revealed itself; there can be no empirical basis for this argument since it is hypothetical and the proposed action seeks to prevent the imagined dangers from ever being realised. The 'guarantors' that inform policy through secret security briefings are literally invisible to us. The politicians to whom they speak now themselves embody belief, revealing themselves to be touched by dark truths known only by insiders.

This economy of threat gave rise to a performative sincerity in which politicians appeal not to shared belief but to shared anxiety, grounding this in their own sense of conviction. Hence, in a *Newsnight* interview on BBC television in February 2003 (Fig. 5.4) (part of which appears in *The Power of Nightmares*), the then British Prime Minister Tony Blair gushed,

> [...] dangers are there and I think it's difficult sometimes for people to see how they all come together but it's my honest belief that they do come together and [...] it's my duty to tell it to you if I really believe it and I do really believe it. I may be wrong in believing it but I do believe it.[37]

On the face of it, this kind of impassioned iteration of belief trades on a conventional sincerity – defined by Lionel Trilling (1972)

Fig. 5.4 Tony Blair interview with Jeremy Paxman, *Newsnight*, detail, Adam Curtis, *The Power of Nightmares: The Rise of the Politics of Fear*, 2004.

as an 'English' form of sincerity that turns on duty rather than self-exploration – that is, in practice, readily acknowledged and dismissed by Blair's political opponents, such as then Liberal Democrat leader Charles Kennedy, who described his support for war as 'sincere' but misguided.[38]

If Blair's persuasiveness really rested on belief, it would surely matter that he 'may be wrong'. Such a concession is possible – perhaps even masked – in the face of the overwhelming urgency of affect, which is what is really in play here. Blair is in fact exasperated and under pressure at this point in the interview – and it is his own mounting distress that functions as what affect theorists call an amplifier.[39]

The dynamic in operation here is quite distinct from the kind of self-conscious emotional accenting of a speech that Blair, the orator, employs very well on occasion. It is not performative

in the same sense, nor does it work in terms of a confluence of emotion and semantic expression; rather it proceeds from the divergence or imperfect fusion of affect and speech. Blair isn't distressed about terrorism at this precise moment; he is distressed about not being believed, about his sincerity evaporating into mimicry.

Affect is, according to Deleuzian theorists like Massumi, an intensity embodied in autonomic reactions on the surface of the body as it interacts with other entities; it precedes its expression in words and operates independently. According to Tomkins, affect extends beyond individuals, and does not pursue the same goals as either drives or cognitive systems.[40] In this sense it does not cohere with individual or psychological motives, and so undermines a model of sincerity predicated on correspondence. Yet affect is the essential amplifier of other drives 'because without its amplification nothing else matters and with its amplification anything else can matter'.[41] So while it is characterised by urgency and generality, since it has no fixed relation to an object it can readily attach itself to new objects and words.

Media vectors

The media – as theorists like Gibbs and Massumi have demonstrated – constitutes vectors for the migration of affect, and for new attachments and collisions. This is why Massumi argues that affect modulation is a key factor in the operations of power.[42] It is also why we can no longer think of sincerity as performed and framed by the media – as something that emerges from the regulated, controlled and pre-determined flow of emotion. Affect is potentially in play – in the dialectic of gesture – before words are

delivered and before an emotional narrative is developed and even before what we might call a feeling is sustained.

In this sense, affective presence in language is not a function of dramatic expression or of the speaker's capacity to marshal emotion, and convey words with feeling. It arises from Kommerell's 'linguistic gesture': 'the stratum of language that is not exhausted in communication and that captures language, so to speak, in its solitary moments'.[43]

Hence Edbauer has argued that the disruptions of expectation that characterise Bush's rhetoric cannot be understood in terms of broken lines of meaning.[44] Bush's efficacy, she suggests, is not locatable in the indexical meaning of speech but in moments of affective intensity. His failure, like Blair's distress or Hanson's embarrassment, does not accent the script – as an appropriate expression of sympathy might, for example – but plays off it as a counterpoint.

In the opening credits of *Fahrenheit 9/11* we see members of the Bush administration receiving attention to hair and make-up in what stands for the 9/11 moment (Plate 11 and Fig. 5.1). Bush is the most fidgety and anxious. He appears to be in dialogue with an off-screen presence, but the sequence is cut to emphasise the non-communicative, solitary nature of his gestures. The muted voice of a technician sounds in the foreground, saying 'testing, Oval Office'. Isolated in the mid-ground, stuck behind the desk, Bush bobs up and down in his chair – looking oddly like a ventriloquist's dummy. He tries out a few expressions, in a tentative fashion, and appears self-conscious, aware of his own gesture. The gestural comedy that Kommerell says always threatens to break out of the dialectic of gesture is happening.

What Moore draws our attention to is the voluble activity at the level of gesture that occurs in the gap in speech or the moment

before speech – precisely the element of the Bush spectacle that works most effectively. Bush is not so much 'gone missing', as Moore implies in his subsequent voiceover; regardless of where his mind actually is, the spectacle is one of presence and activity – because gesture is an activity within language; in the words of Agamben, it is 'speechlessness dwelling in language'.[45]

Moore wilfully over-reads the images of Bush in the schoolroom as the nation is attacked, unable to speak or move until someone gives him direction. But as Riley notes, even when speech is literally given to us from outside, it does not enter the body in the manner of an immaculate conception, because the body itself is within language.[46] The ventriloquy of inner speech and the process of incorporation of language is essentially interactive, so what is really at stake is the manifestation or visibility of an interaction. The satirical figure of the puppet-politician animated externally misses the aspect of inner dialogue, which is precisely where affect comes into play.

This interaction, however, must be understood as a function of both being-in-language and being-in-media. The televisual close-ups which frame Bush in this kind of context readily capture gestural dialogue – but also, in the process, a sense of the dislocation of affect – or what Massumi has identified as the 'autonomy of affect'.[47] It is this autonomy and impersonality that deprives affect of the ethical value required to guarantee sincerity; it can only reveal to us the inauthenticity of self. But this is why it is fundamental to a critical strategy in media.

Within such a strategy, the reduction to gesture (already operative in Bush's delivery) must be combined with a geography of affect that traces its movement in separation from individual subjects. This may in fact entail the recontextualisation of imagery that many people find problematic in Moore's work, insofar as he

substitutes intermedial resonance for the kind of causal argument that is conventionally expected of a political documentary that makes diagnostic claims. In Breitz's work, as we have seen, the steps involved in reducing work to gesture – and also tracing its migration across different media registers or film clips – are explicitly demonstrated. In her *Soliloquy Trilogy*, the spoken word, detached from its motivating dialogue registers simply as affect, characterised and propelled by its own intensity. In *Mother* and *Father*, Breitz's character ensemble recalls the medieval *sacra conversazione* in which holy figures don't so much converse or interact as perform gestures directed toward the viewer; the logic of conversation operates at the level of gestural echo. The repetition of a gesture, of a specific movement or utterance, works to highlight its mediality and reduce its signifying capability; in this recombination and proliferation the geography unfolds as we see the migration of gesture and associated affect across screens. Hunt achieves a similar effect with his sound collage of Hanson's voice, which crescendos with the repetition of the phrase 'Please explain', as if Hanson herself is the symptom.

Bowling for Columbine, led by its political agenda, is concerned with the movement and intensification of affect through media, which in turn coheres around corporeal signs and expressions. As in Breitz's work, the reiterative nature of recut sequences of current-affairs bulletins produces a discomforting intensification of affect. Fear is amplified and perpetuated by its own feedback loop, to the point where its objects are comically inadequate to its intensity and force.

On one level, of course, Moore's pastiche is a send-up of the over-excited pitch of current-affairs television – but while the tone of such media presentations can always be questioned, it is notoriously difficult to attack them on the facts, since there will

always be dangerous escalators, people and predators. As Žižek wrote of the implied racism in the reportage of the Hurricane Katrina aftermath, the problem is not that reportage is untrue, it is rather that the motives that make people say things like 'black men are looting our shops' are false.[48] Thus we are dealing with 'lying in the guise of truth'. Moore makes effectively this same point, frustrated with the media focus on the violent aspects of South Central Los Angeles, and with the propensity for fear falsely to attach itself to proximate objects. It matters not if the reports of deadly escalators, spiked candy and Africanised killer bees are true, or whether scenes of black men arrested on the reality show *Cops* really happened, because the underlying fear is untrue; it's a pathological ideological condition, in Žižek's terms, insofar as social antagonisms are projected onto a black male figure or its equivalent in the bee world.

To expose the insincerity – as opposed to the hyperbole or exaggeration – of the endless stories of black violence, the threat of terror and disaffected teens, therefore, requires some disarticulation of affect and expression. But Moore is unable to effect this in interview or by uncovering the motives of specific actors (he interviews the director of *Cops*, who turns out to be liberal, for example). There *are* no lies, cover-ups or bad intentions to expose; there is no underlying insincerity in this sense. And arguably, exposing false intention is not a good strategy in documentary film unless you have an Enron-scale conspiracy. As a film strategy it is un-aesthetic, liable to be entirely narrative-based, and often bogged down in detail. This is the reason that the story of the Bush family in *Fahrenheit 9/11* is relatively boring as film, however satisfying politically. It's factual; you need only see it once.

Bowling for Columbine is more aesthetic, more exhilarating for the fact that it runs its critique at the level of medium or mediality

itself; that is to say it focuses on the way that affect is propelled and regenerated through media – on the process of affect contagion itself. Moreover, it derives criticism from a comedy of gesture, a sphere which Agamben argues is beyond psychology and, in a certain sense, beyond interpretation.[49] Criticism in this domain cannot amount to readings of underlying motive; it can only function by and through the reduction of work – of speech and expression – to its gestural components. This takes us not to the level of drives and motives – or to the drama of emotion – but to the level of affect, revealing the free-ranging movement of affect (in media and across bodies) and its incongruent attachment to and irruption in the self.

By converting iterations into symptoms – as gestural or linguistic performances characterised by repetition rather than signification, *Bowling for Columbine* traces not just moments of anxiety but the larger migratory forces that propel its movement through media and culture. The frenzied proliferation of images in the 'fear sequence' carries a force to the degree that it mimics the behaviour of affect itself, amplifying narratives and precipitating an ongoing quest for objects. Such a quest is explained by Tomkins (and, in turn, by Gibbs and Angel) as a function of objectless fear:

> Objectless fear is a prime source of more fear of fear because the lack of an identifiable frightening object characteristically prompts an accelerated quest for the unknown source. The longer that source cannot be identified, the greater the probability that fear will be repeated and so provide a trigger which is no more likely to be identified than was the original source. In this case one becomes more afraid just because there is now fear of fear and because one doesn't know what one has feared, has tried too hard and too fast to discover the unknown source. Such speeded attempts become additional sources of free-floating fear.[50]

The migration of fear is traced through the Columbine saga, which produces its phobic object (Marilyn Manson) and then, via enhanced school surveillance regimes, a panoply of danger signs, all of the order of kids with baggy pants or wild hairstyles. None of these signs are themselves the triggers for fear; they can only be understood as effects of fear already at large. What is exposed here is the mimetic contagion that characterises the speeded attempts to find the source of fear – fear's insincerity, in fact.

Incongruence

Fear, like xenophobia, has in recent times produced its own politics of sincerity. As columnist Zev Chafets wrote in relation to the Iraq war, 'war calls for sincerity – or at least the appearance of it'.[51] It is thus notoriously difficult to oppose with cynicism. This is no doubt because the purity of motive that is implied in sincerity transcends the political. Hence Pauline Hanson grounds her ethics in an appeal to something outside political discourse. Similarly, with the 'War on Terror', support was marshalled on ethical rather than political grounds – and the anti-war position gained momentum once it could be wrested from politicians with political motives and grounded in the conviction of the military mothers – an extra political expression of opposition from deeply felt experience.

This is where *Fahrenheit 9/11* plays out according to a more conventional narrative, defeating those who play for political and economic advantage with the sympathetic and apolitical figure of Lila Lipscomb – the grieving military mother who at the end of the film goes to Washington. It is, in this sense, a character study: duplicitous self-interested politicians counterposed with authentic

experience and the voice of those with kids on the front line. *Fahrenheit 9/11* is about the politics of war in which a narrative is already in play. *Bowling for Columbine* is about the politics of fear – about affect itself and its transmission and magnification in media. There, sincerity (as the confluence of avowal and belief or feeling) is no basis for critique, for the same reason that it transcends or simply sidesteps politics; it is neutral with regard to content – Pauline Hanson was sincere but xenophobic, and some argued Tony Blair was sincere but wrong. More than this, the expression of belief and of emotion in congruence with speech is an effect of performance. It is learned behaviour, and so can be genuine or can be simulated.

The problem with sincerity is not that emotion/conviction is fake-able, but that the truth or falsity of it cannot be revealed in media. To overcome this problem we need an expanded conception of language, combined with an understanding of the way language is enacted in media. By shifting emphasis from the congruence of emotion/belief/avowal to the autonomy of affect, I am not simply arguing that primary affect is a more valid guarantor of truth. Affect operates according to a different economy; 'the skin is faster than the word', as Massumi[52] says – and it is this that creates the conditions of possibility for a dialectic of gesture: a relational analysis of being-in-language, rather than a moral evaluation of a performance.

The autonomy of affect is readily captured in media, eased by the fact that, according to Tomkins, its primary site is the face. Hence Tomkins argues that the self is located in the face not language.[53] This does not, of course, imply that we should look for the truth of the subject in the face. As Agamben argues, criticism that focuses on the sphere of the gestic goes beyond psychology and beyond interpretation. We are not, then, concerned with reading meaning

into gesture, which is ultimately futile; as Riley notes, good liars and good truth tellers are one and the same.[54]

But there is a sense in which the self can be exposed in media; if not as sincere, as insincere, in the moment of encountering itself in gesture, of experiencing its own incongruence. As Kommerell saw, and Michael Moore, Pauline Pantsdown and Candice Breitz each in different ways realised, the 'disjunction between appearance and essence' that emerges in this encounter 'lies at the basis of both the sublime and the comical'.[55]

To capture in media a feeling, affect or linguistic emotion may be sublime: a source of comedy and pleasure. But linguistic emotion is in this sense a dialogic experience. 'Gestic' criticism registers but also induces affect or emotion. As much as this is perceived in an interaction it is experienced as part of the critical pleasure of practical intervention.

6
Unimaginable Events and Distant Disasters

Hindsight can sometimes see the past clearly – with 20/20 vision. But the path of what happened is so brightly lit that it places everything else more deeply into shadow […] As time passes, more documents become available, and the bare facts of what happened become still clearer. Yet the picture of how those things happened becomes harder to reimagine, as that past world, with its preoccupations and uncertainty, recedes and the remaining memories of it become colored by what happened.[1]

The 9/11 Commission Report

Description

The event of *The 9/11 Commission Report* is a moment in time: 'a pure pleonasm in between a before and an after', to use Marc Augé's words.[2] The imaginability of the event is a function of where we are in time, imagination being conceived as the capacity for foresight and hindsight: an all-or-nothing state of knowing, dependent on whether we are placed before or after the event.[3] The event is thus an empirical fact that reveals itself for what it is, even as its causes

remain indeterminate; hence, it is incontrovertibly known in the present even as it poses problems for historical imagination.

Reconstructing the period before 11 September, the *Report* paints a picture of blindness – not so much on the part of agents of change who might have opened their eyes, thought harder, but as a lived reality of earlier times, a phenomenological condition. The oddly compelling narrative details an imperceptible reality, comprised of discrete, visible, observed movements: unmodulated, affectless and apparently unmotivated actions, linked by a single invisible thread. Passing along the surface of these facts-of-the-event, which find no traction in perception, the chronicle evokes a paralysis of vision – a disconnect between the seeable, observable detail and the perception of the whole – to drive home the rhetorical point: the event, before it occurred, could not have been envisaged, thought, imagined, or comprehended, let alone prevented.

Banal actions are thereby figured as simultaneously momentous and meaningless, devoid of what film theorists (after Alois Riegl) have termed 'haptic' purchase: the surface modulation that renders things graspable.[4] The chronicle serves to preserve them in this zone of imperceptibility, which in turn generates melancholic recognition. Such an effect finds more poetic development in Gabriel Garcia Marquez's novel *Chronicle of a Death Foretold*, a reconstruction of a murder that might have been pre-empted, foreseen, averted at any point, but that proceeded with a certain inevitability by virtue of the failure of any witness to see, imagine, act precipitously. In common with the *Report*, Marquez's reconstruction (actually an elaboration on an earlier deficient investigation with comparable 'dime store titles') traces the paths of agents and observers in the immediate time before the event, ensuring that it fails, on its own empirical grounds, definitively to resolve issues of guilt and complicity. In both chronicles sequences

of movements are established (Mohammed Atta took a flight here, a vacation there, spent a night in this place; this or that character passed through a doorway at this particular time), but demonstrating that one thing led to another serves only to illustrate that 'the event is not what occurs' (as Deleuze puts it).[5] Scrutinising these details and their separate paths does not yield forensic enlightenment so much as a sense that we are still not seeing the event, which just is not there in the bare matter. The event is somewhere inside what occurs, in its concatenation – in the forces (visible or otherwise) that link components.

Description itself can be the problem (as Rancière argues of the realist novel), depriving action of its power and intelligibility.[6] However well observed and recorded, each action of the chronicle of the (un)foretold event remains obdurate, intransitive – an unjoined dot. What emerges is a pure empirical but imperceptible connectivity – stultifying in its flat inevitability, and devoid of intensity (affective, conceptual, moral, political). Description serves only to induce an 'inertia of the visible that comes to paralyse action', a pathos of melancholic recognition that, like the traumatic moment, is 'arresting'.[7] How, then, does art and exhibition practice invigorate – activate, in political terms – this aesthetic dead zone by literally orchestrating movement between and around discrete entities?

The event in an art exhibition

Exhibition space – as discussed in Chapter 2 – is material in this regard. If exhibitions generate dynamics that connect discrete events and event-worlds as these are evoked in artworks, they do so by virtue of animating connections within a material space,

plotting the coordinates of a more expansive geography onto localised experience. Mark Boulos attempts something similar in a single work exhibited in 2008 in the Sydney Biennale and at the Stedelijk Museum in Amsterdam. *All That is Solid Melts into Air* (2008) (Plate 13) comprises two films, around fifteen minutes long, shown on opposite walls, their editing synchronised to create a dialogue between ritualistic actions in two locations. One follows a militant guerrilla group in the oilfields of the Niger Delta, the other the actions of futures traders on the Chicago Mercantile Exchange. As the title (quoting *The Communist Manifesto*) suggests, this work is an allegory of commodity fetishism, linking the speculative arena of the futures market to a part of the world where the commodity traded – in this case petroleum – has material existence. The artwork embodies what the anthropologist Anna Tsing calls 'patchwork ethnography', mapping global connections through the movement of a dematerialised commodity that affects (and so invisibly connects) disparate communities and life experiences.[8] The orchestrated gesture of this work recalls the ethnographic film of Jean Rouch, but Boulos does not aspire to an ethnographic documentary, eschewing the notion of art with evidentiary pretensions in favour of what he regards as a phenomenological approach.[9] For Boulos, art rematerialises relationships, envisaging a reality we inhabit but cannot access – that is unimaginable in its material totality from any single point of the spectrum, known simply as an abstraction. In Tsing's terminology, Boulos envisages – renders palpable – the animating 'frictions' linked to the sign 'oil'. But what does it mean to shoot footage in the Niger Delta of a movement at war with Royal Dutch Shell, and exhibit in Amsterdam? Does the global art biennial mean that art can and should be shown anywhere?

If political art is now much more self-conscious of its imbrication and of how its effects are produced through relocation, it is hard to evaluate its political dimensions without considering its ongoing life in its exhibition context. This is particularly true in relation to Susan Norrie's extensive multi-channel video installation *Havoc* (2007) (Figs 6.1–6.3, Plate 14), made in collaboration with David Mackenzie, following the sudden eruption in May 2006 of a 'mud volcano' in Sidoarjo in the heavily populated region of East Java. Triggered by a drilling accident, this mud flow has engulfed nine villages as well as many factories and rice fields. Thousands of displaced people are, as a consequence, living in refugee camps on the outskirts of the town, while mud sediment in the riverbank threatens to trigger flooding in Surabaya, Indonesia's second-largest city (the artist Dadang Christanto, together with the Urban Poor Consortium in Jakarta, has staged performance protests relating to this catastrophe).[10]

Venturing into the terrain of the disaster, shooting footage of a community living through the event, Norrie confronts the classic dilemmas of ethnographic documentary: how to tell a story that belongs to a community, whose members become collaborators in its making, and who have specific aims and interests in the project. Yet *Havoc* is neither ethnographic nor testimonial. A creative work made with community engagement and input, it is image-inspired (literally: Norrie saw images of the mud in a news bulletin before embarking on several trips to the site) and incorporates fantasy – a kind of magical-realist final sequence in which local participants perform choreographed actions. Where characters come to the fore they do so as self-conscious actors – whether in these carefully planned wordless final sequences or in the vignettes featuring a local punk band.

Havoc negotiates the local and the global, the actual (materiality of the Sidoarjo event) and the virtual, if virtual is understood not

Practical Aesthetics

as a non-existent imaginary but in the (more Deleuzian) sense of a distillation of key features of actual events that makes possible their re-serialisation. Norrie and Mackenzie went to Sidoarjo in order to make this event global – to transport it out of place – in a literal and conceptual sense, Norrie having received a commission from the Australia Council to make work for the Venice Biennale. *Havoc* was conceived for that framework and location, but more specifically as an intercultural encounter at the level of both production and exhibition.

In one sense, the brief to an eminent artist to represent the nation in the Venice pantheon is wildly antithetical to this endeavour, geared more to showcasing distinguished individual production than to collective enunciation. The national pavilions – especially the palazzo on the Grand Canal secured as an outpost of the Australian pavilion – have an encompassing grandiloquence that the curated open-space may work to override. But *Havoc* aspires to constitute a link between art and life. Contiguity matters, both in terms of the politics and the materiality of the video installation, which is conceived around the movement of bodies through space.

Fig. 6.1 Susan Norrie (in collaboration with David Mackenzie), *Havoc*, 2007 (still).

In this sense the installation is inherently relational and externally oriented. If photography could be said (by Barthes) to be 'past', video installation, which has no continuing existence outside the 'live' exhibition space, is always present and open-ended. It does not simply move within its diegetic space but orchestrates the movement of the visitor around it. *Havoc* exploits this capacity for physical and temporal co-extension to express the force of this environmental disaster, and specifically the material fact of its incontainability.

An Event without End
news/SIDOARJO MUDFLOW
The mud flow that doesn't end
SIDOARJO, 21 October 2007

The mud flow, which has been active since 29 May 2006, exhausts around 150,000 cubic meters of mud every single day and may flow indefinitely. At this moment it has already consumed an area the size of Venice. Australian artist Susan Norrie has made a series of videos which brings this disaster to world attention.

The mud flow, referred to by locals as just 'Lapindo', has displaced over 21,000 people. 23 schools and 20 companies have shut down. Hundreds of hectares of residential and agricultural land are now just a mud swamp. At least 13 people have been killed in various accidents surrounding the mud flow.

The mud flow has now become a macabre tourist destination. Some houses are beneath five meters of mud and in some places only roofs are visible. Most of the displaced people live in rented houses and some 2,500 are living in a refugee camp at the central market of Porong, near Sidoarjo. For over one year these victims have made makeshift houses in the still bustling market. Most of them have lost their homes and their job.

Posted 21 October 2007 @ 07:55[11]

Experts say the mud flow is likely to continue for months or years, perhaps forever. According to the media, 'the disaster can't be

stopped by humans'.[12] Court cases against the perpetrators are ongoing (WALHI, the Indonesian Friends of the Earth filed a lawsuit against PT Lapindo Brantas and the other mining companies involved, as well as against President Yudhoyono and a couple of ministers). Engineering solutions are meeting with limited success.

news/SIDOARJO MUDFLOW
Mud volcano swallows concrete balls
SIDOARJO, 27 February 2007

The plan to drop giant concrete balls into the still active mud volcano to slow its flow may be changed after these balls slid far deeper than expected, Rudi Novrianto, a spokesman said earlier today. The balls slid as far as one kilometer into the crater, roughly twice as deep as expected.

Posted 27 February 2007 @ 09:02

A surreal and apocalyptic imagery characterises the chronicle of Sidoarjo, extended through blogs and media reports. Practical interventions prove no match for the engulfing mouth of the volcano. Political and geological forces are out of control, and volatile thermodynamics seem to suggest some larger global or spiritual disorder.

Families come to offer prayer; magicians and spiritualists to perform rites. Amulets and sacrificial animals (cows, goats, chickens, monkeys) have been tossed into the mud – a practice that had to be banned as the embankments are liable to leak after the frenzied activity of a sacrificial gathering. Hundreds of paranormals and psychics have come to meditate at the shores. Some paranormals blame the mud flow on the spirit of a dragon that inhabits the earth and has been angered by humans, so they focus on appeasing this spirit. The prize of a new house was offered to the person who could stop the mud gushing from its core each day, but the house

itself was submerged before it could be claimed. That is the nature of Sidoarjo tourism: faith and magic.

Installed in three adjoining rooms of the Palazzo Giustinian Lolin in Venice, *Havoc* commenced with shots of a Lapindo mining operation. The central room had a more conventional documentary feel, albeit in non-narrative format. Ten monitors screened loops of footage from the disaster zone, encompassing a labour-intensive bailing operation with men up to their chests in sludge, protestors demonstrating, a rock group performing and playing to the camera, and everyday life as it continues in and around the mud. The final room was dramatically distinct, comprising two carefully choreographed, black-and-white sequences shot in the nearby mountains. In the first, a group of horsemen ride in formation (Fig. 6.2). Wearing balaclavas and Slayer T-shirts (a reminder of Mathew Barney's collaboration with the Slayer drummer in his surreal epics), they are the heralds of the modern Apocalypse, played by the local guides who escort visitors across to the volcano on horseback.

In the following sequence, a goatherd wanders the mountains (Fig. 6.3) and raises a goat above his head. This gesture evokes the

Fig. 6.2 Susan Norrie (in collaboration with David Mackenzie), *Havoc*, 2007 (still).

Fig. 6.3 Susan Norrie (in collaboration with David Mackenzie), *Havoc*, 2007 (still).

sacrificial ritual – banned on the riverbanks, and outlawed under Islamic law – that is never directly represented in *Havoc*. Again, the shot is arranged. The man has removed the headdress that would mark him as a Hindu from the village of Cemorolawang; and he does not offer the animal as a sacrifice. *Havoc* is not a study that proceeds from the particular or the ethnographic; nor is it fake. Simple underdetermined actions enfold the facticity of cultural detail to express the larger dynamics of a disaster. At the same time, the gestures are deliberately performed, abstracted and generalised within the carefully constructed tableaus. If the goatherd's actions are not an expression of culture or subjectivity, he is present within the performed activity (as Agamben might say, within the mediality of gesture). Affect is not the content of what is expressed, but the trace of a subject acting or supporting gesture.

In the Arsenale – the principal venue for the curated international show in Venice, some distance from the Palazzo – there was a series of videos with comparable poetic vision and movement, Yang Fudong's *Seven Intellectuals in a Bamboo Forest*, an allegory of

Chinese society, filmed on location but in the manner of a fairytale. Like *Havoc*, it concerns the progress of figures (in this case, curious intellectuals)[13] through an environment: a real place with a specific cultural and geographic history. A magical realist sense of incongruity characterises the relationship of body movements and gestures with the place of their unfolding. While *Seven Intellectuals* is character-driven, however, *Havoc* does not trace a path of discovery but a disturbance of the environment, of mud and clouds, and unstoppable volcanic forces: a movement of elements that encompass bodies. In this sense, human movement is conceived as an extension and expression of environment, occurring at various points upon this volatile and shifting ground.

Havoc comprises a series of mobile sections in this regard, and it is through their momentum and extension that haptic perception is engaged. The latter is generally understood within a Deleuze-inspired film theory[14] as the sensory, tactile or affective dimension of a visual engagement. Focused on the close-up detail, rather than the synthesised whole, haptic perception absorbs and compromises sight by virtue of its immediacy and surface concentration, derailing narrative and spatial order. It is affective rather than emotional; a pre-reflective corporeal mode of perception, rather than the product of a complex narrative organisation, grounded on recognition and identification. *Havoc* does not reproduce the clichés of haptic cinema or merely illustrate its precepts with a passage from abstraction to figuration, however. It embodies the construction of a porous imagery that allows for 'surface' connection with its constitutive moving parts rather than with its cultural content. The detail (of actuality and culture) often remains elliptical, but the movement of environmental forces and camera that together conveys the nature of the disaster is brought close to the surface by virtue of its amenability to corporeal perception in real space.

The relationship between the palazzi on the water of this sinking city and these elemental processes was a direct, if ambivalent one, particularly in the heat of the Venetian summer as visitors trekked from one Biennale venue to the next. The heat of the sun, the coolness of the interiors, the lapping water, the cloying mud. The flow of this installation through three rooms of the Palazzo, orchestrated in relation to its internal movement, was an extension of this environment as much as of Sidoarjo. If quotidian details remain opaque and impermeable components of the video, the mud moves close to the surface, producing the 'thinness' – purchase and traction – that enables it to fasten or graft onto the bodies coming in hot off the canal.[15] 'Everyone seems to get *Havoc*,' remarks the attendant in the Palazzo…It connects.

Imbrication

Conventional art-world discourse has it that artists make work, finish work, and then, all going to plan, sensitive curators hang the work in a way that respects its integrity. In such stark terms, these institutional relations do not offer much latitude for rethinking the relationship of art with the real in a way that goes beyond the documentary function. Political art connects to the real not just at the point of inspiration, research and production but also as an output.

'Living and writing, art and life, are opposed only from the point of view of major literature,' say Deleuze and Guattari,[16] because major work is, within the terms of its institutionalisation, profoundly individuated. However social or personal, it is configured as an exceptional expression, and thereby removed from the sphere of the collective. This is what happens when works that are 'great' in

their own right are juxtaposed; they affirm their own authority and allow viewers to make only visual or interpretative connections (Norrie is somewhat uneasy at having *Havoc* elevated as the output of herself and Australia in this sense, despite the obvious allure of the Palazzo and the water).

A newer mode of curatorial practice – of which the 2007 *Documenta 12* was a notable example – recasts work as minoritarian by locating it in a less competitive environment in which it can function as part of a collective enunciation. The key dimension to such a process is not simply to admit 'life' as either documentary representation or spectator interaction. It is to understand contemporary art as existing and operating within the contemporary – so that the exhibiting space is always an extension of and into the outside: the local politics, the world. Politics comes from the configuration of art in this unbounded contemporary space, rather than from institutional designation: making the exhibition contemporary, folding outwards, rather than institutionalising contemporary art. Politics are realised and embodied in this sense when distinct practices configure themselves as continuous; when art – and exhibition-making – is collective and relational.

As video artist Hito Steyerl has indicated, the foundations of an argument for a political relational aesthetics can be found in film practice itself. Steyerl focuses on montage, citing the experimental documentary work of the Dziga Vertov Group (Jean-Luc Godard, Jean-Pierre Gorin and Anne-Marie Miéville, specifically *Ici et Ailleurs* [*Here and Elsewhere*] [1976], a film about the PLO). The Dziga Vertov Group, she claims

> [...] translate the temporal arrangement of the film images into a spatial arrangement. What becomes evident here are chains of pictures that do not run one after the other, but rather are shown at the same time. They place the pictures next to one another and shift

their framing into the focus of attention. What is revealed is the principle of their concatenation.[17]

Steyerl exhibited two videos at *Documenta 12*, both constructed as detective stories, ostensibly aiming to uncover lost 'evidence'. *Journal no. 1 – An artist's impression* (2007) – the more conventionally 'political' piece – is premised on the search for a missing Bosnian newsreel made in 1947 and lost during the war in 1993. *Lovely Andrea* (2007) (Plate 15 and Fig. 6.4) – more whimsical in terms of content – is based on an implausible search for a commercial bondage photograph made by the artist for a Japanese studio in 1987. Installed at the heart of the Fridericianum, *Lovely Andrea* embodied relational aesthetics as both an internal and a curatorial principle. Structured as a temporal narrative, it unfolds in contiguous space, materialising concatenation in a third dimension. Time-based components that might otherwise register events as a sequence are cut across by spatial, physical and affective structures and connections that pull it into a synchronic and relational format.

The search within the video for a lost photograph of Nawa-shibari-style bondage, which involves the suspension of women by ropes, gives rise within the video to multiple connections (via literal web spinning and a montage combining Japanese bondage girls, Spiderman and bound prisoners at Guantanamo Bay) and a semiosis that plays on the meaning of binding and restraint ('there is bondage all over the place'). Externally it resonated with other works in the spectator's visual field and in surrounding rooms, becoming a spatial-visual experience that extended and propelled the visitor through the exhibition. The video was screened on a balcony immediately above and within sight of Trisha Brown's *Floor of the Forest* (1970) (Fig. 6.5) in which live dancers perform on a suspended rope network, and adjacent to both Sheela Gowda's suspended rope cords, which snake across the ground (*And Tell*

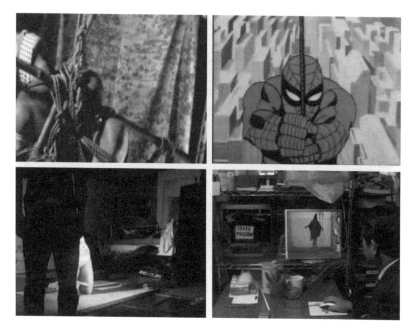

Fig. 6.4 Hito Steyerl, *Lovely Andrea*, 2007 (stills).

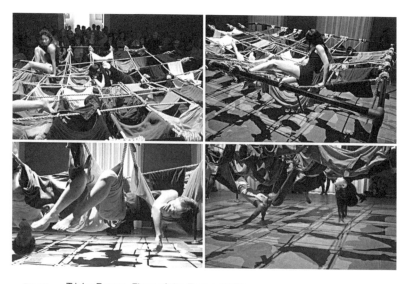

Fig. 6.5 Trisha Brown, *Floor of the Forest*, 1970.

Him of My Pain, 1998), and the mass of tangled electrical cord that comprises Tanaka Atsuko's *Electric Dress* (1956). These literal and metaphorical elements of bondage also migrated through the nearby *Album III*, by Luis Jacob (2004), a collage compiled from magazines on similar open-structure principles that extend into a range of depicted events. Aesthetic resonance was enacted and understood here as the interplay not simply of form but of perception, ranging across and connecting works via their mode of apprehension.

In *Lovely Andrea* the lost photograph is eventually tracked down (against long odds, but it makes no real difference). The Bosnian newsreel is never found. But what displaced the obsession with the lost object was the multiplication of relationships across the exhibition space; the imbrication of the work by aesthetic means, effected as we perceived the migration of form.

Revelation

The stronger argument to be made here is that art, and particularly video installation, with its complex interplay of temporal and spatial unfolding, touches the event by extending outwards. That is to say, it connects rather than reveals.

Steyerl, Boulos and many others debunk the idea that art can ever be properly evidence-based. Too affectively driven to be documentary, to pursue a single track, it cannot organise evidence without corrupting it. Scrutinising the detail (or, as in *Havoc*, moving along a particular trajectory), looking at it in ways that give rise to new connections and semiosis, art generates flows and associations that diverge from the event narrative. And the more haptic an artwork – the more its elements engage forms of sensory and tactile

perception – the more it dispels the illusion of a complete narrative through the generation of extraneous relationships. Haptic work is thus ill-suited to empirical description or to the kind of unmodulated chronology that a report upon an event consists in. Art is intensity: aesthetic, affective connectivity; it registers the detail, only to allow it to resonate. *Havoc* in this sense is always in motion. Rather than the inertia of facticity, overly described, it embodies haptic reach, connecting before it names and analyses.

If art can access the unimaginable it does so by realising certain hidden connections, not by laying bare evidence. Writing of the history of Western painting, James Elkins notes that a picture is,

> [...] always also the product of a dialogue with unrepresentable 'blindness', marked by the half-legible scars of unpicturable thoughts, pulled outward and away from itself by the attraction of the inconceivable, and folded back into itself with hidden and supernumerary unseen images.[18]

Elkins is here elaborating Derrida's concept of blindness in terms of a series of sub-categories: the unrepresentable, the unpicturable, the inconceivable and the unseeable. The unrepresented is (in Derrida's terms) 'another visible': that which is imagined but not shown. The inconceivable, by contrast, is that which does not present itself to imagination, even as its domain is delineated by the image. The unseeable is that which is physically present but induces a selective cultural blindness, 'hiding itself in its own medium'. In Renaissance painting Christ's penis is such a form, located 'right on the visible' but nevertheless overlooked. At work here is a complex interplay of cultural schema and aesthetic pressures that holds off the emperor's-new-clothes moment and calls into question the capacity of the image to expose.

The theatre and aesthetics of revelation may be mobilised, not just in a spiritual context but also, around violent events which

become the official 'unseen' – past tense – once they come to light. Here, we can think of a mechanism like the South African Truth and Reconciliation Commission (TRC), and of the apartheid victims whose suffering for years beforehand appeared nightly on South Africa news broadcasts yet remained 'unseen' until publicly – ceremoniously – unveiled with the fall of apartheid and the theatre of the TRC. This notion of unveiling, as Eve Kosofsky Sedgwick has noted, implies an infinite repository of naiveté on the part of 'spectators' who all too readily engage in the bad-faith belief that what has come to light was previously unseen, even unimaginable.[19] The issue here is that imagery (art or media) does not simply make something present or seeable – *except* as it colludes in, negotiates or acknowledges the interplay with occlusion or the 'unseen known' – and therefore cannot pretend to a privileged role in the unveiling of truth or the illumination of history.

The theatrics of revelation make the image itself an event: the point at which we first saw visible evidence with our own eyes, but also an event in the sense of a 'pleonasm between a before and an after' – a demarcation in time. Of course, events may be experienced like this – as a watershed. But the global remit of contemporary art engenders specific possibilities and responsibilities. The politics of exhibitions lie with unfolding connections between synchronously present events, between art and life. What this means is not a reduction to sameness or common features, but active conjunction. By making perceiving bodies the vehicle for such conjunction, *Havoc* embeds vision in haptic experience, challenging the conflation of visibility and knowledge. Merely seeing or feeling does not yield revelation or knowledge-transfer in any deeper sense; and it would be idealistic to imagine that art is transformative in this way. But art can multiply connections precisely by implicating the sensing, affective bodies of viewers in the connecting process. Concatenation

is itself the means of re-serialising events – of moving the unimagined into touch.

Moving Sidoarjo to Venice, locating it in this way, registers the disaster not as an exceptional occurrence but as an event animated through a haptic interplay, locally generated in relation to the environmental surrounds and the bodies that pass through the space of exhibition. *Havoc* renders the event transparent (in its virtual dimensions) in the sense of 'thin', permeable, graspable: transparent through haptic perception rather than in the clichéd sense of self-evidently knowable.

Hope

Fixing on the unimagined, on conquering its dark reaches, is, as Kosofsky Sedgwick has argued, a form of 'paranoid knowing'. The latter is marked by 'a distinctively rigid relation to temporality, at once anticipatory and retroactive, averse to all surprise', characterised by an extreme faith in knowing as exposure, and hence in rigid historiographic principles.[20] Insofar as paranoia looks forward, it identifies only threat – the bad surprise. Everything must be foreseen, traced to its antecedent causes or predicted and prevented. Hope, Sedgwick argues, emerges from relinquishing the paranoid anxiety that no horror shall ever come 'as new', and from the energies of organising the fragments and part objects one encounters and creates. These are the very energies that are engaged by the material structure of an exhibition. Curatorial practice, in this sense, might be understood as the organisation of fragments into new assemblages – structures that create space to realise not only that the future can be different from the present, but that the past might have unfolded differently.

Works like *Havoc*, which isolate and mobilise the moving sections of an artwork, constitute the event in terms that self-consciously organise internal and external relations; the event here is its concatenation rather than its sequential unfolding or its experience from a given point. It is its virtual extension rather than its actual representation. An aesthetic rendering this expansive is not the transcription of the event or its recording from a human perspective. As such, it avoids the paralysis of shock and incorporates at least the possibility of the good surprise.

Havoc is about the future event that is hoped for: the magic or the prayer that stops the flow, rather than the initial catastrophic eruption, which it does not directly investigate. It also acknowledges that the mud volcano is not something that one day became imaginable and changed the world, but something innately surreal, catastrophic and present, the daily reality of which is characterised by a series of surprises – new eruptions and developments – but equally by the energies of organisation and hope.

Havoc embodies Sidoarjo tourism; its magic realism – its co-production of reality – is not just about the past event but an investment in the generative virtual event. If it evokes the forces that constitute the Sidoarjo mud volcano and events like this (future and past), it does so by extending and generalising the ground of this disaster, rather than its cultural properties. It moves this ground quite literally and technically, staging upon it vignettes that are in some part traces of actuality (the specifics of Sidoarjo life). This is the sense in which *Havoc* makes no pretence to ethnographic authority, instead working with collaborators to imagine a virtual event from one particular actuality.

If art is not the faithful transcription of the actual event (its subsequent representation), nor does it lead us to the event as an endpoint; it may, however, constitute a process of intersections

and collisions, realised where connections and perceptions fasten or are 'stickiest'. Transparency and permeability are aesthetic properties that may be materialised through art – not as a direct knowledge effect but as sensory, aesthetic experiences that enable us to move through events. The conduits that art materialises by inviting a certain kind of viewing perhaps do not so much conjoin distinct events as enjoin and co-opt us into certain movements and formations by which we see as everyday reality that which, for us, remains unimaginable. An aesthetics of movement and concatenation counters the paralysis of descriptive realism with an affective engagement, neither empathetic nor melancholic, nor programmatic. It does not extract the event from the level of empirical everyday facticity. It simply locates the event in the world; actively links it in its various haptic dimensions to a shared, interconnected and present reality. A common, if unstable, moving ground.

The event called Lapindo goes on.

news/SIDOARJO MUDFLOW
Mud flow causes living room geyser
SIDOARJO, 20 June 2007

Large amounts of water have been shooting out of the ground in homes and a restaurant hundreds of meters away from the submerged area of land near the mud volcano in Eastern Java. Experts tell that these bursts are caused by underground pressure linked to the flow of mud flowing out of a drilling site near Sidoarjo.

Residents tell that the bursts first appeared several months ago when a one-meter high geyser of water and gas shot out of the floor in a living room almost one kilometer from the mud volcano.

Since then, the eruptions have become more frequent and much higher. Earlier this week a mixture of hot water and fine sand reached heights of five meters, damaging the roof of an abandoned coffee shop next to the main railroad. 'I thought it was raining but when

I stepped out of my stall I saw that water was bursting out of the restaurant's kitchen,' said Lilik, who owns a nearby cigarette stand.

Posted 20 June 2007 @ 15:54

SIDOARJO, 26 January 2008

Quite a big number of gas leaks have emerged in the area of Siring Barat in Sidoarjo [...] some of the villagers have attached some pipes at the gas leaks. They use the gas for cooking. There are even villagers which, unknowing of the dangers, are smoking near the leaks.

7

Compassion, Resentment and the Emotional Life of Images

Every sufferer instinctively seeks a cause for his suffering, more exactly, an agent; still more specifically a guilty agent who is susceptible to suffering – in short, some living thing upon which he can on some pretext or other, vent his affects, actually or in effigy.

Nietzsche, *The Genealogy of Morals*.[1]

Pathos and formula

In a sketch titled 'One Love Kenya', aired on the 2007 UK Comic Relief telethon, the comedian Ricky Gervais appears in an African shanty town, striking a tone of concern that – for a moment – gives the impression that this is an interlude in the comedy marathon, reminding us of its more serious purpose. Gervais begins with deadpan narration of a walk through the shantytown, building to tears of humility as he accepts a gift from an impoverished 'Kenyan' in what is subsequently revealed to be a BBC set. Exposed in the fake Kenyan shack, he confesses: it's not enough to be a comic genius, if you want to retain popularity and market share, you need to be out saving the world. A dream-team of

bleeding-heart celebrities one by one wanders onto the set, keen to get in on the act. Bob Geldof, Jamie Oliver and Bono all end up crammed into the modest 'Kenyan' dwelling, contriving tears and product placements to boost flagging careers and record sales.

No longer, it seems, do we need cultural theory to highlight the ironies of rock stars and celebrities co-opting the imagery of African poverty in a process that becomes indistinguishable from their own self-marketing. Such deconstructive work comes easily to television satire, where the production of effects can be staged and elegantly subverted rather than merely described. And what better irony than for this to be performed in the context of yet another television bonanza by the doyens of *Live Aid* who first spectacularised famine relief? The sketch works beautifully because they know and we know that suffering – real or televisually manufactured – is immediately moving, even as its delivery repeats certain formulas or sentimental clichés. Moreover, in such territory as this, formula has a distinctive purpose.

Recognised and readily accommodated by media presenters and audiences alike, formula frames the viewing of distressing spectacle in terms of what Marcel Mauss calls the 'obligatory expression of sentiment'.[2] Such is the discomfort attached to the viewing of discrepant suffering that some emotional acknowledgement is required during its mediation. The affected reverence of the opening of 'One Love Kenya' confirms that we have transitioned into a space where serious attention is required. It cues us to modify affect and expectation, much as we would if we entered a sacred place. The joke tickles us because of the reversal of affective expectation; in other words, if we have followed the formula and thereby aligned with the mood, the reversal is more profoundly felt, and so funnier. It works not as debunking satire that contests the premise of the presentation – the requirement of

sympathy – but to the degree that we collude in the production of sentiment.

Famine, perhaps more than any other subject of visual imaging, disturbs and motivates. Unlike many other depictions of atrocity, famine imagery presents ongoing human suffering rather than a past event or completed action: suffering with the possibility of alleviation. It attests both to the human consequences of chronic neglect and to the need for life-saving action, giving rise not only to sympathy but also to a desire for action. The call-to-action has become, in turn, a justification for the display of famine images and an established feature of their institutionalised setting. Whereas other forms of atrocity image – the iconic images of the Vietnam War or those of the Nazi camps, for example – are associated primarily with their news function, famine images are often directly or indirectly linked to relief campaigns. Such campaigns create a framework for action that builds on the image's capacity to incite emotion but by holding out the promise of remedial action serve to assuage the negative affects of distress, guilt and anger that passive viewing promotes.

The 1985 *Live Aid* campaign formalised this set-up on an unprecedented scale, providing immediate channels for action. Images of starvation were woven into the *Live Aid* telethon, aesthetically framed (notably in a video set to the Cars' song 'Drive') but displaced by the uplifting spectacle of live concert performance, the function of which was to command a response from a global audience. In this way the live telethon served as an aesthetic supplement to the documentary footage, providing a new and attractive brand image in the persona of the cajoling but entertaining rock-and-roll activist. In campaign terms, the expanded field of the telethon repositioned famine imagery, creating a new (Western) face to the relief effort. The glamour

of the event and its protagonists significantly lessened the relief campaign's reliance on documentary imagery. At the same time, however, this produced a certain interdependency. Images of famine were no longer simply 'news', they were a means to action.

In constituting a media setting that transported famine imagery beyond the domain of the news event or static advertorial, *Live Aid* materially altered the visual cultural landscape. This new setting imbricated famine imagery into a viewing context that delivered certain returns – emotional and moral as well as monetary. *Live Aid* essentially marketed a feel-good brand (the self-aggrandising aspect of which was pointedly debunked in the 1986 album *Pictures of Starving Children Sell Records* by anarcho-punk band Chumbawamba). The campaign's impact, however, cannot simply be measured in marketing or dollar terms. *Live Aid* formalised a framework for the expression of sympathy. Relying minimally but essentially on the use of famine footage as a trigger of compassion, the campaign changed the viewing context of famine representation, if not its basic form. It modelled a response that made viewing tenable – a response that linked emotion and sensitivity to the moral satisfaction of practical action.

If the *Live Aid* phenomenon demonstrated the extent to which sympathy, anger and concern, even casual indifference, might be channelled and manipulated within a media event, it served to highlight the critical role of media in shaping and managing emotional expectations in relation to the viewing of famine imagery. Against this backdrop, photojournalism – specifically the iconic news photograph – would be found wanting. One image more than any other exemplifies the problems of the genre and the emotional impact of famine imagery in this period: a 1993 photograph of a young victim of Sudanese famine (Plate 16), crouching helplessly on the ground as a predatory vulture looked

on. A startling encapsulation of human vulnerability, and of the *realpolitik* of famine, the image by South African photojournalist Kevin Carter was published by the *New York Times* and went on to win a Pulitzer Prize in 1994. Feted as an exemplary characterisation of a humanitarian crisis, it nevertheless triggered a debate that called into question the *raison d'être* of the photojournalist endeavour.

The tragedy of this image extended beyond the event pictured. Following the furore that surrounded its publication, Carter committed suicide. Friends and colleagues have linked his death to his traumatic experience in the Sudan and persistent exposure to extreme suffering as well as to personal attacks levelled by incensed newspaper readers and commentators. These denunciations centred on the fact that in the Sudan Carter had witnessed a scene of extreme vulnerability but had failed to save the life of the child photographed. Challenging the humanitarian pretext of the photojournalistic mission, critics condemned the ethics of a photographer who would wait for the shot rather than put down his camera and carry a malnourished girl the remaining distance to a food station. An emotive editorial in the *St Petersburg Times* established a common theme: 'The man adjusting his lens to take just the right frame of her suffering might just as well be a predator, another vulture on the scene.'[3] Confronted with the practical demands of a catastrophic event, the famine image, in this instance, could no longer find justification in representation alone.

Cast as a symptom of photography's disengagement from real-world consequences, this image and the saga of its 'emotional life' may be understood as an index of the increasingly marginal status of documentary photography. Paradoxically, however, it attests to the enduring capacity of a strong symbolic composition to express and incite affect. Brilliant in its own terms but inadequate to greater practical and moral demands, the photograph aroused both

compassion and anger but, in confronting the viewer with neglect and inaction, offered no practical means of directing compassion. Strong feelings turned quickly to denunciation of Carter himself, who became a *cause célèbre*, inspiring over time a variety of creative interventions, from a Manic Street Preachers tribute song to Dan Krauss's award-winning documentary *The Life and Death of Kevin Carter*. In each of these works Carter is less flawed hero than one more casualty of larger forces, his ineffectual actions engulfed in the larger narrative of famine. But if Carter's notoriety and personal tragedy turns on the fate of a single image, this remains above all a case of iconophobia and its emotional politics. Caught up in a volatile circuit of emotion, the image is both a catalyst and a provocation; it expresses profound affect but thwarts certain expectations with regard to the expression of sentiment. How it does so and how criticism might bridge the gap between image and action is an issue for practical aesthetics.

Writing on a related topic, Georges Didi-Huberman has commented that the revival of Aby Warburg in art theory has to do with an incipient need to reconcile 'pathos' and 'formula': 'Warburg with his pathos formulas and Mauss with his "mandatory expression of sentiments" have made us understand that the event – emotional or "pathetic" – never comes without the form that presents it to the gaze of others.'[4] That is to say, there is no immediate voice of the event that might constitute its documentary form, other than one that can be formulated. The critical aspect of Didi-Huberman's formulation is not the familiar acknowledgement of the impossibility of a purer form of documentary, but the notion that we can talk about the voice, the cry, the interior experience of the event, even the essence of its trauma, in relation to a formula; that a profound dimension of imagery and human relations to that imagery can be understood as formulaic. Formula in this regard does not merely

denote conventions of form but the manner in which affect and emotion is modelled, managed and expressed through imagery.

The notion of formula in art, which in earlier times offered rich expressive possibilities, today seems restrictive. At odds with the avant-garde predisposition toward experimentation rather than convention, it is easily reduced to cliché through its instrumental use in contemporary media. In ritual contexts where distressing affect must be shared and modulated, the mandatory expression of sentiment that Mauss identifies can be understood to sustain deep social and psychological bonds. The same phenomenon of mandated expression in media – particularly within the condensed form of a news bulletin – inevitably reduces 'expression of sentiment' to a set of shorthand gestures and intonations.

Warburg's pathos formula, by contrast, is not the convenient application of an off-the-shelf mode of expression but a catalyst for an affective force extending itself into a visual form. It is the strength of this force – affect's need to find expression – that gives rise to the most powerful form. The pathos formula, which captures the body sustaining sensation is thus of a different order to the affected sentiment of the applied formula. Its vigour and tenacity, and its grounding in deeper cultural or social energy is precisely what distinguishes it from the posturing of an overlaid narrative or aesthetic. Put simply, it embodies affect as animating force, rather than surface production.

Mandated sentiment

In this chapter I suggest that a critical role for art practice – for practical aesthetics – emerges from an understanding of the complex dynamics of formula. This role moves beyond negative

critique or denunciation towards active intervention into the affective circuits of media. My aim is not to produce a Warburgian account of specific pathos formulae, although Warburg provides an expansive concept of formula and a touchstone for an analysis of form focused on the affects that motivate and sustain it. Carter's composition may certainly be deemed successful by virtue of the coalescence of form and affect. The fact that it captured affect at large is not in doubt. In this instance, however, strong sentiment is focused on but at variance with an image. It does not align with the interests of photography, nor find sufficient outlet in the image.

If the complex apparatus that brokers the expression and formalisation of the 'spectacle' of famine has proved indispensable, critical art practice has served to demonstrate the function of different kinds of 'housing' and the ways in which these direct flows of emotions. Among the creative responses are three substantial experimental works that explicitly consider the form and formula of the photograph in the context of the emotional entanglements that

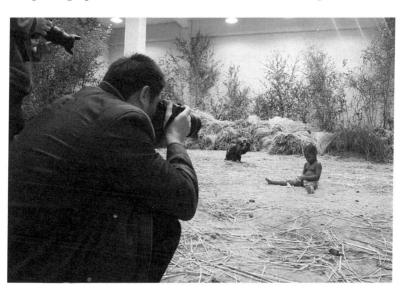

Fig. 7.1 Xu Zhen, *The Starving of Sudan*, 2008.

give it meaning: Xu Zhen's *The Starving of Sudan* (2008) (Fig. 7.1), Mark Z. Danielewski's *House of Leaves*, and Alfredo Jaar's *Sound of Silence* (2006) (Figs 7.3–7.5). Each of these works reconstructs the scene of the photograph. Jaar, whose work *Sound of Silence* I will discuss in more detail, constructs a foreboding concrete structure, an austere viewing apparatus that minimises direct contact with the famine photograph. This apparatus might be read as a corrective viewing device, a reconditioning of the viewer, who might readily consume such images in their mass-media presentation. But in fact the piece is attuned precisely to the dynamics of contemporary media, to the circuits of emotion that govern the flow of images across different registers.

Xu Zhen, by contrast, re-enacts the scene over several days in a 400-square-metre space in a Beijing gallery, a well-nourished local child playing the role of the Sudanese child, alongside an animatronic vulture. Like Jaar, Xu is concerned with the manner in which an image is consumed and animated. His aim is to 're-fresh' the image and the complex system of interpretation built around it (a term he uses in reference to the way web pages are refreshed or re-loaded). For Xu what is at stake is not interpersonal ethics but the processes of social validation or denunciation that provide us with moral narratives and value judgements (the Pulitzer Prize being one of these).

Danielewski's monumental novel can barely be summarised in this context; as a literary work it requires separate analysis. Here I will touch briefly on moves Danielewski makes in his intermedial commentary on the image of the Sudanese child he dubs Delial (the play on 'denial' presumably intended). The story of Delial is a story within a story, featuring photojournalist Will Navidson (Kevin Carter), a character whose exploits are within the narrative subject to a process of mock-forensic reconstruction. Danielewski

'cites' from copious letters, interviews, conferences on media ethics, astutely crafted journalistic commentary and pseudo-academic papers in *New Criticism, Art News, Sight and Sound, American Heritage* and so on; even from Susan Sontag's *On Photography* (imagined additional pages) in an attempt to account for the psychology of the photojournalist. From these sources emerge full blown 'criteria' such as the Bister-Frieden-Josephson (BFJ) Criteria (presented at a Nuremberg 'Conference on the Aesthetics of Mourning' in 1985) which offers an analysis of Navidson's excessive exposure to traumatic events and 'life snaps', paying particular attention to the 'incoherence' of Navidson's own letter and expression of pain 'over the image he burned into the retina of America'. The layering of source material (like more and more loose 'leaves') renders the object of analysis ever more elusive: 'Academia marches in' to examine the literary consequences of the discovery that Navidson had named the child ('Delial is to Navidson what the albatross is to Coleridge's mariner [...] both men shot their mark only to be haunted by the accomplishment') but the child is scarcely present in the burgeoning archive; in the film version, *The Navidson Record*, Delial appears only once, without music or commentary 'just Delial: a memory, a photograph, an artefact'.[5] Predictably, none of the competing frameworks, reconstructions and mappings does justice to its subject, generating stories around stories that inevitably fall short of an ethical mark:

> To this day the treatment of Delial by The Bister-Frieden-Josephson Criteria is still considered harsh and particularly insensate toward international tragedy. While Navidson's empathy for the child is not entirely disregarded, The Criteria asserts that she soon exceeded the meaning of her own existence: 'Memory, experience and time turned her bones into a trope for everything Navidson had ever lost.'[6]

Danielewski's 'point' is similar to Xu Zhen's in this regard. All moral narratives make a move to claim 'Delial', thereby advancing self-interest. Academic discourse – brilliantly parodied in *House of Leaves* – provides an explicit model of the way in which discourse occupies its own self-sustaining realm, generating thesis and antithesis, approbation and condemnation, thought lines that structure moral debate at a comfortable level of abstraction. Institutionalised discourse – the house of leaves – is formula, in other words.

Danielewski's work cannot be reduced to academic satire, however. The spoof theories and papers are not themselves the object of critique but just part of a momentous discursive flow, an endless mill of speech propelled by the desire to pass judgement, to name, assuage, foreclose. Academic speech readily formularises this process – as does the endless production of imagery (if *The Navidson Record* had been a Hollywood production, Delial would have appeared at the heart of the house, pronounces one commentator on contemporary cinema).[7]

Danielewski's wittily assembled art-historical experts (associate UCLA professor Rudy Snyder, a 'sadly musing' Sontag and the wistful Rouhollah W. Leffler 'reacquainting' himself with the photograph in a recent retrospective) offer observations that are characteristically poised between clever, sometimes poignant, insight and vacuous circularity, contributing to the story's dense weave and general inertia. The emptiness of the picture the analysis offers is a 'gnomonic representation' of Navidson's 'presence and influence, challenging the predator for a helpless prize [...]' Ironic twists and turns notwithstanding, the fictional critic hits on a primary cause of the discomfort of viewing this image; far from expressing sanctioned or obligatory sentiments, it hints at illicit sensation:

Perhaps this is why any observer will feel a slight adrenal rush when pondering the picture. Though they probably assume subject matter is the key to their reaction, the cause is the way the balance of objects within the frame involves the beholder. It instantly makes a participant out of any witness […] Though this is all still dark work […][8]

The housing of Alfredo Jaar's *Sound of Silence* is something of a visual analogue to the literary *House of Leaves*, itself a dark work, tracing the flow of affect and sentiment. The exalted edifice of art, built to contain emotion, is an ironic gesture that underlines one important point: all images of famine are not just formularised but are affective rather than representational. Photojournalism may gesture toward the descriptive rather than emotive, holding that emotion arises from a spectator's apprehension of the scene itself; but even in such instances it seems impossible to identify a moment when the image does not embody the quality of affection defined by Deleuze as occupying the interval between a troubling perception and a hesitant action.[9] Affection in this sense mediates between perception and action; it manifests in the meeting between subject and object, but before any action can result. The inherent pathos of famine images derives from the fact that they – all of them, by their nature – stop short of action.

Famine aesthetics

The topic of African famine is an area of contemporary global politics where the interest of a mass Western audience has been brokered almost exclusively in visual terms (Fig 7.2).[10] Until there were photographs and videos of the famines in Ethiopia in the 1980s and Sahel in the early 1990s there was very little global awareness or response. In both cases, the indicators of drought and famine

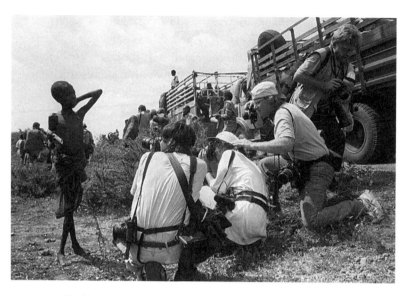

Fig. 7.2 Paul Lowe, *Western photojournalists take pictures of a starving child during the 1992 famine caused by the civil war in Somalia.*

were tangible and recognised, but it wasn't until the 'body-count' was rising and pictures of dying children were circulated that a massive relief effort occurred. A key event in this regard was the 1984 report from Korem by Mohammed Amin and Michael Buerk. Aired on 425 networks worldwide, through which some 470 million people witnessed the death of a three-year-old, this was the report that inspired *Live Aid*.

The role of photography in this field has been integral but somewhat invidious, squeezed between the television spectacle and the avant-garde rejection of both realism and formularism. No longer a vital means of breaking stories, and in the face of television's claim to bring us the news as it is unfolding, photojournalism now seems to come too late, not just to the scene but to publication. It is 'after-the-fact'. Under pressure to redefine and justify its continuing documentary mission, or find its aesthetic purpose, photojournalism is confronted with the practical demands of

catastrophic situations so engulfing that there can be no aesthetic excess. If there is an ethical window of operation open for the primary job of information capture, the more this is usurped by television the more photojournalism's mission seems superfluous – that is, gratuitously aesthetic.

Yet the rhetoric of atrocity photography typically disavows aestheticism, the presence or absence of which becomes the measure of respect for the subject matter. Reflecting a general discomfort with looking at the scene of disaster, aestheticism in these negative terms is a mark of lingering too long, an undesirable tendency of professional photographers. Amateurism has acquired a particular value in this regard, functioning as a guarantee of the absence of artifice, manipulation or stylisation – of something unstudied (Sontag, for example, suggested that photographs by anonymous witnesses of Buchenwald, Dachau and Bergen-Belson in 1945 were somehow 'more valid' than those taken by the celebrated photographers Lee Miller and Margaret Bourke-White).[11]

In this vein, arguments against particular stylistic conventions or formulas frequently devolve into anti-aesthetic polemics. Ingrid Sischy, for example, lambastes Sebastiao Salgado's photographs of the Sahelian famine, calling for an anti-aesthetic photography that matches the ugliness of famine itself.[12] 'Beauty is a call to admiration not action,' she argues. For Sischy, Salgado is a visual rhetorician, too busy with compositions, crops, lighting, angles and toning, 'in sharp contrast to the usual lack of insistent style in photojournalism'. His biblical themes are pretentious, the beauty he finds in his African subjects too 'formalised', all adding up to 'aestheticisation not reportage'.

If anti-aesthetic rhetoric speaks respectfully to the subject of atrocity, it disavows the aesthetic basis of image-perception, equating aisthesis with style and excess rather than perceptual

experience. It thereby misrecognises the aesthetic impetus underpinning all photographic mediation of the real – a characteristic succinctly defined by the former Magnum and *Newsweek* photographer Luc Delahaye (himself well known for large-format images of war in Lebanon, Afghanistan, Yugoslavia, Rwanda and Chechnya, and for crossing the boundary between atrocity photography and a more reflective art practice). As Delahaye puts it, the documentary tends inevitably towards the imaginary, just as fiction tends towards the real. Hence 'reality becomes enigmatic precisely because it is obvious'.[13] In other words, 'aestheticisation' is not a function of the extraction of content from reality or its stylisation. The 'poetic' possibilities of the documentary photograph are immanent in the capture of the scene, a function of the fact that aesthetic perception is always already in operation.

There can, in these terms, be no purely formal or stylistic means of overcoming the perceived tension between practical and aesthetic work. The style debate is, in fact, something of a diversion that masks a substantive issue. The repudiation or mere absence of self-conscious stylisation does not in itself address the underlying structural problem of the power differential that characterises the consumption of famine imagery by a global audience. (Indeed Salgado, whose work is 'stylised', has some credibility in this regard, having moved toward a less photojournalist, more ethnographic approach, engaging directly with his subjects and with local Coptic rituals in an attempt to co-produce imagery.) A practical aesthetics in this context is one that fastens on the nature of emotional response to both critically examine and productively direct its flow.

Practical politics vs aesthetics

In a 1969 essay on Beckett, Stanley Cavell draws attention to an 'aesthetic problem'. The problem 'concerns what limits there may be to subjects of art. Is, for example, the Bomb too *practically engulfing* to fit requirements of artistic treatment?' he asks.[14] Moving beyond the more familiar question of whether the disaster is representable, Cavell identifies a tension between the event's contradictory demands for realistic appraisal and practical political attention on the one hand and aesthetic treatment on the other. Cavell (in a single footnote) describes how aesthetics is already a problem for politics, citing the example of Alain Resnais's *Hiroshima mon Amour* (1959). The film, he argues, does not reveal the evil of the Bomb (which scarcely needs pointing out) but is about the evil of using the Bomb as an excuse – or as a symbol – for inner horror, and thence about the oblique and ironic relations between inner and outer worlds. In this sense, then, the event configured in art or film permits of a phenomenological exploration of life under the sign of the Bomb, materialised not just in the actuality of Hiroshima but through the paraphernalia of the cultural imagery. Art in this vein no longer serves politics by mimicking realistic appraisal or argument; it is neither documentary nor didactic, but instead reveals how processes of perception, which themselves take on aesthetic form or properties, enact and feed into a politics.

I have argued throughout this book that contemporary political art exhibits two key features: one is the exploration of affective relations, the second is a sense of the way that such relationships are constituted within media. Such art requires us to attend to what is distinctive about its form but also to confront the fact that it operates in an open field, and that both its form and content are shaped by larger media dynamics. Alfredo Jaar's *Sound of Silence*

Fig. 7.3
Alfredo Jaar, *Sound of
Silence*, 2006.

(Figs 7.3–7.5) is exemplary in this regard: a multimedia installation that takes as its point of departure a photograph in the public domain, a photograph that had become a convenient symbol for inner horror and the expression of public feeling. Inserting itself into the flow of images, the work does not offer a corrective in the classic Brechtian mode that would have us relinquish the affective tie. Affect here is both the substance and object of political aesthetics – the means of enquiry and the subject. As art animates affective process it doubles back on itself and examines that process.

Visitors to the exhibition of *Sound of Silence* are confronted with a metal-clad structure, entrance to which is authorised by a bank of horizontal red LED lights switching to vertical green. Inside is a small room with three benches and a screen projecting a grey scale and a countdown ticker. The video sequence of *Sound of Silence* begins with a fragmented narrative, sparsely rendered in an

old-style typewriter font. Like a news report coming (literally) to light, white letters illuminate a black ground, emerging as a kind of concrete poetry with a pulsing rhythm that surges and recedes. At first a name appears, 'Kevin', followed by 'Kevin Carter'.

And then the details of the life of the photographer of that name: his birth in apartheid South Africa in 1960; his army service, desertion and attempted suicide before return to the army; his introduction to photography and his evolution into a photojournalist. Each segment is introduced the same way with, 'Kevin; Kevin Carter'.

The narrative builds to the moment in which Carter encounters the vulture and a starving young girl in the Sudan desert, to the capture of the photograph itself, which flashes momentarily onto the screen. Two blinding flashlights facing the audience on either side of the screen pop simultaneously as the image vanishes and the text continues to surge and recede, relating the history of the photograph's ownership and reproduction rights after Carter's death, culminating with its current management by 'Corbis; Corbis, a corporation owned by Bill Gates'.

Thus the image is anticipated in the narrative of Carter's life, traced to its point of production – or a sudden moment of coming into being – into a phase of disembodied circulation where it is no longer visible. The image is in large part, talk and emotion.

Sound of Silence is not the story of a heroic photojournalist, Kevin Carter, secondary victim. The moral question of whether Carter should or could have saved the child is never addressed and resolved by Jaar. The story of this image had already become about Kevin Carter – or at least a putative bystander who could be identified as having failed to save life – and a personified victim.

Figs 7.4 and 7.5 Alfredo Jaar, *Sound of Silence* (interior), 2006.

Waiting

With its somewhat oppressive pacing and fleeting revelation of the anticipated image, *Sound of Silence* extends the excruciating but futile experience of waiting and expectation. Carter was all too aware of the symbolic values of the scene he had stumbled upon (according to an interview that appears in the Krauss film), and waited patiently for the vulture to spread its wings. As viewers implicitly realised, he had crossed a line from reportage into metaphor, into a field practice more akin to wildlife photography than atrocity photography, where the photographer silently stalks the subject, waiting for action.

Carter's image embodies the passive complicity of the bystander rather than the active witnessing of the action photographer. Its amplified stillness and inertia is very different in tone from the speed and chaos of the classic images of fast-unfolding atrocity (Eddie Adams's photograph of the street execution of a Vietcong prisoner or Nick Ut's iconic image of the girl fleeing from a napalm attack, for example), as well as of Tom Stoddart's comparable treatment of the theme of a starving child vulnerable to a predator. Stoddart's 1998 photograph (Fig. 7.6) of a man robbing a child of maize at a food centre in Southern Sudan registers as a fleeting encounter. The high viewpoint suggests that Stoddart turned his lens momentarily toward the crawling child and the legs of the thief to capture the crime in progress. The action reads as a relatively self-contained peripheral event, the child just far enough away to occupy a discrete zone. By moving in on his subject, Carter constitutes an intimate shared space, so that the primary relationship is no longer that between the vulture in the background and the child in the foreground but that between the child and the nearby spectator. The popular reading in which the photographer supplants

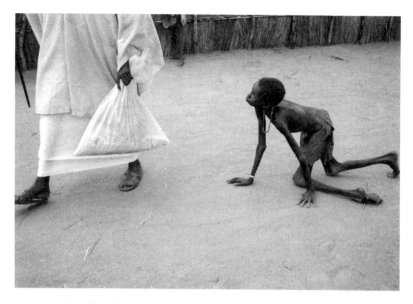

Tom Stoddart, *A well nourished Sudanese man steals maize from a starving child during a food distribution at Medecins Sans Frontieres feeding centre at Ajiep, southern Sudan, in 1998.*

the predator is on the mark in this regard, the substitution all the more uncomfortable for the fact that the anticipated, incomplete action extends the duration of an already painful scene.

Unlike the documents of atrocity that capture the immediate aftermath of an attack, this one evokes less of its immediate before than of its potential after. Iconic atrocity images derive their effect as 'decisive moments' from a capacity to evoke a larger action. This image fails to stand for the larger scene to the extent that it is compromised by the nagging fact of its contiguity. Everyone wants to know what happened next. The week following the image's publication, a *New York Times* editor's note appeared in response to an outcry from readers:

A picture last Friday with an article about the Sudan showed a little Sudanese girl who had collapsed from hunger on the trail to a feeding centre in Ayod. A vulture lurked behind her. Many readers

have asked about the fate of the girl. The photographer reports that she recovered enough to resume her trek after the vulture was chased away. It is not known whether she reached the centre.[15]

Carter's focus on a single child personalises suffering in a way that inspired compassion yet failed to direct this towards the larger humanitarian catastrophe. The detail is so affecting in this case that it fails as metonymy – fails to signify. The image does not allow us to envisage a scene that may in fact have been over-populated with children and adults in distress, characterised by irrepressible forces. Yet as Susan Moeller writes in *Compassion Fatigue*, Carter was shooting in the village of Ayod where people were dying at the rate of twenty an hour: 'Seeking relief from the masses of people starving to death, he wandered into the open bush where he saw a small emaciated girl,' she says; when Americans were calling him in the middle of the night asking why he hadn't rescued her, 'Carter found it difficult to explain that at the time she was just one of hundreds of starving children in Ayod.'[16]

The impossibility of imputing action, of *feeling* action in this scene, undercut the photograph's representational or political value to the extent that it was countered in the public domain with a vengeance that cast the picture as a worthless substitute for action. The evidence of moral action, on these terms, could only be the non-existence of the picture. It is this phenomenon of the image's untenable existence that Jaar's installation dramatises without losing or lingering over the shocking effect that it has. Far from an argument for the continued presence or viewing of the image, Jaar captures the nature of an overdetermined image, anticipated, on screen momentarily, then withdrawn, present in words and affective traces. *Sound of Silence* is about affects set in train by an image. But what are the affects in play?

Compassion

Were people who saw Carter's image in the *New York Times* overcome by strength of compassion? Or did the scene of vulnerability produce a desire to withhold compassionate attachment, to be irritated by the scene of suffering, as Lauren Berlant suggests may occur when compassion is called forth?[17]

To feel compassion – co-suffering – is to be directly affected: 'stricken with the suffering of someone else as though it were contagious' in Hannah Arendt's definition.[18] Compassion is generated through proximity. It is intense (though not necessarily enduring), intimate and localised. In this regard it is distinguished from the related but more cosmopolitan sentiments of sympathy and pity, which are founded on a shared relation to an object but not necessarily on contagion. Pity describes the moral but depersonalised response to what Luc Boltanski calls 'distant suffering'. It substitutes an outward focused moral sentiment for a direct engagement with suffering ('being sorry without being touched in the flesh').[19] Unlike the more contagious affect of compassion, this leaves the self intact and unaffected, maintaining suffering at a distance. If pity grounds a certain form of humanitarian politics, compassion promotes a more immediate identification. The particularity and immediacy of this identification precedes the constitution of a more social or moral emotion and also politics.

For Boltanski, compassion is an expressive quality mediating between perception and action: a mimetic response to suffering that 'fills the space between sight and gesture, between knowledge and action, leaving only the alternative of flight or help'.[20] In this sense, compassion-inducing imagery poses an immediate problem. If compassion calls forth action, such a call is short-circuited when the content of an image does not propose an action, frustrated by

the fact of representation itself. Action is required too quickly, too immediately for the spectator to find the means to respond.

The irrepressible call to action is both exacerbated and frustrated in Carter's image. The figure of the child, close to the picture plane, grounds an appeal to empathy in direct apprehension of distress. Closeness, the precondition for compassion, is a function of a confrontation with the particular. It arises from a relationship to the specifics of the actual case rather than an engagement with a 'problem', abstracted to the level of a political phenomenon like famine. If the latter is subject to contextual evaluation, the sight of particular suffering commands immediate action or intervention. Paradoxically, then, it is the image's capacity to inspire compassion that is its undoing.

Common to the responses published in the press and on message boards is a fantasy of action: 'I would have stomped that bird, picked up the baby, put her in my camera bag and gotten her to a hospital and then adopted her.' Such an impetus to narrativise, to write the script of rescue, is a feature of academic analysis as well as popular editorialising.[21] Inevitably, however, the rehearsal of an alternate outcome with actors differently acting turns to denunciation of the photographer, the agent who might have acted.

The entrainment of affect that turns compassion first to anger, then to resentment in this scenario reflects the toll of compassion and the injunction to act, conforming to the frustrated rage that Nietzsche and subsequently Max Scheler called ressentiment.[22] Ressentiment is a feeling that arises as a reaction to a state of affairs that is unpleasant – and, crucially, beyond the power of the affected person to control or alter.[23] Essentially an expression of powerlessness – resentment of the incapacity to act – ressentiment recruits emotions such as hatred, anger and vengefulness and vents

against the putative actor: someone present at the scene who might have acted.

The Carter image triggered a virulent response because it exacerbated to an unusual degree the distinction between the one empowered to act and the one constrained. The photograph *was* in and of itself the exposure of inaction and impotence on multiple levels. In this regard it is harder to confront than the image of atrocity occurring too quickly for intervention to be imagined, or than the Abu Ghraib images which have the perpetrators – the worthy objects of denunciation – built into their narrative from the beginning. Not only that: the Abu Ghraib images neatly resolve the issues that cloud photojournalism, because, outside a uniquely self-serving context, the images seek and find no justification. They are in a literal sense illicit, unsanctioned and unpublishable, stolen images, and thus readily understood as being as reprehensible as the scenes they represent. To condemn the image is to condemn the practice.

The discomfort of viewing Carter's image called forth a narrative of revenge; not revenge for the famine but revenge for the picture. Read not as a representation of inaction (which in fact might have led to political condemnation) but *experienced* affectively as a constraint, the image itself is intolerable. Through a careful restaging of the moment of encounter, and of the interval in which affect emerges, Jaar exposes and traces the workings of compassion, its tenuous relation to vision and amplification in a moral narrative. Jaar redeems this image through aesthetics, not as a moral proposition but in order to challenge the idea of politics or practical intervention as the realm of action that is always opposed to the image. Politics has to be a process that may occur through the image rather than defined by its absence. In rejecting the single-track emotional narrative, the aesthetic affirms its own distinct status as a domain that affords affect freer rein.

Boltanski says of the 'aesthetic topic' that it 'rejects both denunciation and sentiment and, appealing to the control of any emotion other than aesthetic, refuses to be either indignant or tender-hearted. This double refusal contains the possibility of a radical rejection of pity.'[24] Casting pity as the manifestation of resentment, the Nietzschean view links criticism to the unmasking of an accusation – not only in denunciation (where it is quite visible), but more importantly in the feeling which claims to eschew it. Jaar's work in this sense is the unmasking of the accusation – not as a pure speech act but as irrupting affect.

As Nietzsche writes, 'between two thoughts all kinds of affects play their game, but their motions are too fast, therefore we fail to recognise them.'[25] Jaar's strategy (like that of many video artists) is to change pace and flow, to amplify and magnify, to catch affect in transit in the space between sight and gesture. Affect is an energising force that takes possession of words, phrases, utterances, images – so that the feeling derived from *Sound of Silence* is not one of beholding an image but of inhabiting the space of the image's appearance. In Jaar's work, as I argued in Chapter 2 (referencing Martin Seel), the image reveals itself as resonating. In *Sound of Silence*, text that says something definite repeatedly morphs into a resonating (to paraphrase Seel once again), so that it is experienced as an oscillation of form and as 'a curse on the dangerous power of a speech that buries every conceivable object beneath it'.[26] The focus of Seel's analysis is the writing of Elfriede Jelinek, which, much like the flow of words in *Sound of Silence*, pulls readers 'into a torrent of dismay about the stream of public and private speech, but in such a way that they can't be sure at any time whether they are swimming with or against the current of false language'. Jaar submerges the audience in familiar words and images, propelling, escalating and redirecting the affective

current to shake moral certainty that does not acknowledge its aesthetic base.

Boltanski designates the aesthetic as structurally geared to this kind of critique by virtue of its non-reciprocal character – and the fact that it does not simply mediate a relationship to the real in terms that mimic the face-to-face encounter. On this basis art refuses the readily accessed scripts of indignation or tender-heartedness. If a given artwork or documentary photograph may incline to activate or suppress emotional scripts, Boltanski's argument is that to indulge them is to opt for a literal and inaesthetic sentimentality over aesthetic expression. The aesthetic is fundamentally a different kind of statement or affirmative communication that seeks no democratic authorisation. Art does not speak to a subject or about a subject in the same way that one would if one were present in a conversation with that subject.

Popular denunciation co-opts the image into such an exchange so that it figures in an imaginary encounter, co-extensive with the real. We saw this in the discursive tactics of opponents of photomedia artist Bill Henson, who called not only for the removal of Henson's work from display in a Sydney gallery but for punitive action.[27] The would-be censors were acting to protect children, and victims of child abuse, from predators; Bill Henson, photographer of adolescents, was a predator. Aside from the interpersonal relations between photographer and sitter, which Henson's lawyers argued were consensual and non-threatening, there are significant assumptions here about putative victims. It is certainly true that 'victims' or 'innocents' or those potentially subject to paedophilic desire are not addressed as the protected in Henson's work. The art does not do the bidding of those who wish to cast any discussion of sexuality in paternalistic terms.

Art, in accordance with Boltanski's definitional claim for the aesthetic, can never say, 'Don't worry I am looking out for you' or 'I am angry about what has happened to you,' because the aesthetic does not function as a reciprocal exchange. Art does not represent the subject (which would entail the impossible capture of subjectivity and its communication to another) and it does not allow one to take up a position in a moral narrative, to feel sympathy or indignation, the things that one might well say and do in a given one-to-one or public encounter. It is in this sense that art is not accountable, because it does not substitute for an affective exchange between two subjects but occupies an interval. Jaar's work exemplifies the staging of an event – an occasion that calls forth emotion – embedding affects in space and time, so that even where these are co-opted into narratives they are experienced as less organised forces that make us aware of the manner in which emotions, images and narratives ebb and flow, of their inherent dynamics rather than their necessary attachment to a given object.

The affection-image is an extensive surface, comprising what Nigel Thrift calls 'an archaeology […] both transcendent and therapeutic'.[28] If it is expressive of affect and emotion it is so by the layering and replaying of various visual conventions and pathos formulae that serve as imprints of sensation and mnemonic traces. Through their activation, images like Henson's may promote affective connection: feeling into a situation, without the self-recognition or exposure that would engender shame or embarrassment. A viewer who is marked in some way by trauma may be moved by the image without perceiving it as a figurative self-representation, and hence as a loss that must be recouped or punished.

It is important not to see this anti-representational defence as antithetical to ethnographic endeavour, as if respect for people were solely evidenced in representation. There is certainly a point where

we would want to say that other people's trauma is not available to art and exhibition. But the affirmative politics of aesthetics is not solely a matter of self-determination; it derives in part from the possibility of creative collaboration and unanticipated exchange. The guarantee of ethical appropriateness in this instance cannot be the reduction of art to a simple discursive transaction.

Jaar traces the lineaments of an affective response, so that the true object of this work is not Kevin Carter but the affect that animates this narrative. In this way the means by which affects coalesce as social emotions, or flourish and transform beyond social discourse are exposed and critiqued. In its refusal of sentimental identification and the appeal of denunciation, this form of art as criticism rejects both easy techniques of distanciation and also attempts to reinstate compassion, as if this were an easy thing for aesthetics to do. Art can occupy the interval, pursue the flow of affect within that space and pull this to the surface in a way that promotes a critical encounter. In doing so – in staging a resonating or oscillation – it opens up a gap between free flowing affect and the objects to which that affect attaches. The aesthetic thereby mimics the behaviour of affect itself: its tendency to amplify narratives and to seek out and attach itself to new objects – objects that inhabit the political field but may simply be 'in the way', buried under a torrent of affectively propelled speech. This capacity for the aesthetic to track, render and work with affect – to work between thought and image, perception and action – is the underpinning of political art. Art that does this cannot be read outside its operational context; it has no 'message' other than in its self-reflexive affective terms. And if it did have a message, it would move beyond aesthetic means toward something else, more didactic.

This is not to say that art revels in its wordless condition or rests at the level of some inchoate affect. Jaar's work, I am suggesting,

comes to the assistance of an image that encountered and revealed a set of problems. His intermedial criticism enables that image to manifest something about the world and ourselves that it could not articulate in its own media context. If, as Peter Sloterdijk argues, criticism was itself born of a desire to turn resentment into positive affect, aesthetic techniques are fundamental to its extension.[29] In exposing negative affect, *Sound of Silence* turns that affect not towards negative critique nor to positive resolution but simply to practical ends. It does so by working on the mutability and possibility of affect itself.

Jaar's work is also, however, a discourse on the subject of iconophobia, to which he frequently returns. The subject of *Sound of Silence* is in part, Corbis, 'Corbis, a corporation owned by Bill Gates', and the burial of images in an underground storeroom. The story of Corbis, which buys and sells the rights to images, dates from Gates's purchase of the Bettman Collection in 1995, which left him with the problem of storing over eleven million original images. Because photographs and negatives are inherently unstable, they need to be in cold storage to be preserved, so they are now buried 200 feet below the earth in an abandoned limestone mine near Butler, Pennsylvania, at the entrance to which is an iron gate.

This is the inspiration for the secure facility of *Sound of Silence* and the principal subject of his earlier work, *Lament of the Images* (Fig. 2.5), where Jaar riffs on the theme of light – blinding light, photographic light, the irony of consigning illuminating images documenting key world events to an underground cavern. Jaar's work is concerned primarily with conditions of viewing, but also with iconophobia as an affective condition. That is to say, it is not a defence of images *per se*, but an investigation of a condition in which one finds oneself afraid to look at the image, an image vilified for its iconicity.

Corbis for Jaar embodies the desire that images be contained but not seen. In this sense, we may note the irony in Jaar's own dramatic incarceration of this single photograph, and in a critic's suggestion that Carter's image cannot justify its own existence, but that we may countenance its extended life within this vault.

Affects are volatile in politics, aesthetics and life; to trace the emotional life of images is to trace circuits of affect that generate but move faster than ethical and political propositions. But this is why they are the proper – if messy and impure – subject of practical aesthetics.

Notes

Chapter 1

1 See: Lawrence D. Kritzman (ed.), *The Columbia History of Twentieth-Century French Thought* (New York: Columbia University Press, 2006), p. 134. This volume cites the above causes, also noting that aesthetics had lost its basis as a philosophy of experience in the face of the poststructuralist critique of the metaphysics of presence and of the subject. Also see: Isobel Armstrong, *The Radical Aesthetic* (Oxford: Blackwell, 2000), for an account of the 'turn to an antiaesthetic' from a literary-theory point-of-view.

2 From a cultural-studies perspective, Raymond Williams distinguishes 'actual cultural practice' from aesthetic theory, the latter in his view serving as an 'instrument of evasion'. Raymond Williams, *Marxism and Literature* (New York: Oxford University Press, 1977), p. 154.

3 Alexander G. Baumgarten, *Aesthetica*, 2 vols, originally published 1750–1758 (Hildesheim: Olms, 1970).

4 Jacques Rancière, *The Politics of Aesthetics*, trans. G. Rockhill (London: Continuum, 2004), p. 65. Published in French under the title *Le Partage du Sensible: Esthétique et politique*. Rancière rejects the notion of aesthetics as a theory of art, arguing instead that the aesthetic is a configuration of experience - a 'distribution of the sensible'. Art for Rancière serves to create new modes of sense perception and subjectivity.

5 Dominic Willesdon coins the phrase 'aesthetics-at-large' to serve as 'a heading under which we could talk about the affective traits of images and objects, inside or outside art museums or

art history'. See the discussion in James Elkins (ed.), *Art History Versus Aesthetics* (London and New York: Routledge, 2005), p. 70.

6 Gilles Deleuze, *Cinema 1: The movement-image*, trans. H. Tomlinson and B. Habberjam (Minneapolis, MN: University of Minnesota Press, 1986), p. 65.

7 Bruno Latour, *Reassembling the Social* (London: Oxford University Press, 2005), p. 82.

8 Giovanna Borradori, *Philosophy in a Time of Terror: Dialogues with Jurgen Habermas and Jacques Derrida* (Chicago: University of Chicago Press, 2003); see especially interview with Derrida.

9 Baumgarten, *Aesthetica*.

10 John Gountas and Joseph Ciorciari used brain scans to divide mavens into four broad personality groups based on a variation of the Myers-Brigg Type Indicator (MBTI) personality traits. John Gountas and Joseph Ciorciari, 'Neuromarketing crosses another frontier – EGG brain scans break the mould for market mavens', *Latrobe University News,* 9 May 2008. Available online: http://www.latrobe.edu.au/news/articles/2008/article/neuromarketing-crosses-another-frontier---eeg-brain-scans-break-the-mould-for-market-mavens.

11 Cf James Elkins, *Visual Studies: A skeptical introduction* (London and New York: Routledge, 2003), p. 76. Elkins notes that advertising makes fun of itself and its own assumptions, leaving little work for visual studies.

12 *The Weekend Australian,* 16–17 August 2008, reports that the *National Review of Visual Education* has called for visual literacy ('visuacy') to be afforded the same prominence as literacy and numeracy in schools and taught as a basic skill. The purpose of teaching visual arts, the report affirms, is not simply to train visual artists but to equip students both to create and critically analyse images encountered in all walks of life, be they advertisements, news images, or Picasso's *Guernica* (1937). In other words, to train students to think, process information and express ideas visually as well as linguistically.

13 On the Madonna question see: Simon Frith, *Performing Rites: On the value of popular music* (Cambridge, MA: Harvard University Press, 1996); also, for an overview of these debates, see: Michael Bérubé 'Engaging the Aesthetic', in Michael Bérubé (ed.), *The Aesthetics of Cultural Studies* (Malden: Blackwell, 2005), pp. 1–27. Elkins also comments on the strategy of unmasking, asking 'exactly how hidden is the hidden meaning that scholarship uncovers'. He suggests that the meaning of much lightweight television output is not concealed but simply 'kept sufficiently out of mind'. See: Elkins, *Visual Studies*, p. 73.

14 Bérubé, 'Engaging the Aesthetic', p. 6.

15 Bruno Latour, *We Have Never Been Modern*, trans. Catherine Porter (Cambridge, MA: Harvard University Press, 1991), p. 2.

16 Félix Guattari, *Chaosmosis: An ethico-aesthetic paradigm* (Bloomington, IN: Indiana University Press, 1995); archived writings by Guattari on transdisciplinarity are discussed and quoted in: Gary Genosko, *Félix Guattari: An aberrant introduction* (London and New York: Continuum, 2002). On transdisciplinarity as a space beyond disciplines also see: Basarab Nicolescu (ed.), *Transdisciplinarity: Theory and practice* (Cresskill, NJ: Hampton Press, 2008).

17 Elkins (ed.), *Art History Versus Aesthetics*.

18 See for example: Frances Halsall, Julia Jansen and Tony O'Connor (eds), *Rediscovering Aesthetics: Transdisciplinary voices from art history, philosophy and art practice* (Stanford, CA: Stanford University Press, 2008), p. 2. Like Elkins (ed.), *Art History Versus Aesthetics*, this is an ecumenical volume with some excellent contributions and critiques but nevertheless framed in terms of a return. The term 'transdisciplinary' in the subtitle is used loosely to denote 'cross-disciplinary approaches' and the mix of disciplines, rather than in a substantive theoretical sense, denoting a post-disciplinary space. Cf note 16 above.

19 Diarmuid Costello, cited in: Elkins (ed.), *Art History Versus Aesthetics*, p. 57; see also his essay 'Overcoming postmodernism' in that volume, pp. 92–98.

20 Latour, *We Have Never Been Modern*.

21 Elkins argues, 'there have actually been very few attempts to think about what happens beyond the opposition of the aesthetic and the anti-aesthetic.' Elkins (ed.), *Art History Versus Aesthetics*, p. 85.

22 Jacques Rancière, 'What aesthetics can mean', in Peter Osborne (ed.), *From an Aesthetic Point of View: Philosophy, art and the senses* (London: Serpent's Tail, 2001), p. 33.

23 On the use of the term 'contemporaneity' to denote a period after postmodernism, see Terry Smith, Okwui Enwezor and Nancy Condee (eds), *Antinomies of Art and Culture: Modernity, postmodernity, contemporaneity* (Durham, NC: Duke University Press, 2008).

24 Anna Dezeuze claims that aesthetics in the Anglo-American world lags behind art due to its restricted idea of how art relates to the everyday. See: Elkins (ed.), *Art History Versus Aesthetics*, p. 71. On transdisciplinary work and 'deterritorialisation' of disciplines (with reference to the work of Deleuze and Guattari), see: Susan Kelly, 'The transversal and the invisible: how do you really make a work of art that is not a work of art?', *Republic Art*, January 2005, www.republicart.net/disc/mundial/kelly01_en.htm.

25 See the debates extended through the *Journal of Visual Culture* by W.J.T. Mitchell, Mieke Bal, Nicholas Mirzoeff et al. (London and Thousand Oaks, CA: Sage Publications, 2002–3); see also Chapters 1–3 in Elkins, *Visual Studies*.

26 See for example: W.J.T. Mitchell, *What Do Pictures Want? The lives and loves of images* (Chicago, IL: University of Chicago Press, 2004); Otto K. Werckmeister, *Der Medusa-Effekt: Politische Bildstrategien seit dem 11. September 2001* (Berlin: Form and Zweck, 2005); Nicholas Mirzoeff, *Watching Babylon: The war in Iraq and global visual culture* (New York and London: Routledge, 2005).

27 Richard B. Miller, *Casuistry and Modern Ethics: A poetics of practical reasoning* (Chicago, IL: University of Chicago Press, 1996).

28 Ibid., p. 201.

29 Brian Massumi, *Parables for the Virtual: Movement, affect, sensation* (Durham, NC: Duke University Press, 2002), pp. 253–54.

30 Elkins, *Visual Studies*, p. 81.

31 Mitchell, *What Do Pictures Want?*

32 Elkins, *Visual Studies*, p. 73; Cf note 11 above.

33 Elkins, *Visual Studies*.

34 See for example: Judith Greenberg, *Trauma at Home: After 9/11* (Lincoln, NE: University of Nebraska Press, 2003).

35 Elkins's advisory resonates with voices in the arts: 'Wait ten years,' Norman Mailer advised Jay McInerney, who wrote a 9/11 novel in 2002, 'it will take that long for you to make sense of it.' See Jay McInerney, 'The uses of invention', *Guardian*, 17 September 2005. Available online: http://www.guardian.co.uk/books/2005/sep/17/fiction.vsnaipaul.

36 Giovanna Borradori, '9/11 and global terrorism: a dialogue with Jacques Derrida', originally published in Borradori, *Philosophy in a Time of Terror*. Excerpt available online: http://www.press.uchicago.edu/books/derrida/derrida911.html.

37 Borradori, '9/11 and global terrorism'.

38 The concept of the transversal as a means of cutting across conventional discipline, institutional or party lines derives from Félix Guattari, and is developed in Gilles Deleuze and Félix Guattari, *A Thousand Plateaus: Capitalism and schizophrenia* (Minneapolis, MN: University of Minnesota Press, 1987). In relation to activist art, see Kelly, 'The transversal and the invisible'.

39 Okwui Enwezor (ed.), *The Unhomely: Phantom scenes in global society*, exhibition catalogue (Seville: Fundación Bienal Internacional de Arte Contemporáneo de Sevilla, 2006), p. 15.

40 Quoted in McInerney, 'The uses of invention'.

41 André Green, *Le Discours Vivant: La conception psychanalytique de l'affect* (Paris: Presses Universitaires de France, 1973), p. 224.

42 Armstrong, *The Radical Aesthetic*, p. 117. This notion of being a spectator of one's own affect is explored within a different theoretical framework to Armstrong's in Chapter 3.

43 For examples of such studies, see Sue Malvern, 'Art history after 9/11', *Art History* 32, no 2 (2009) pp. 387–99. Malvern's text is a

review of Otto K. Werckmeister's *Der Medusa-Effekt*; Nicholas Mirzoeff, *Watching Babylon: The war in Iraq and global visual vulture*; Stephen F. Eisenman, *The Abu Ghraib effect* and the book *Beautiful suffering: photography and the traffic in pain.*

44 Elkins, *Visual Studies*, p. 78.

45 Frederich Nietzsche, *The Genealogy of Morals*, trans. W. Kauffman and R.J. Hollingdale, originally published 1887 (New York: Vintage Books, 1989). See Chapter 5 of this book for further discussion.

46 See Armstrong for a discussion of Green's notion of affect in relation to aesthetics. Affect in his view 'hooks onto things and hallucination alike, indiscriminately'. Unlike the reality principle it does not renounce the hallucinated object. *The Radical Aesthetic*, p. 120.

47 Werckmeister, *Der Medusa-Effekt*; Mirzoeff, *Watching Babylon*; Mitchell, *What Do Pictures Want?*

48 Ibid., p. 11.

49 Mitchell, *What Do Pictures Want?*, p. 49. 'Affect' is in fact only invoked on one other occasion in this book.

50 Mitchell, *What Do Pictures Want?*, p. 12.

51 Brian Massumi, 'Fear (the spectrum said)', *Positions* 13, no 1, 2005. See also: Massumi, *Parables for the Virtual*; Ned Rossiter, 'Processual media theory', *Symploke* 11, nos 1–2, 2003, pp. 104–31.

52 Eve Kosofsky Sedgwick and Adam Frank (eds), *Shame and its Sisters: A Silvan Tomkins reader* (Durham, NC: Duke University Press, 1995), p. 55.

53 Armstrong, *The Radical Aesthetic*; cf. Chapter 4, pp. 108–48.

54 Ibid., p. 117. Armstrong claims 'Affect makes us feel alive' to be a fundamental axiom for Green.

55 Wolfgang Welsch, 'Aesthetics beyond aesthetics', in Francis Halsall, Julia Jansen and Tony O'Connor (eds), *Rediscovering Aesthetics: Transdisciplinary voices from art history, philosophy, and art practice* (Stanford, CA: Stanford University Press, 2008), p. 191.

56 Bruno Latour, *Reassembling the Social*, p. 83.

57 Ibid., pp. 84–85.

58 Ibid., p. 49.

59 Mary Zournazi, *Hope: New philosophies for change* (London and New York: Routledge, 2003), p. 204.

60 Gilles Deleuze, *Empiricism and Subjectivity*, trans. Constantin V. Boundas (New York: Columbia University Press, 1991). See also: Jeffrey Bell, *Deleuze's Hume: Philosophy, culture, and the Scottish enlightenment* (Edinburgh: Edinburgh University Press, 2009).

61 Archived paper quoted in Genosko, *Felix Guattari*, p. 26.

Chapter 2

1 Marc Augé, *Non-Places: Introduction to an anthropology of supermodernity*, trans. John Howe (New York: Verso, 1995), p. 27.

2 Gilles Deleuze and Félix Guattari, *What is Philosophy?*, trans. Hugh Tomlinson and Graham Burchill, originally published 1991 (London and New York: Verso, 1994).

3 For further elaboration of Deleuze's conception of the event in this regard, see Paul Patton, 'The world seen from within: Deleuze and the philosophy of events', *Theory & Event* 1, no 1, 1997.

4 Thomas Demand, 'A thousand words: Thomas Demand talks about *Poll*', *Artforum* 39, no 9 (May 2001), p. 145. Available online: http://www.findarticles.com/p/articles/mi_m0268/is_9_39/ai_75914323.

5 Demand, 'A thousand words'.

6 Deleuze and Guattari, *What is Philosophy?*, p. 110. See also Gilles Deleuze, *The Logic of Sense*, trans. Mark Lester and Charles Stivale, ed. Constantin Boundas, originally published 1969 (New York: Columbia University Press, 1990). On genealogy as an alternative to history, see, C. Colwell, 'Deleuze and Foucault: series, event, genealogy', *Theory and Event* 1, no 2, 1997.

7 For a representative sample of the dominant positions within trauma studies see Cathy Caruth (ed.), *Trauma: Explorations in*

memory (Baltimore, MD: Johns Hopkins University Press, 1995). For discussion of the arguments around representation and trauma, see Jill Bennett, *Empathic Vision: Affect, trauma and contemporary art* (Stanford, CA: Stanford University Press, 2005).

8 See Bennett, *Empathic Vision*, p. 23.

9 Bennett, *Empathic Vision*.

10 Jill Bennett, 'Tenebrae after September 11: art, empathy and the global politics of belonging', in Jill Bennett and Rosanne Kennedy (eds), *World Memory: Personal trajectories in global time* (London: Palgrave MacMillan, 2003); 'Jill Bennett interviews Doris Salcedo', in *Doris Salcedo*, exhibition catalogue (London: Camden Arts Centre, 2001).

11 See Colwell, 'Deleuze and Foucault'.

12 Viktor Shklovsky, 'Art as technique', in L.T. Lemon and M. Reis (eds), *Russian Formalist Criticism*, originally published 1917 (Lincoln, NE: University of Nebraska Press, 1965), p. 12.

13 Jacques Rancière, *The Politics of Aesthetics*, trans. Gabriel Rockhill, originally published 2000 (London: Continuum, 2004).

14 See Bhimji's website: http://www.zarinabhimji.com/dspseries/12/1FW.htm.

15 Martin Seel, *Aesthetics of Appearing*, trans. John Farrell (Stanford, CA: Stanford University Press, 2005), p. 147.

16 Rancière, *The Politics of Aesthetics*, p. 63.

17 Ibid.

18 Deleuze and Guattari, *What is Philosophy?*, p. 161.

19 Bennett, *Empathic Vision*, p. 23.

20 Deleuze, *The Logic of Sense*, p. 153.

21 The source of this quotation is an article in *Nouvel Observateur*, 1968 by Claude Roy: Deleuze, *The Logic of Sense*.

22 See Al Strangeways, '"The boot in the face": the problem of the Holocaust in the poetry of Sylvia Plath', *Contemporary Literature*, XXXVII, no 3 (1996), pp. 370–90.

23 Bhimji, http://www.zarinabhimji.com/dspseries/12/1FW.htm.

24 Rancière, *The Politics of Aesthetics*, p. 65.

25 Deleuze, *The Logic of Sense*, p. 5.

26 This exhibition was held at the Ivan Dougherty Gallery, Sydney and the Golden Thread Gallery, Belfast in 2005. See Jill Bennett, Felicity Fenner, Liam Kelly and Abigail Solomon-Godeau, *Prepossession*, exhibition catalogue (Sydney: Ivan Dougherty Gallery, University of New South Wales, 2005).

27 Deleuze, *The Logic of Sense*, p. 149.

Chapter 3

1 While Illingworth's work references the village of Balnakeil, she initially used the spelling Balnakiel for this work.

2 Peter Sloterdijk: *Sphären I – Blasen* (Frankfurt-am-Main: Suhrkamp, 1998); *Sphären II – Globen* (Frankfurt-am-Main: Suhrkamp, 1999); *Sphären III – Schäume* (Frankfurt-am-Main: Suhrkamp, 2004); Sloterdijk's trilogy on the spheres is not yet published in its entirety in English. See Peter Sloterdijk, 'Something in the air', *Frieze*, 127 (November–December 2009). Available online: http://www.fricze. com/issue/print_article/something_in_the_air.

3 Sloterdijk, *Sphären I – Blasen*, p. 28.

4 On the inadequacy of the conventional flashback or 'recollection-image' see Gilles Deleuze, *Cinema Two: The time image*, trans. Hugh Tomlinson and Robert Galeta (Minneapolis, MN: University of Minnesota Press, 1989).

5 Hal Foster, 'Polemics, postmodernism, immersion, militarized space', *Journal of Visual Culture* 3 (2004), pp. 320–35.

6 Ibid., p. 327. See also: Frances Dyson, *Sounding New Media: Immersion and embodiment in the arts and culture* (London: University of California Press, 2009), p. 112. Dyson analyses an implicit assumption in the work of key theorists that inactive immersion undermines critical evaluation. She circumvents this objection by establishing the value of modes of embodied experience – the breath interface, for example.

7 See Jill Bennett 'Atmospheric affects', in Marta Zarzycka and Bettina Papenburg (eds), *Carnal Aesthetics* (London and New York: I.B.Tauris, 2011) for further discussion.

8 Cf Viktor Shklovsky, 'Art as technique', in Lee T. Lemon and Marion J. Reiss (eds), *Russian Formalist Criticism: Four essays* (Lincoln, NE: University of Nebraska, 1965), pp.3–24. The Russian Formalist Viktor Shklovsky advanced the concept of defamiliarisation or estrangement to describe the capacity of art to counter the effect of habit and convention by investing the familiar with strangeness.

9 Teresa Brennan, *The Transmission of Affect* (New York: Cornell University Press, 2004), p.1.

10 Christopher Bollas, *Cracking Up: The work of unconscious experience* (New York: Hill and Wang, 1995), p.116.

11 Attunement is discussed by K. Stewart, 'Atmospheric Attunements', 'Transforming Cultures' programme, University of Technology, Sydney, 20 August 2009 (unpublished lecture).

12 Gilles Deleuze, *Francis Bacon: The logic of sensation*, trans. D.W. Smith (Minneapolis, MN: University of Minnesota Press, 2003), p.31.

13 Gilles Deleuze and Félix Guattari, *What Is Philosophy?*, trans. Hugh Tomlinson and Graham Burchill (London: Verso, 1994), p.164.

14 In addition to a subwoofer generating deeper sound, there are nine channels of sound: five running through the floor, four through overhead speakers. FeONIC 'actuators' attached to the underside of the specially constructed floor translate sound signals into vibrations, driving amplified sound through this floor. Unlike conventional speakers that generate sound from a single point, the actuators distribute sound across a horizontal plane.

15 Deleuze, *Francis Bacon*.

16 Christian Metz, 'Aural objects', *Cinema/Sound* 60 (1980), p.26. 'As soon as the source of the sound is recognized (jet plane), the taxonomies of the sound itself (buzzing, whispering etc.) can only provide, at least in our era and geographic location, supplementary precisions [...] of a basically adjectival nature.'

17 The term 'ecomimesis' is used by Timothy Morton in *Ecology Without Nature* (Cambridge, MA: Harvard University Press, 2007). See F. Dyson, *Sounding New Media: Immersion and embodiment in the arts and culture*, p.132 for further discussion of ecomimesis in immersive art.

18 John Dewey, *Art as Experience* (New York: Perigee Books, 2005), p.21.

19 Brennan, *The Transmission of Affect*, p.71.

20 Sloterdijk, *Sphären I – Blasen*.

21 Brennan, *The Transmission of Affect*, pp.68–73.

22 Ibid., p.70; Cf G. Deleuze, *Francis Bacon*, p.xv. Rhythm, like sensation, is a term Deleuze applies to the fundamental operation of art, a process distinguished from signification.

23 Dewey, *Art as Experience*, p.302.

24 Dewey, *Art as Experience*, p.24. 'Aesthetic experience' for Dewey is continuous with the processes of living, grounded in the same impetus to make for practical advantage. A certain 'anatomy of experience' divides and compartmentalises activities, bringing about the separation of 'practice' from insight, of imagination from executive doing, of emotion from thought: see *Art as Experience*, p.21.

25 Jill Bennett, review of Georges Didi-Huberman, *Images in Spite of All: Four photographs from Auschwitz* (Chicago, IL: Chicago University Press, 2008), CAA reviews. Available online: http://www.caareviews.org/reviews/1380, 31 December 2009.

26 Didi-Huberman, *Images in Spite of All*.

27 Deleuze, *Francis Bacon*, p.33: 'Every sensation [...] is already an "accumulated" or "coagulated" sensation, as in a limestone figure. Hence the irreducibly synthetic character of sensation.'

28 Dewey, *Art as Experience*, p.24.

Chapter 4

1 Cartier Bresson, Henri, *The Decisive Moment* (New York: Simon & Schuster, 1952).

2 Giorgio Agamben, 'Notes on Gesture', *Means Without End: Notes on politics*, trans. Vincenzo Binetti and Cesare Daniel Heller (Minneapolis, MN: University of Minnesota Press, 2000), pp. 49–59.

3 For an explication of the 'dialectic of gesture', see Giorgio Agamben, 'Kommerell, or on Gesture', *Potentialities: Collected essays in philosophy*, trans. Daniel Heller-Roazen (Stanford, CA: Stanford University Press, 1999), pp. 77–85.

4 Agamben, 'Notes on Gesture', p. 58.

5 Benjamin Buchloh, 'Cosmic reification: Gabriel Orozco's photographs', in *Gabriel Orozco* (London and Cologne: Serpentine Gallery, 2004), pp. 75–96.

6 Agamben, 'Notes on Gesture', p. 58.

7 Ibid.

8 Ibid., p. 57.

9 Brian Massumi, *Parables for the Virtual: Movement, affect, sensation* (Durham, NC and London: Duke University Press, 2002); Mieke Bal, 'Visual essentialism and the object of visual culture', *Journal of Visual Culture* 2, no 1 (2003), pp. 5–32.

10 Massumi, *Parables*, pp. 253–54.

11 Ibid., p. 253.

12 Archive of the Warburg Institute, London. For a recent edition, see Aby Warburg, *Mnemosyne: l'Atlante delle immagini*, ed. Martin Warnke (Turin: Nino Aragno Editore, 2002).

13 See Philippe-Alain Michaud, *Aby Warburg and the Image in Motion*, trans. Sophie Hawkes (New York: Zone Books, 2004), p. 263.

14 Ibid., p. 277.

15 Georges Didi-Huberman, 'Dialektik des Monstrums: Aby Warburg and the symptom paradigm', *Art History* 24, no 5 (2001), pp. 621–45, 637.

16 Agamben, 'Notes on Gesture,' p. 54.

17 See Silvan S. Tomkins, 'Affect imagery consciousness', *The Positive Affects*, vol. I (New York: Springer, 1962).

18 Agamben, 'Kommerell, or on Gesture', p. 80.

19 http://www.festival-cannes.fr/films/fiche_film.php?langue=6002&id_film=4359365 (accessed 3 September 2006).

20 See Michael Fried and Tim Griffin, 'Douglas Gordon and Philippe Parreno's *Zidane*: a portrait of the twenty-first century', *Artforum* 45, no 1 (September 2006), pp. 332–39.

21 See Agamben, 'Kommerell, or on Gesture'.

22 Marcella Beccaria, 'Process and meaning in the art of Candice Breitz', in Marcella Beccaria (ed.), *Candice Breitz* (Turin: Castello di Rivoli, 2005), p. 43.

23 Mieke Bal, *Quoting Caravaggio* (Chicago, IL: University of Chicago Press, 1999), p. 117.

24 Bal, 'Visual essentialism', p. 25.

25 Michaud, *Aby Warburg and the Image in Motion*.

26 Bal, 'Visual essentialism', p. 7.

27 Bruno Latour, *We Have Never Been Modern*, trans. Catherine Porter (Cambridge, MA: Harvard University Press, 1991).

28 Ibid., p. 2.

29 Ibid., p. 3.

30 Mieke Bal, *Travelling Concepts in the Humanities: A rough guide* (Toronto: University of Toronto Press, 2002).

31 Massumi, *Parables*, p. 246.

32 Andrew Murphie, 'Electronicas: differential media and proliferating, transient worlds', *Fineart Forum* 17, no 8 (2003), p. 8. Available online: http://www.fineartforum.org/Backissues/Vol_17/faf_v17_n09/reviews/murphie.html and http://hypertext. rmit.edu.au/dac/papers/Murphie.pdf.

33 See also: Andrew Murphie, 'The mutation of "cognition" and the fracturing of modernity: cognitive technics, extended mind and cultural cisis', *Scan*, journal of media arts culture. Available online: http://scan.net.au/scan/journal/display.php?journal_ id=58.

34 Giorgio Agamben, 'Aby Warburg and the nameless science', in *Potentialities*, pp. 8–103.

35 Michaud, *Aby Warburg and the Image in Motion*, p. 278; Agamben, 'Notes on Gesture', p. 54.

36 Kurt Forster, 'Introduction', in *Aby Warburg: The renewal of pagan antiquity*, trans. David Britt (Los Angeles, LA: Getty Research Institute for the History of Art and the Humanities, 1999) (1932), pp. 1–75.

37 Forster, *Aby Warburg*, p. 56; see also: Michaud, *Aby Warburg*, p. 102.

38 Agamben, 'Notes on Gesture', p. 54.

39 Didi-Huberman, 'Dialektik des Monstrums', p. 641.

40 *T_Visionarium* is a project of iCinema (the Centre for Interactive Cinema), led by Dennis Del Favero, Neil Brown, Jeffrey Shaw, Peter Weibel (lead software engineer Matt McGinity). The first phase was premiered in Lille in 2003, the second in Sydney in 2006.

Chapter 5

1 Michael Moore (dir.), *Fahrenheit 9/11* (Weinstein Company: New York, 2004).

2 Michael Moore, *The Official Fahrenheit 9/11 Reader* (London: Penguin, 2004), p. 18.

3 M. Sifry and A. Rasiej, 'Welcome to the age of the soundblast', 2008. Available online: http://thebreakthrough.org/blog/2008/03/youtubes_political_revolution.shtml; www.personaldemocracy.com.

4 George E. Marcus et al. (eds), *The Affect Effect: Dynamics of emotion in political thinking and behavior* (London: University Chicago Press, 2007).

5 Dustin Harp and Mark Tremayne, 'Programmed by the people: the intersection of political communication and the YouTube Generation', 2008. Available online: www.allacademic.com/meta/p173067_index.html.

6 *Vote Different*, ParkRidge47, 2008. Available online: http:www.youtube.com/watch?v=6h3G-IMZxjn

7 Marcella Beccaria, 'Process and meaning in the art of Candice Breitz', in Marcella Beccaria (ed.), *Candice Breitz* (Turin: Castello di Rivoli, 2005), p. 22.

8 Giorgio Agamben, 'Notes on Gesture', *Means Without End: Notes on politics*, trans. Vincenzo Binetti and Cesare Daniel Heller (Minneapolis, MN: University of Minnesota Press, 2000), p. 58.

9 Mark Crispin Miller, *The Bush Dyslexicon: Observations on a national disorder* (New York: Norton, 2001), p. 6.

10 Jenny Edbauer, 'Executive overspill: affective bodies, intensity, and Bush-in-relation', *Postmodern Culture* 15, no 1 (2004), pp. 1–25.

11 John L. Austin, *How to Do Things With Words*, the William James Lectures delivered at Harvard University in 1955, 2nd edn, ed. J.O. Urmson and Marina Sbisà (Cambridge, MA: Harvard University Press, 1975).

12 Toni Morrison, 'Nobel Lecture', 7 December 1993. Available online: http://nobelprize.org/nobel_prizes/literature/laureates/1993/morrison-lecture.html.

13 Judith Butler, *Excitable Speech* (New York: Routledge, 1997).

14 Denise Riley, *Impersonal Passion: Language as affect* (Durham, NC: Duke University Press, 2005), pp. 6, 102.

15 Riley, *Impersonal Passion: Language as affect*, p. 7.

16 Giorgio Agamben, 'Kommerell, or on Gesture', *Potentialities: Collected essays in philosophy*, trans. Daniel Heller-Roazen (Stanford, CA: Stanford University Press, 1999), p. 77.

17 Agamben, 'Kommerell, or on Gesture', p. 79.

18 Max Kommerell, *Gedanken Uber Gedichte* (Frankfurt-am-Main: Klostermann, 1943), p. 36; Agamben, 'Kommerell, or on Gesture', p. 78.

19 Kommerell, *Gedanken Uber Gedichte*, p. 36; Agamben, 'Kommerell, or on Gesture', p. 78.

20 Paul Ekman and Wallace V. Friesen, 'Nonverbal leakage and clues to deception', *Psychiatry* 32, no 1 (1969), p. 98; Paul Ekman, 'Darwin, deception, and facial expression', *Annals of the New York Academy of Sciences* 1000, December, 2003, special issue: Emotions:

Inside Out: 130 years after Darwin's *The Expression of Emotions in Man and Animal*, pp. 205–21.

21 Elaine Virginia Demos, ed., *Exploring Affect: The selected writings of Silvan S. Tomkins* (Cambridge and New York: Cambridge University Press, 1995), p. 217.

22 Demos, *Exploring Affect.*

23 Kommerell, *Gedanken Uber Gedichte*, p. 36; Agamben, 'Kommerell, or on Gesture', p. 78.

24 Max Kommerell, *Jean Paul* (Frankfurt-am-Main: Klostermann, 1933), p.48; Agamben, 'Kommerell, or on Gesture', p. 79.

25 Agamben, 'Kommerell, or on Gesture' p. 78.

26 Brian Massumi, *Parables for the Virtual: Movement, affect, sensation* (Durham, NC: Duke University Press, 2002).

27 Agamben, 'Notes on Gesture', p. 59.

28 L. M. Bogad, *Electoral Guerrilla Theatre: Radical ridicule and social movements* (New York: Routledge, 2005), pp.172–75.

29 Simon Hunt, 'I don't like it', TWA Records, 1998.

30 Simon Hunt, *The Pauline Pantsdown Story*, unpublished documentary, 1998.

31 Anna Gibbs, 'Contagious feelings: Pauline Hanson and the epidemiology of affect', *Australian Humanities Review*, December 2001: Available online: http://www.lib.latrobe.edu.au/AHR/archive/Issue-December-2001/gibbs.html, 2001.

32 Jon Stratton, '"I don't like it": Pauline Pantsdown and the politics of inauthenticity', *Perfect Beat: The Pacific journal of research into contemporary music and popular culture* 4, no 4 (1999), pp. 3–29.

33 Brian Massumi, 'Fear (the spectrum said)', *Positions: East Asia critique* 13, no 1 (2005), p. 34.

34 Michel de Certeau, *The Practice of Everyday Life*, trans. Steven Rendall (Berkeley, CA: University of California Press, 1984).

35 Ibid., p. 188.

36 Slavoj Žižek, 'The subject supposed to loot and rape: reality and fantasy in New Orleans', *In These Times*, 20 October 2005. Available online: http://www.inthesitimes.com/site/main/article/2361.

37 Tony Blair, 'Transcript of Tony Blair's Iraq interview', *Newsnight*, BBC TV, 6 February 2003. Viewed December 2005. Available online: http://news.bbc.co.uk/1/hi/programmes/newsnight/2732979.stm.

38 Lionel Trilling, *Sincerity and Authenticity* (London: Oxford University Press, 1972).

39 Demos, *Exploring Affect*.

40 Silvan Tomkins, 'Affect imagery consciousness', *The Positive Affects*, vol. I (New York: Springer, 1962).

41 Demos, *Exploring Affect*, pp. 355–56.

42 Massumi, *Parables for the Virtual*.

43 Agamben, 'Kommerell, or on Gesture', p. 77.

44 Edbauer, 'Executive overspill', p. 12.

45 Agamben, 'Kommerell, or on Gesture', p. 78.

46 Riley, *Impersonal Passion*, pp. 6–7.

47 Brian Massumi, 'The autonomy of affect', *Deleuze: A critical reader*, ed. Paul Patton (Oxford and Cambridge, MA: Blackwell, 1996).

48 Žižek, 'The subject supposed to loot and rape'.

49 Agamben, 'Kommerell, or on Gesture', p. 80.

50 Silvan Tomkins, 'Affect imagery consciousness', *The Negative Affects*, vol. III (New York: Springer, 1991), pp. 541–42.

51 Z. Chafets, *Jewish World Review*, 18 November 2002. Available online: http://www.jewishworldreview.com/1102/chafets111802.asp

52 Massumi, *Parables for the Virtual*.

53 Tomkins, 'Affect imagery consciousness'.

54 Riley, *Impersonal Passion: Language as Affect*.

55 Kommerell, *Gedanken Uber Gedichte* p. 48; Agamben 'Kommerell, or on Gesture', p. 79.

Chapter 6

1 *The 9/11 Commission Report*, National Commission on Terrorist Attacks Upon the United States, 22 July 2004, 12.06. Available online: http://pdfhacks.com/9/11Report/pdfportal-1.0/pdffile.php?pdf=/9/11Report/9/11Report.pdf, p. 339.

2 Marc Augé, *Non-places: Introduction to an anthropology of supermodernity*, trans. John Howe (New York: Verso, 1995), p. 27.

3 As Rancière observes, the discourse of the unimaginable is only ever 'authorised' by the event's having happened. Jacques Rancière, *The Future of the Image*, trans. G. Elliott (London and New York: Verso, 2007), pp. 134–35. On the unimaginability of 9/11, see also Alison Young, 'Documenting September 11th: trauma and the (im)possibility of sincerity', in Ernst Van Alphen et al. (eds), *The Rhetoric of Sincerity* (Stanford, CA: Stanford University Press, 2008).

4 See Laura Marks, *The Skin of the Film: Intercultural cinema, embodiment, and the senses* (Durham, NC: Duke University Press, 2000), pp. 163–64. Marks invokes Deleuze's concept of the affection-image and a notion of 'haptic cinema' to argue that cinema does not invite identification with figures but a direct sensory engagement with the image, also evaluating this as an intercultural dynamic.

5 Gilles Deleuze, *The Logic of Sense*, trans. Mark Lester and Charles Stivale, ed. Constantin Boundas, originally published 1969 (New York: Columbia University Press, 1990), p. 149. Deleuze describes the event as 'rather inside what occurs, the purely expressed'.

6 See Rancière, *The Future of the Image*, p. 121.

7 Ibid., p. 121.

8 Anna L. Tsing, *Friction*: *An ethnography of global connection* (Princeton: Princeton University Press, 2004).

9 Marc Boulos, interview with Stedelijk Museum. Available online: http://www.youtube.com/watch?v=BX6rYfNzTJ8 (accessed 21 November 2010).

10 Susan Ingham, 'Dadang Christanto: Art, activism and the Environment', *C Arts Asian Contemporary Art & Culture*, September–October 2009, pp. 112–15.

11 http://news.indahnesia.com/event/43/sidoarjo_mudflow.php. All subsequent quotations headed 'news/SIDOARJO MUDFLOW' are from this site.

12 See, for example, 'The gods must be crazy', *Courier-Mail,* 29 December 2006, http://www.news.com.au/couriermail/story/0,23739, 20987236-5003416,00.html.

13 *Seven Intellectuals in a Bamboo Forest* is a contemporary adaptation of the traditional Chinese stories known as 'The seven sages of the bamboo grove'.

14 See Marks, *The Skin of the Film.*

15 See Ibid., p.163. Marks describes haptic images as a subset of Deleuze's optical images, 'so "thin" and unclichéd that the viewer must bring his or her resources of memory and imagination to complete them', as opposed to being pulled into a narrative that offers the illusion of completeness.

16 Gilles Deleuze and Félix Guattari, *Kafka: Toward a minor literature,* trans. Dana Polan (Minneapolis, MN: University of Minnesota Press, 1986), p.41.

17 Hito Steyerl, 'The articulation of protest', in *Subsol: Technologies of truth and fiction.* Available online: http://subsol.c3.hu/subsol_2/ contributors3/steyerltext2.html.

18 James Elkins, *On Pictures and the Words that Fail Them* (Cambridge: Cambridge University Press, 1998), p.261.

19 Eve Kosofsky Sedgwick, *Touching Feeling: Affect, pedagogy, performativity* (Durham, NC: Duke University Press, 2003).

20 Ibid., p.146.

Chapter 7

1 Frederich Nietzsche, *The Genealogy of Morals,* trans. W. Kauffman and R.J. Hollingdale, originally published 1887 (New York: Vintage Books, 1989), p.127.

2 Marcel Mauss, 'L'expression obligatoire des sentiments', *Journal de psychologies,* 18, 1921.

3 Reena Shah Stamets, 'Were his priorities out of focus?', *St Petersburg Times,* 14 April 1994, 1.A.

4 Georges Didi-Huberman, 'Emotion Does Not Say I, Ten Fragments on Aesthetic Freedom', *Alfredo Jaar: The Politics of Images* (JRP Ringier: Zurich, 2007), pp. 57–70.

5 Mark Z. Danielewski, *House of Leaves* (New York: Pantheon, 2000), pp. 394–95.

6 Danielewski, *House of Leaves*, p. 395.

7 Ibid.

8 Ibid., p. 421.

9 Gilles Deleuze, *Cinema 1: The movement-image*, trans. H. Tomlinson and B. Habberjam (Minneapolis, MN: University of Minnesota Press, 1986), p. 65.

10 David Campbell et al., *Imaging Famine*, exhibition catalogue, 2005. Available online: www.imaging-famine.org.

11 Susan Sontag, *Regarding the Pain of Others* (New York: Farrar, Straus and Giroux, 2003), p. 77.

12 Ingrid Sischy, 'Photography: good intentions', *New Yorker*, 9 September 1991, reprinted in Liz Heron and Val Williams (eds), *Illuminations: Women writing on photography from the 1850s to the present* (London: I.B.Tauris, 1996).

13 J. Paul Getty Trust, *Recent History: Photographs by Luc Delahaye*, exhibition catalogue (Los Angeles: J. Paul Getty Museum at the Getty Centre, 2007).

14 Stanley Cavell, 'Ending the waiting game', in *Must We Mean What We Say?: A Book of Essays* (Cambridge: Cambridge University Press, 2002) p. 136

15 Editor's note, *New York Times*, 30 March 1993, A2.

16 Susan Moeller, *Compassion Fatigue: How the media sell disease, famine, war and death* (New York: Routledge, 1999), pp. 147–48

17 Lauren Berlant (ed.), *Compassion: The culture and politics of an emotion* (New York: Routledge, 2004), p. 9.

18 Hannah Arendt, *On Revolution* (London: Penguin, 1965), p. 85.

19 Ibid.

20 Luc Boltanski, *Distant Suffering: Morality, media and politics* (Cambridge: Cambridge University Press, 1999), p. 11.

21 Griselda Pollock writes, 'The "real" conditions of the existence of a photograph, are that someone was there in the landscape and instead of picking up this child in his arms and taking her to safety and sustenance, the photographer that he was, he considered the taking of a good picture to show the condition of which this fading life was but an illustration': *Alfredo Jaar: The Politics of Images* (Zurich: J.R.P. Ringier, 2007), pp.113–37.

22 Max Scheler, *Ressentiment*, trans. William H. Holdheim (New York: Noonday, 1973).

23 Nietzsche, *On the Genealogy of Morals*. Brian Leiter argues that powerlessness rather than apprehension of another's superiority is the key trigger for ressentiment; see Brian Leiter, *Nietzsche on Morality* (London: Routledge, 2002), p.202.

24 Boltanski, *Distant Suffering: Morality, media and politics*, p.11.

25 Frederich Nietzsche, *The Will to Power*, trans. Walter Kaufmann and R.J Hollingdale (New York: Vintage, 1968), p.263, cited in Nigel Thrift, 'Intensities of feeling: towards a spatial politics of affect', *Geografiska Annaler, Series B, Human Geography*, 86, no 1 (2004), special issue, *The Political Challenge of Relational Space*, p.171.

26 Martin Seel, *Aesthetics of Appearing*, trans. John Farrell (Stanford, CA: Stanford University Press, 2005), p.157. Seel is discussing Elfriede Jelinek's language.

27 Philippa Hawker, 'Photographer faces obscenity charges after raid on gallery', *The Age*, 24 May 2008, first ed. 3. Henson's May 2008 exhibition at the Roslyn Oxley9 Gallery in Sydney was cancelled following complaints made to the police about works depicting a nude 13-year-old girl. Immense public debate ensued, and on 23 May 2008 the police announced their intention to charge the artist with 'publishing an indecent article'. Charges were subsequently dropped.

28 Thrift, 'Intensities of feeling', p.73.

29 Peter Sloterdijk, *Rage and Time* (New York: Columbia University Press, 2010), p.228.

Bibliography

Agamben, Giorgio, *Potentialities: Collected essays in philosophy*, trans. Daniel Heller-Roazen (Stanford: Stanford University Press, 1999)

— *Means Without End: Notes on politics*, trans. Vincenzo Binetti and Cesare Daniel Heller (Minneapolis, MN: University of Minnesota Press, 2000)

Arendt, Hannah, *On Revolution* (London: Penguin, 1965)

Armstrong, Isobel, *The Radical Aesthetic* (Oxford: Blackwell, 2000)

Augé, Marc, *Non-Places: Introduction to an anthropology of supermodernity*, trans. John Howe (New York: Verso, 1995)

Austin, John. L., *How to Do Things With Words*, the William James Lectures delivered at Harvard University in 1955, 2nd edn, ed. J.O. Urmson and Marina Sbisà (Cambridge, MA: Harvard University Press, 1975)

Bal, Mieke, *Travelling Concepts in the Humanities: A rough guide* (Toronto: Toronto University Press, 2002)

— 'Visual essentialism and the object of visual culture', *Journal of Visual Culture* 2, no 1, 2003

Baumgarten, Alexander G., *Aesthetica*, 2 vols (Hildesheim: Olms, 1970)

Beccaria, Marcella (ed.), *Candice Breitz* (Turin: Castello di Rivoli, 2005)

Bell, Jeffrey, *Deleuze's Hume: Philosophy, culture, and the Scottish enlightenment* (Edinburgh: Edinburgh University Press, 2009)

Bennett, Jill, 'Jill Bennett interviews Doris Salcedo', in *Doris Salcedo*, exhibition catalogue (London: Camden Arts Centre, 2001)

— 'Tenebrae after September 11: art, empathy and the global politics of belonging', in Jill Bennett and Rosanne Kennedy (eds), *World Memory: Personal trajectories in global time* (London: Palgrave MacMillan, 2003)

— *Empathic Vision: Affect, trauma and contemporary art* (Stanford, CA: Stanford University Press, 2005)

— Review of Georges Didi-Huberman, *Images in Spite of All: Four photographs from Auschwitz* (Chicago, IL: Chicago University Press, 2008), CAA reviews, available online: http://www.caareviews.org/reviews/1380, 31 December 2009

Berlant, Lauren (ed.), *Compassion: The culture and politics of an emotion* (New York: Routledge, 2004)

Bérubé, Michael (ed.), *The Aesthetics of Cultural Studies* (Malden, MA: Blackwell, 2005)

Blair, Tony, 'Transcript of Tony Blair's Iraq interview', *Newsnight*, BBC TV, 6 February; viewed December 2005, available online: http://news.bbc.co.uk/1/hi/programmes/newsnight/2732979.stm

Bogad, Lawrence M., *Electoral Guerrilla Theatre: Radical ridicule and social movements* (New York: Routledge, 2005)

Bollas, Christopher, *Cracking Up: The work of unconscious experience* (New York: Hill and Wang, 1950)

Boltanski, Luc, *Distant Suffering: Morality, media and politics* (Cambridge: Cambridge University Press, 1999)

Borradori, Giovanna, *Philosophy in a Time of Terror: Dialogues with Jurgen Habermas and Jacques Derrida* (Chicago, IL: University of Chicago Press, 2003)

Boulos, Mark, interview with Stedelijk Museum, available online: http://www.youtube.com/watch?v=BX6rYfNzTJ8

Brennan, Teresa, *The Transmission of Affect* (New York: Cornell University Press, 2004)

Buchloh, Benjamin, 'Cosmic reification: Gabriel Orozco's photographs', in *Gabriel Orozco* (London and Cologne: Serpentine Gallery, 2004)

Butler, Judith, *Excitable Speech* (New York: Routledge, 1997)

Campbell, David et al., *Imaging Famine*, exhibition catalogue, 2005, available online: www.imaging-famine.org

Cartier-Bresson, Henri, *The Decisive Moment* (New York: Simon & Schuster, 1952)

Caruth, Cathy (ed.), *Trauma: Explorations in memory* (Baltimore, MD: Johns Hopkins University Press, 1995)

Chafets, Zev, *Jewish World Review*, 18 November 2002, available online: http://www.jewishworldreview.com/1102/chafets111802.asp

Colwell, C., 'Deleuze and Foucault: series, event, genealogy', *Theory and Event* 1, no 2, 1997

Crispin Miller, Mark, *The Bush Dyslexicon: Observations on a national disorder* (New York: Norton, 2001)

Danielewski, Mark. Z, *House of Leaves* (New York: Pantheon Books, 2000)

De Certeau, Michel, *The Practice of Everyday Life*, trans. Steven Rendall (Berkeley, CA: University of California Press, 1984)

Deleuze, Gilles, *The Logic of Sense*, trans. Mark Lester and Charles Stivale, ed. Constantin Boundas, originally published 1969 (New York: Columbia University Press, 1990)

— *Cinema 1: The movement-image*, trans. H. Tomlinson and B. Habberjam (Minneapolis, MN: University of Minnesota Press, 1986)

— *Cinema 2: The time image*, trans. Hugh Tomlinson and Robert Galeta (Minneapolis, MN: University of Minnesota Press, 1989)

— *Empiricism and Subjectivity*, trans. Constantin V. Boundas (New York: Columbia University Press, 1991)

— *Francis Bacon: The logic of sensation,* trans. D.W. Smith (Minneapolis, MN: University of Minnesota Press, 2003)

Deleuze, Gilles and Félix Guattari, *Kafka: Toward a minor literature*, trans. Dana Polan (Minnesota, MN: University of Minnesota Press, 1986)

— *A Thousand Plateaus: Capitalism and schizophrenia* (Minneapolis, MN: University of Minnesota Press, 1987)

— *What is Philosophy?,* trans. Hugh Tomlinson and Graham Burchill, originally published 1991 (London and New York: Verso, 1994)

Demand, Thomas, 'A thousand words: Thomas Demand talks about *Poll'*, *Artforum* 39, no 9 (May 2001), available online: http://www.findarticles.com/p/articles/mi_m0268/is_9_39/ai_75914323

Dewey, John, *Art as Experience* (New York: Perigee Books, 2005)

Didi-Huberman, Georges, 'Dialektik des Monstrums: Aby Warburg and the symptom paradigm', *Art History* 24, no 5, 2001

— *Images in Spite of All: Four photographs from Auschwitz* (Chicago: Chicago University Press, 2008)

Dyson, Frances, *Sounding New Media: Immersion and embodiment in the arts and culture* (London: University of California Press, 2009)

Edbauer, Jenny, 'Executive overspill: affective bodies, intensity, and Bush-in-relation', *Postmodern Culture* 15, no 1, 2004

Elkins, James, *On Pictures and the Words that Fail Them* (Cambridge: Cambridge University Press, 1998)

— *Visual Studies: A skeptical introduction* (London and New York: Routledge, 2003)

— (ed.), *Art History Versus Aesthetics* (London and New York: Routledge, 2005)

Ekman, Paul, 'Darwin, deception, and facial expression', *Annals of the New York Academy of Sciences* 1000 (December, 2003)

Ekman, Paul and Wallace V. Friesen, 'Nonverbal leakage and clues to deception', *Psychiatry* 32, no 1, 1969

Enwezor, Okwui (ed.), *The Unhomely: Phantom scenes in global society*, exhibition catalogue (Seville: Fundación Bienal Internacional de Arte Contemporáneo de Sevilla, 2006)

Forster, Kurt, 'Introduction', in *Aby Warburg: The renewal of pagan antiquity*, trans. David Britt (Los Angeles, CA: Getty Research Institute for the History of Art and the Humanities, 1999)

Foster, Hal, 'Polemics, postmodernism, immersion, militarized space', *Journal of Visual Culture* 3, 2004

Fried, Michael and Tim Griffin, 'Douglas Gordon and Philippe Parreno's *Zidane*: a portrait of the twenty-first century', *Artforum* 45, no 1, September 2006

Frith, Simon, *Performing Rites: On the value of popular music* (Cambridge, MA: Harvard University Press, 1996)

Genosko, Gary, *Felix Guattari: An aberrant introduction* (London and New York: Continuum, 2002)

Getty Trust, *Recent History: Photographs by Luc Delahaye*, exhibition catalogue (Los Angeles: J. Paul Getty Museum at the Getty Centre, 2007)

Gibbs, Anna, 'Contagious feelings: Pauline Hanson and the epidemiology of affect', *Australian Humanities Review*, December 2001, available online:http://www.lib.latrobe.edu.au/AHR/archive/Issue-December-2001/gibbs.html

Gountas, John and Joseph Ciorciari, 'Neuromarketing crosses another frontier – EEG brain scans break the mould for market mavens', *Latrobe University News*, 9 May 2008, available online: http://www.latrobe.edu.au/news/articles/2008/article/neuromarketing-crosses-another-frontier---eeg-brain-scans-break-the-mould-for-market-mavens

Green, André, *Le Discours Vivant: La conception psychanalytique de l'affect* (Paris: Presses Universitaires de France, 1973)

Greenberg, Judith, *Trauma at Home: After 9/11* (Lincoln, NE University of Nebraska Press, 2003)

Guattari, Felix, *Chaosmosis: An ethico-aesthetic paradigm* (Bloomington, IN: Indiana University Press, 1995)

Halsall, Frances, Julia Jansen and Tony O'Connor (eds), *Rediscovering Aesthetics: Transdisciplinary voices from art history, philosophy and art practice* (Stanford, CA: Stanford University Press, 2008)

Harp, Dustin and Mark Tremayne, 'Programmed by the people: the intersection of political communication and the YouTube Generation', available online: www.allacademic.com/meta/p173067_index.html

Hawker, Philippa, 'Photographer faces obscenity charges after raid on gallery', *The Age*, 24 May 2008

Hunt, Simon, 'I don't like it', TWA Records, 1998

— *The Pauline Pantsdown Story*, unpublished documentary, 1998

Ingham, Susan, 'Dadang Christanto: art, activism and the environment', *C Arts Asian Contemporary Art & Culture*, Sept–Oct 2009

Jaar, Alfredo, 'The politics of images' (London: Phaidon, 2007)

Kelly, Susan, 'The transversal and the invisible: how do you really make a work of art that is not a work of art?', *Republic Art,* January 2005, available online: www.republicart.net/disc/mundial/kelly01_en.htm

Kosofsky Sedgwick, Eve, *Touching Feeling: Affect, pedagogy, performativity* (Durham, NC: Duke University Press, 2003)

Kosofsky Sedgwick, Eve and Adam Frank (eds), *Shame and its Sisters: A Silvan Tomkins reader* (Durham, NC: Duke University Press, 1995)

Kritzman, Lawrence D. (ed.), *The Columbia History of Twentieth-Century French Thought* (New York: Columbia University Press, 2006)

Latour, Bruno, *We Have Never Been Modern*, trans. Catherine Porter (Cambridge, MA: Harvard University Press, 1991)

— *Reassembling the Social: An introduction to actor-network-theory* (Oxford: Oxford University Press, 2005)

Leiter, Brian, *Nietzsche on Morality* (London: Routledge, 2002)

McInerney, Jay, 'The uses of invention', *Guardian*, 17 September 2005, available online: http://www.guardian.co.uk/books/2005/sep/17/fiction.vsnaipaul

Marcus, George. E, et al. (eds), *The Affect Effect: Dynamics of emotion in political thinking and behavior* (London: University Chicago Press, 2007)

Marks, Laura, *The Skin of the Film: Intercultural cinema, embodiment, and the senses* (Durham, NC: Duke University Press, 2000)

Massumi, Brian, 'The autonomy of affect', *Deleuze: A critical reader*, ed. Paul Patton (Oxford and Cambridge, MA: Blackwell, 1996)

— *Parables for the Virtual: Movement, affect, sensation* (Durham, NC: Duke University Press, 2002)

— 'Fear (the spectrum said)', *Positions: East Asia critique* 13, no 1, 2005

Mauss, Marcel, 'L'expression obligatoire des sentiments', *Journal de psychologies*, 18, 1921

Metz, Christian, 'Aural objects', *Cinema/Sound* 60, 1980

Michaud, Philippe-Alain, *Aby Warburg and the Image in Motion*, trans. Sophie Hawkes (New York: Zone Books, 2004)

Miller, Richard B., *Casuistry and Modern Ethics: A poetics of practical reasoning* (Chicago, IL: University of Chicago Press, 1996)

Mirzoeff, Nicholas, *Watching Babylon: The war in Iraq and global visual culture* (New York and London: Routledge, 2005)

Mitchell W.J.T., *What Do Pictures Want? The lives and loves of images* (Chicago, IL: University of Chicago Press, 2004)

Moeller, Susan, *Compassion Fatigue: How the media sell disease, famine, war and death* (New York: Routledge, 1999)

Moore, Michael, *The Official Fahrenheit 9/11 Reader* (London: Penguin, 2004)

Morrison, Tony, 'Nobel Lecture', 7 December 1993, available online: http://nobelprize.org/nobel_prizes/literature/laureates/1993/morrison-lecture.html

Morton, Tim, *Ecology Without Nature* (Cambridge, MA: Harvard University Press, 2007)

Murphie, Andrew, 'Electronicas: differential media and proliferating, transient worlds', *Fineart Forum* 17, no 8 (August 2003), available online: http://www.fineartforum.org/Backissues/Vol_17/faf_v17_n09/reviews/murphie.html> and http://hypertext.rmit.edu.au/dac/papers/Murphie.pdf

— 'The mutation of "cognition" and the fracturing of modernity: cognitive technics, extended mind and cultural crisis', *Scan*, journal of media arts culture, available online: http://scan.net.au/scan/journal/display.php?journal_ id=58

Nicolescu, Basarab (ed.), *Transdisciplinarity: Theory and practice* (Cresskill, NJ: Hampton Press, 2008)

Nietzsche, Friederich, *On the Genealogy of Morals*, trans. W. Kauffman and R.J. Hollingdale, originally published 1887 (New York: Vintage Books, 1989)

Patton, Paul, 'The world seen from within: Deleuze and the philosophy of events', *Theory & Event* 1, no 1, 1997

Rancière, Jacques, 'What aesthetics can mean', in *From an Aesthetic Point of View: Philosophy, art and the senses,* ed. Peter Osborne (London: Serpent's Tail, 2001)

— *The Politics of Aesthetics*, trans. G. Rockhill (London: Continuum, 2004), published in French under the title *Le Partage du Sensible: Esthétique et politique*

— *The Future of the Image*, trans. G. Elliott (London and New York: Verso, 2007)

Riley, Denise, *Impersonal Passion: Language as affect* (Durham, NC: Duke University Press, 2005)

Schweizer, Nicole (ed.), *Alfredo Jaar: The Politics of Images* (Zurich: J.R.P. Ringier, 2007)

Seel, Martin, *Aesthetics of Appearing*, trans. John Farrell (Stanford, CA: Stanford University Press, 2005)

Shah Stamets, Reena, 'Were his priorities out of focus?', *St Petersburg Times*, 14 April 1994

Shklovsky, Viktor, 'Art as technique', in *Russian Formalist Criticism: Four essays*, ed. Lee T. Lemon and Marion J. Reiss, originally published 1917 (Lincoln, NE: University of Nebraska, 1965)

Sifry, Micah and Andrew Rasiej, 'Welcome to the age of the soundblast', available online: http://thebreakthrough.org/blog/2008/03/youtubes_political_revolution.shtml; www.personaldemocracy.com

Sischy, Ingrid, 'Photography: good intentions', *New Yorker*, 9 September 1991, reprinted in *Illuminations: Women writing on photography from the 1850s to the present*, eds Liz Heron and Val Williams (London: I.B.Tauris, 1996)

Sloterdijk, Peter, *Sphären I – Blasen* (Frankfurt-am-Main: Suhrkamp, 1998)

— *Sphären II – Globen* (Frankfurt-am-Main: Suhrkamp, 1999)

— *Sphären III – Schäume* (Frankfurt-am-Main: Suhrkamp, 2004)

— 'Something in the air', *Frieze* 127 (November–December 2009), available online: http://www.frieze.com/issue/print_article/something_in_the_air

— *Rage and Time: A psychopolitical investigation* (New York: Columbia University Press, 2010)

Smith, Terry, Okwui Enwezor and Nancy Condee (eds), *Antinomies of Art and Culture: Modernity, postmodernity, contemporaneity* (Durham, NC: Duke University Press, 2008)

Sontag, Susan, *Regarding the Pain of Others* (New York: Farrar, Straus and Giroux, 2003)

Steyerl, Hito, 'The articulation of protest', in *Subsol: Technologies of truth and fiction*, available online: http://subsol.c3.hu/subsol_2/contributors3/steyerltext2.html

Strangeways, Al, '"The boot in the face": the problem of the Holocaust in the poetry of Sylvia Plath', *Contemporary Literature* XXXVII, no 3, 1996

Stratton, John, '"I don't like it": Pauline Pantsdown and the politics of inauthenticity', *Perfect Beat: The Pacific journal of research into contemporary music and popular culture* 4, no 4, 1999

Thrift, Nigel, 'Intensities of feeling: towards a spatial politics of affect', *Geografiska Annaler, Series B, Human Geography*, 86, no 1, 2004, special issue, *The Political Challenge of Relational Space*

Tomkins, Silvan S., 'Affect imagery consciousness', *The Positive Affects*, vol. I (New York: Springer, 1962)

— 'Affect imagery consciousness', *The Negative Affects*, vol. III (New York: Springer, 1991)

— *Exploring Affect: The selected writings of Silvan S. Tomkins*, ed. Virginia Demos (Cambridge and New York: Cambridge University Press, 1995)

Trilling, Lionel, *Sincerity and Authenticity* (London: Oxford University Press, 1972)

Tsing, Anna L., *Friction: An ethnography of global connection* (Princeton, NJ: Princeton University Press, 2004)

Welsch, Wolfgang, 'Aesthetics beyond aesthetics', in Francis Halsall, Julia Jansen and Tony O'Connor (eds), *Rediscovering Aesthetics: Transdisciplinary voices from art history, philosophy, and art practice* (Stanford, CA: Stanford University Press, 2008)

Werckmeister, Otto K., *Der Medusa-Effekt: Politische Bildstrategien seit dem 11. September 2001* (Berlin: Form and Zweck, 2005)

Williams, Raymond, *Marxism and Literature* (New York: Oxford University Press, 1977)

Young, Alison, 'Documenting September 11th: trauma and the (im)possibility of sincerity', in Ernst Van Alphen et al. (eds), *The*

Rhetoric of Sincerity (Stanford, CA: Stanford University Press, 2008)

Žižek, Slavoj, 'The subject supposed to loot and rape: reality and fantasy in New Orleans', *In These Times,* 20 October 2005, available online: http://www.inthesetimes.com/site/main/article/2361/, 2005

Zournazi, Mary, *Hope: New philosophies for change* (London and New York: Routledge, 2003)

Websites

http://www.zarinabhimji.com/dspseries/12/1FW.htm

Index